STORY-
BOARDING
ESSENTIALS

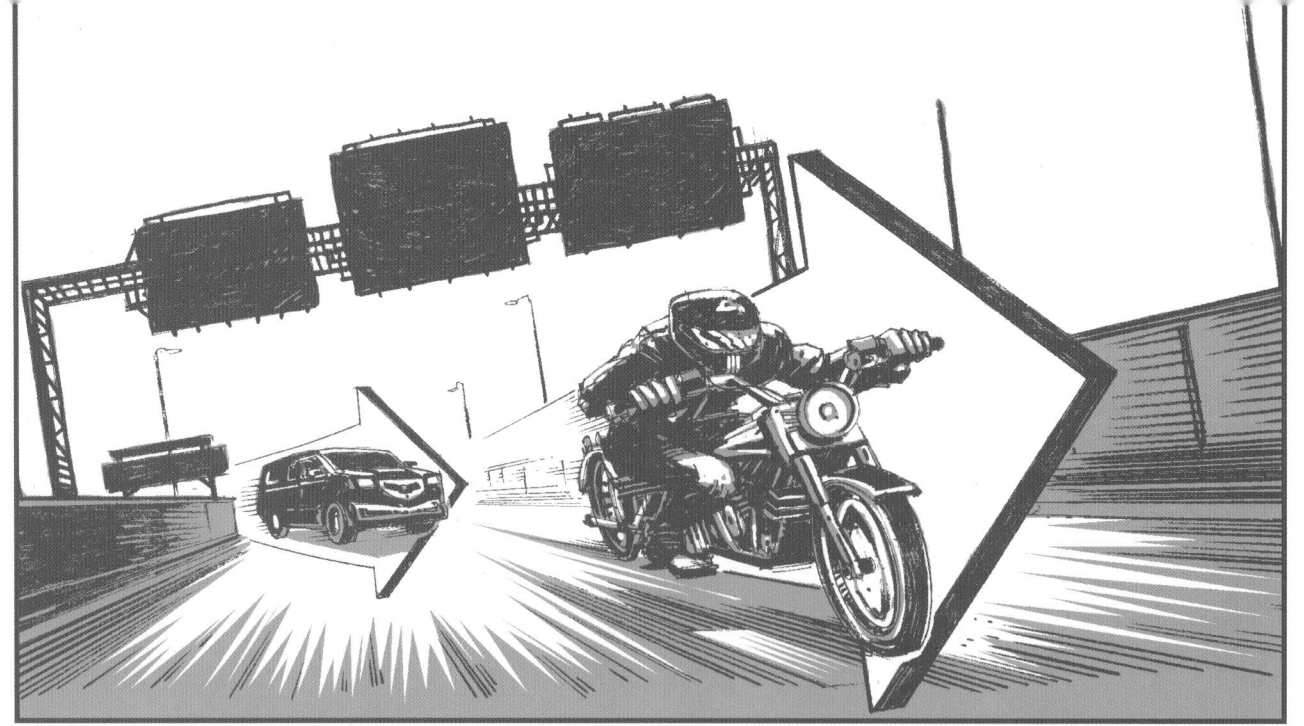

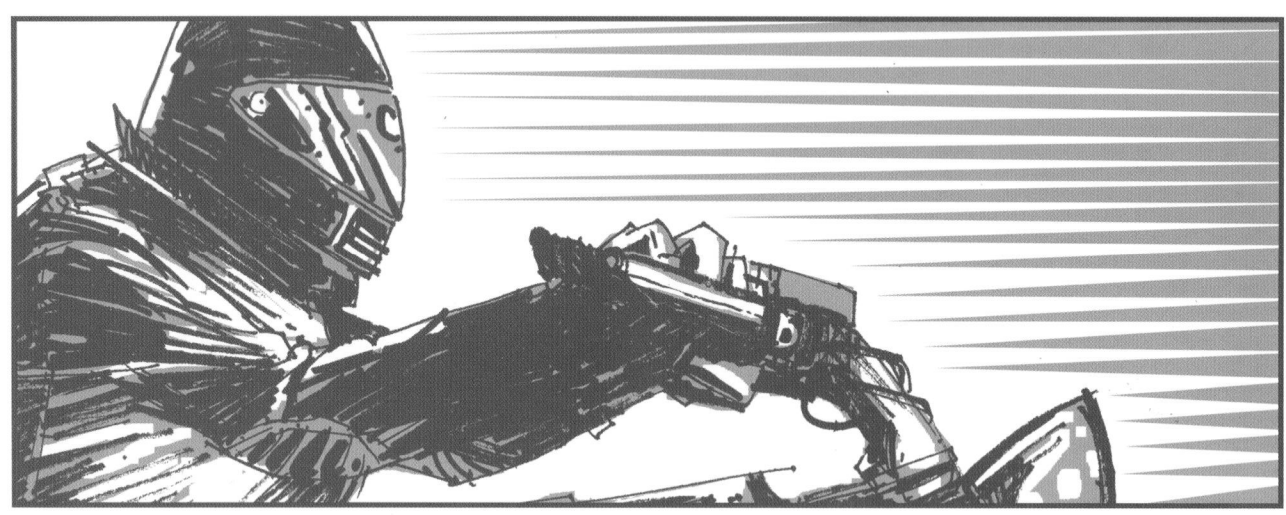

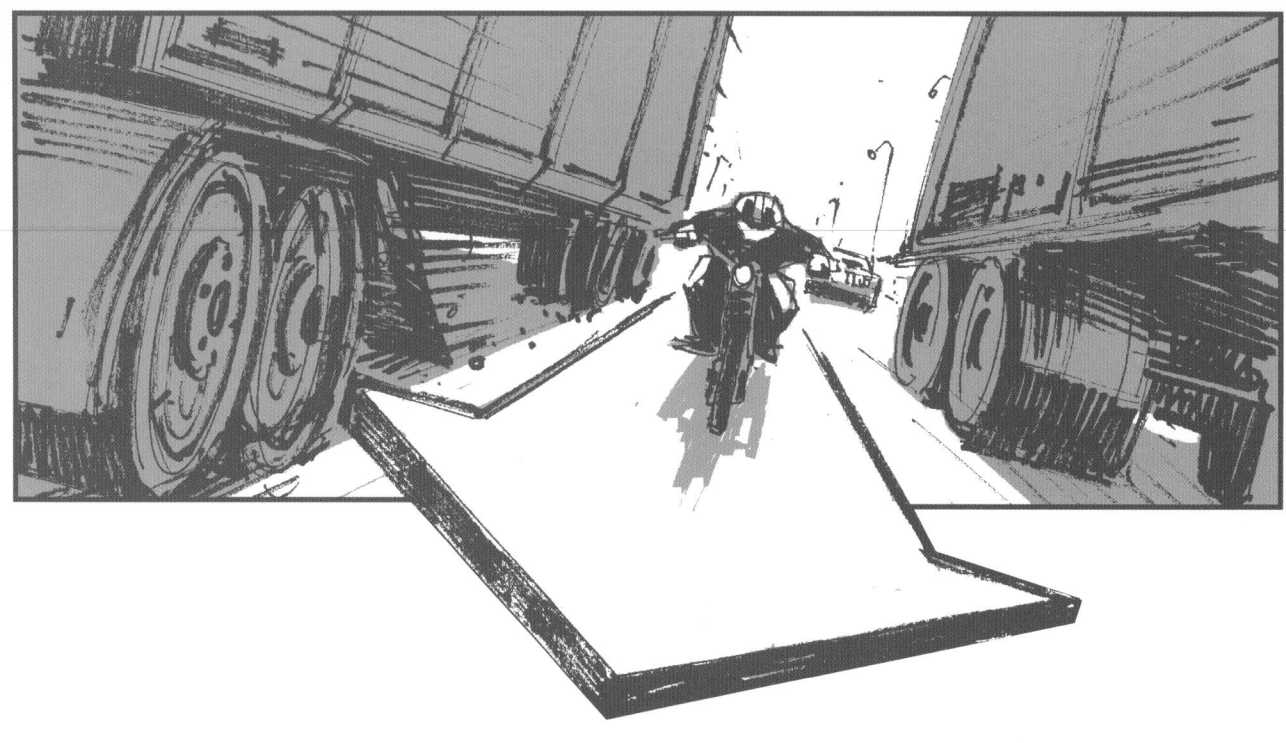

David Harland Rousseau and Benjamin Reid Phillips

STORY-BOARDING ESSENTIALS

How to Translate Your Story to the Screen for Film, TV, and Other Media

Watson-Guptill Publishers
New York

SCAD.®
Creative Essentials

Published in the United States by Watson-Guptill Publications, an imprint of the
Crown Publishing Group, a division of Random House, Inc., New York.
www.crownpublishing.com
www.watsonguptill.com

WATSON-GUPTILL is a registered trademark and the WG and Horse designs are
trademarks of Random House, Inc.

Library of Congress Cataloging-in-Publication Data
Rousseau, David H. (David Harland)
 Storyboarding essentials : how to translate your story to the screen for film, tv, and other media
/ David Harland Rousseau and Benjamin Reid Phillips.
 p. cm.
 Includes index.
 1. Motion pictures—Production and direction. 2. Storyboards. I. Phillips, Benjamin Reid. II. Title.
 PN1995.9.P7R655 2013
 791.4302'3—dc23
 2012023065

ISBN 978-0-7704-3694-0
eISBN 978-0-385-34559-0

Printed in China
Book design by Angela Rojas
Cover design by Ken Crossland
Cover illustrations © Benjamin Reid Phillips
1 2 3 4 5 6 7 8 9 10

First Edition

DEDICATION

To our talented students at SCAD. You continue to inspire us through your hard work and dedication to the art of storyboarding, and we dedicate this book to you.

THE SCAD CREATIVE ESSENTIALS SERIES

The SCAD Creative Essentials series is a collaboration between Watson-Guptill Publications and the Savannah College of Art and Design (SCAD), developed to deliver definitive instruction in art and design from the university's expert faculty and staff to aspiring artists and creative professionals.

CONTENTS

PREFACE

When we first started teaching storyboarding, we discovered that there were few books dedicated to the "visual mechanics of storyboarding." Sure, we found countless resources in coffee table books that generally started with the words "The Art of" We discovered a passing nod to the subject of storyboarding in endless websites promoting the work of remarkably talented illustrators, in books specializing in animation, and in books telling the history of cinema. But we found nothing that broke storyboarding down into terms that anyone other than an aspiring illustrator or animator would appreciate.

We muddled through. We met for coffee now and then and shared ideas based on our research and development. Ben drew from his experience in the world of sequential art; I drew from my experience in front of and behind the camera. Together, we developed a fairly comprehensive glossary. We began to break down the differences between moving and static shots. We identified issues related to continuity, screen direction, and visual logic. We even determined a method of interpreting the written word that parallels the method used by assistant directors (ADs) when creating shooting scripts and call sheets.

Through all of this, we discovered commonalities between the four main applications of storyboarding: live action, animation, advertising, and visual effects.

There is no "right way" to draw for storyboards—and they don't have to be beautifully rendered. The one important requirement is that the panels must clearly indicate framing height, camera angle, and movement. All else is fair game. To prove the point, in this book we have included a series called "A Difference of Opinion." In each installment, two artists go head-to-head, and each artist presents his or her take on the same scene from the same script excerpt. The artists were given panel count and time restrictions. The artists' boards are quick and to the point, with each panel clearly communicating camera angles, framing heights, and movement directions. As you look at the drawings, ask yourself how you would have approached the same scene.

Storyboarding Essentials won't teach you how to draw better or faster, but if you have drawing ability, you will appreciate the chapter on rendering. The book doesn't promise to give you shortcuts, but following important chapters, it does include exercises on numbering and visual logic, which reinforce key concepts.

Storyboarding Essentials is intended for a variety of disciplines, including illustration, film, television, advertising, and animation. Filmmakers will appreciate its common sense approach to framing heights and camera angles; aspiring ADs will benefit from its practical take on breaking down the script; illustrators with some drawing skill will value the discussion on composition and visual language; and virtually everyone will appreciate the insight provided by outstanding professionals through stand-alone interviews with Ken Chaplin, DGA/DGC, animation veteran Keith Ingham, and illustrator Whitney Cogar.

We hope this practical introduction to the "invisible art" of this specialized visual narrative will provide you, the reader, with a strong foundation for building the bridge between story and screen.

David Harland Rousseau and Benjamin Reid Phillips

Savannah, Georgia

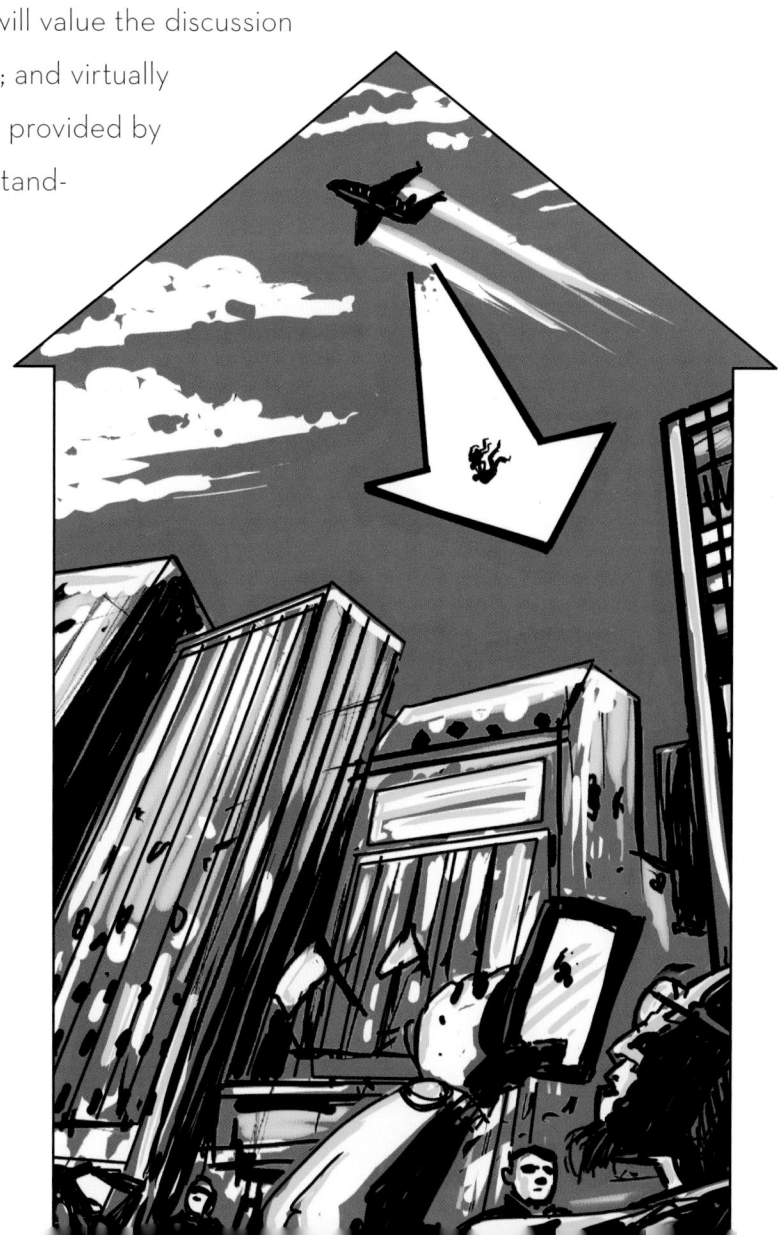

WHAT IS STORYBOARDING?

1

The Types of Storyboards

Storyboards are powerful planning tools that can be used in a variety of disciplines, with the lion's share of the work being dedicated to filmed visual narratives such as live action productions and animation. Storyboards are also used for advertising and visual effects, and their use has expanded into the fields of interactive design, game development, and even theme park attractions.

Editorial, or Shooting (Live Action)

Editorial storyboards, or shooting boards, for live action production are mainly concerned with the camera's position, angle, and movement. They are typically used for complex sequences, action scenes, and stunt choreography. In this traditional sense, they are a cinematographer's companion.

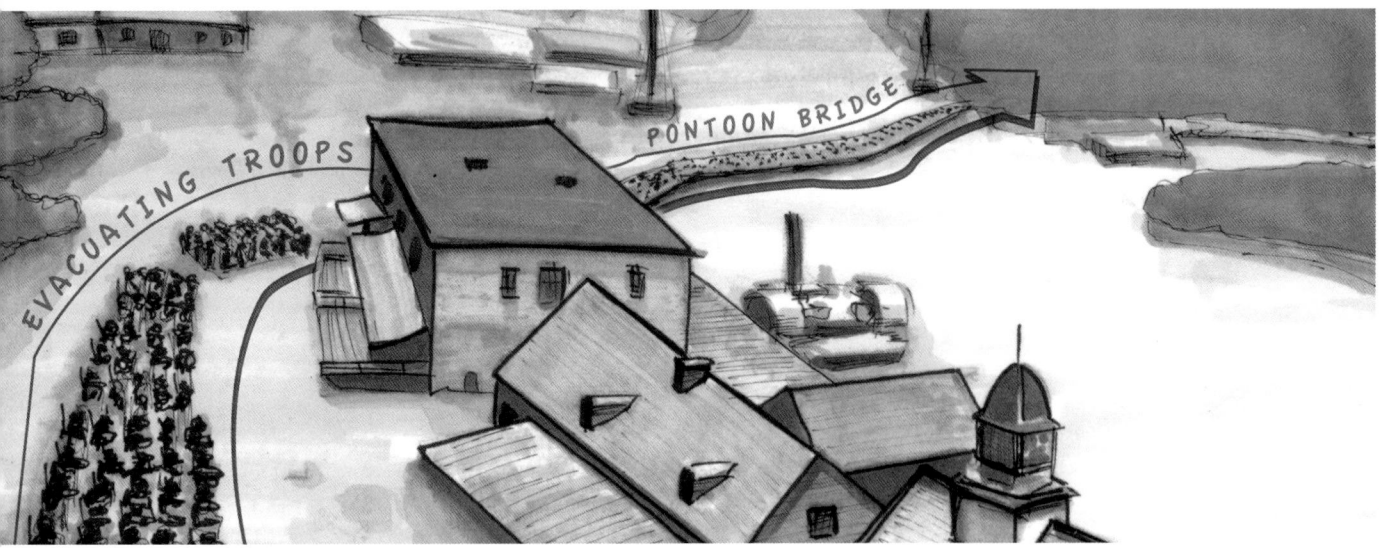

Editorial Storyboard: This aerial shot captures the magnitude of Confederate soldiers evacuating from the city of Savannah in December 1864.

The Origins of Storyboarding

Storyboarding's origins are in animation. At the dawn of the industry, animators would create story sketches for their short films. Rather than draft a formal script, these sketches served as effective visual shorthand used to preplan the cartoons. By the mid-1930s, animation studios were employing a system of pinning drawings on boards in the studio during production meetings. The combination of their practical purpose (which was to tell a story) and the method of their presentation (which was to pin the drawings to display boards) gave us the term *story board*. Somewhere along the way, the two words became one.

Animation

Animation places great demands on the storyboard artist. Beyond the camera's position and angle, animation storyboards are concerned with timing and layout relative to developing the story and performance. As a result, it is necessary to draw out multiple storyboards for a single shot, which greatly increases the required number of panels.

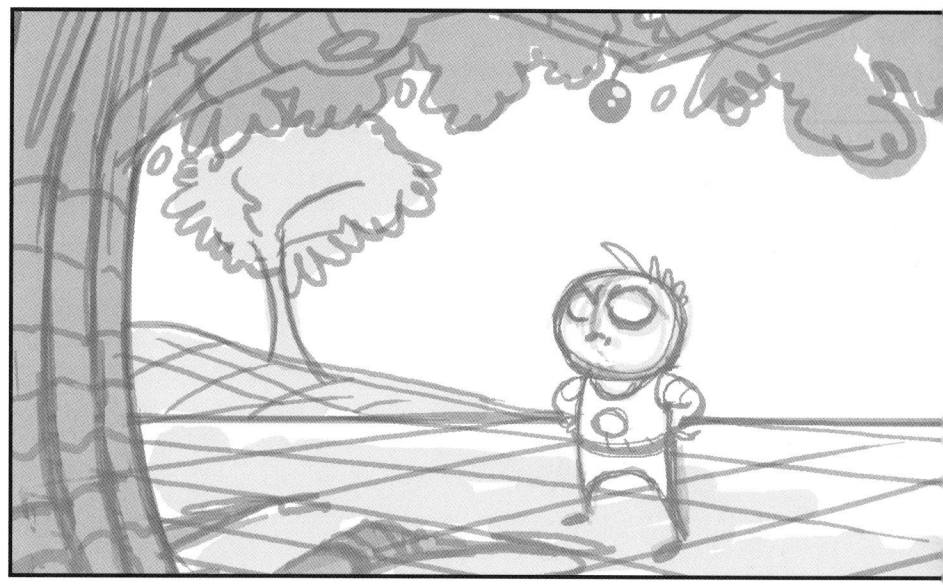

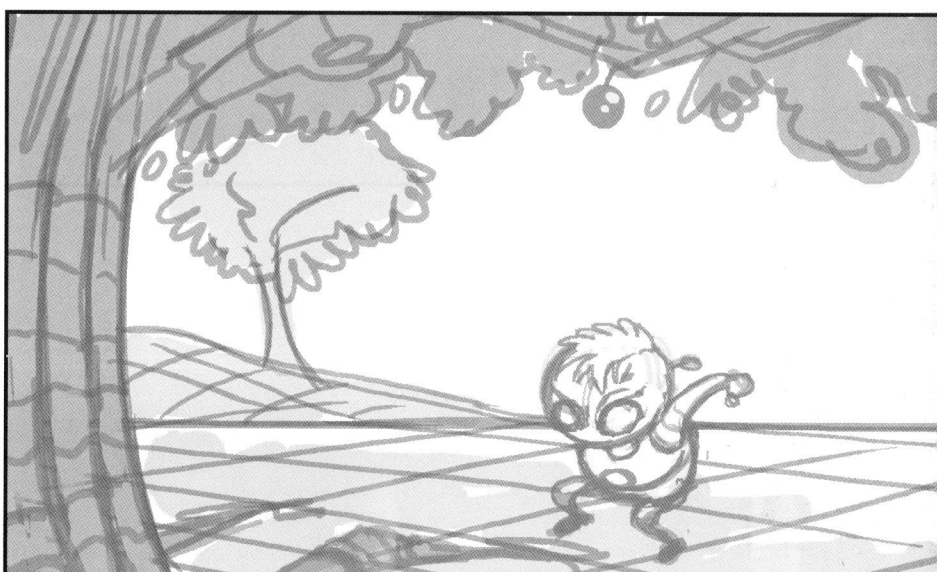

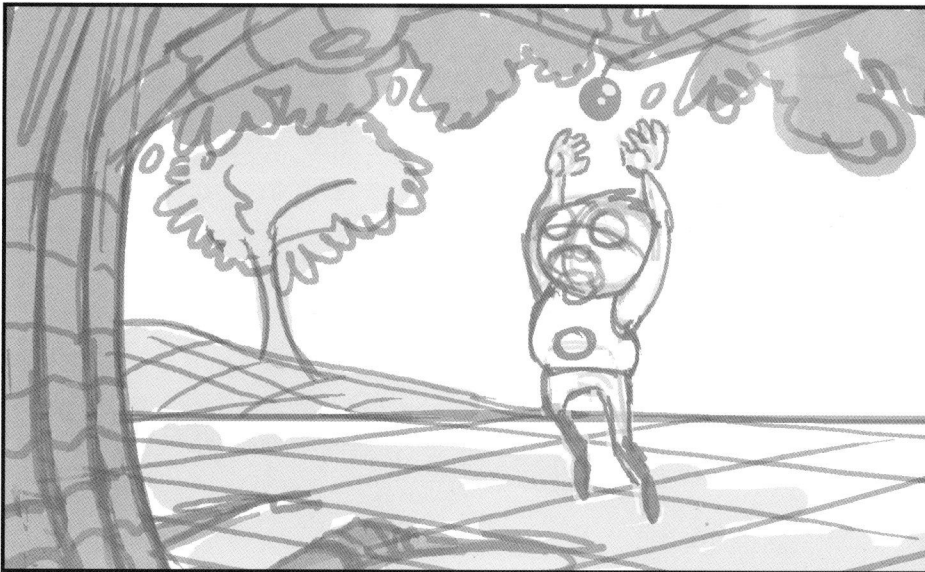

Animation Storyboards: This series of storyboards has been executed to visualize one shot, or *scene* as it is called in animation, of a small character trying to reach some dangling fruit.

Comp, or Presentation (Advertising)

Comp, or presentation, boards tend to be more colorful and illustrative, for advertising is concerned with the selling of a concept. The main purpose of these storyboards is to highlight the key moments of a televised commercial campaign in order to demonstrate how the features and benefits of a particular product or service will be pitched to the consumer. Graphics, logos, and text are often used in conjunction with the design of the commercial as part of the overall presentation. As a general rule, comp boards do not serve as blueprints for the filming of 30-second spots; instead, shooting boards are used for such purposes.

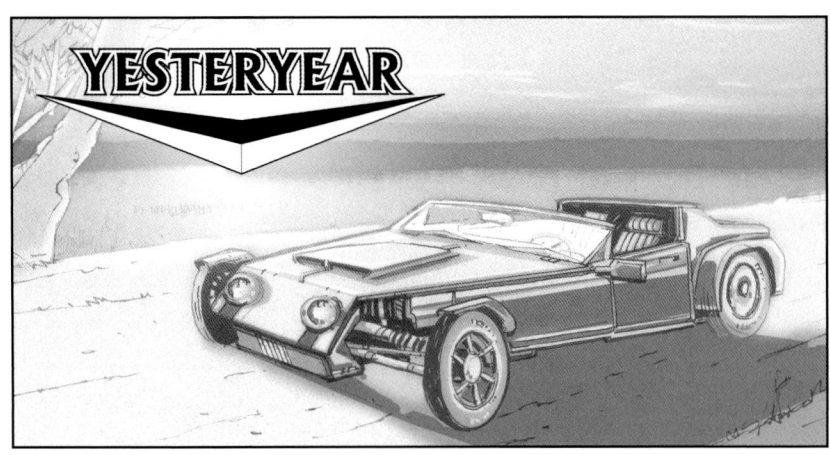

Comp, or Presentation, Board: This "beauty shot" of a fictitious hybrid roadster is an example of how drawing, photography, and graphic elements, such as logos, can be combined to help sell a product or idea.

Previsualization (CGI)

Previsualization storyboards, also known as *previz boards*—a hybrid of live action shooting boards and animation storyboards—have emerged in response to the continued development of increasingly complex computer-generated imagery (CGI). Previz boards concern themselves with camera placement as their primary focus while incorporating performance, motion, and timing elements. As with animation, this often requires multiple drawings for a single shot. Certain shots require a composite of live action and visual effects elements, which require a strong understanding of lighting. This adds to the complexity of these specialized boards.

Previsualization Storyboards: Since computer-generated imagery lives and operates in a world between shooting and animation, these two boards both show a single shot. The arrow in the board on the bottom is used to emphasize and show that the robot has risen up from the ground.

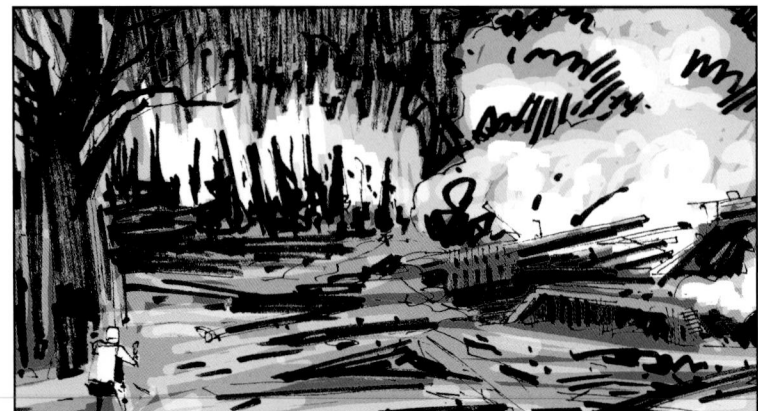

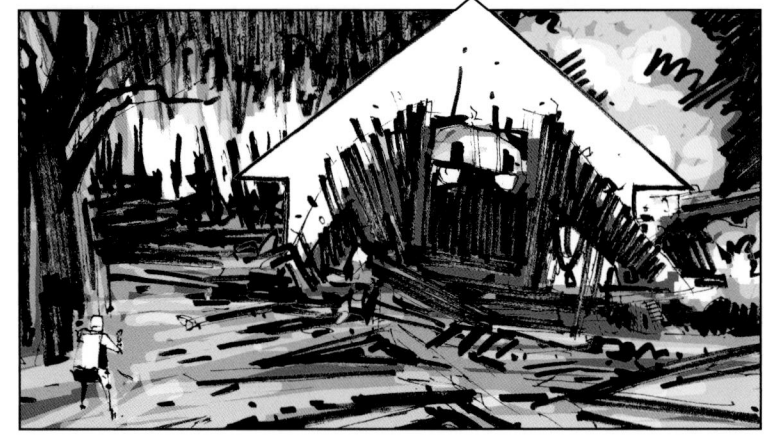

A Visual Road Map

Storyboards have become increasingly complex since the early story sketches created by the pioneers of animation, but their fundamental purpose has not changed. These formatted drawings are used for the planning of a visual narrative.

Collaborative in nature, storyboards rely on the words of the screenwriter, the vision of the director, the world created by the production designer, and, of course, the images drawn by the illustrator. These images are then reproduced, organized, and distributed to members of the production crew who use them as a visual road map of sorts.

When properly organized, storyboards become effective tools for assistant directors and producers. They provide clarity when setting the shooting schedule or planning a budget. Of course, storyboards can also be of great help to prop masters, wranglers, production designers, and script supervisors.

Regardless of genre or discipline, storyboards share a language that reflects the jargon and terminology employed by industries born out of filmed visual narrative. They connect written word to final cut; they concern themselves with what the camera "sees" (framing height, camera angle, and movement); they use standard and recognized formats (aspect ratios); and they even employ similar organizational systems (numbering). While the cinematographer relies on instinct and experience, a good storyboard artist will develop a strong understanding of camera angles and framing heights to help the director achieve his or her vision.

Sometimes, it's just as important to remember what storyboarding is not. Even though graphic novels have made the leap to the silver screen, storyboards are not comic books; though they are illustrated, they are not meant to tell stories; though they frame an image, they can never replace the skilled eye of a cinematographer; though they are carefully conceived and composed, they can never be a substitute for the director's vision; though they are polished and presented, they are only a beginning, not an end.

Student Storyboards: In these examples, students were asked to analyze a sequence from a film. The completed images were then posted on a board for critique and review.

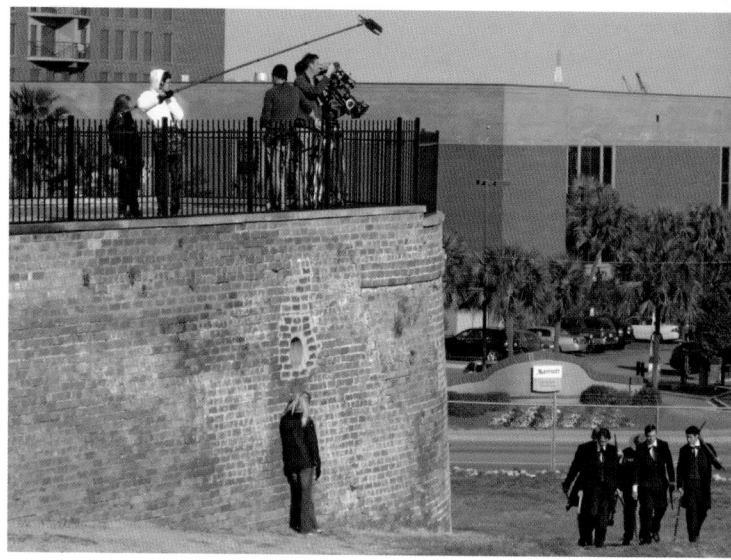

Cast and Crew Shooting on Location for Abraham Lincoln vs. Zombies: The horror film, produced by Four Score Films, LLC, and distributed by the Asylum, was shot on location throughout Savannah in 2012. For dramatic effect, the cinematographer chose to capture from a high angle the movement of the returning heroes. (For more on framing heights and angles, please see pages 116–119.)

Jack
Dahlia
Portly

crowd
drivers
mechanics

Buick ~~~~
Jack's racer

EXT. CITY HALL — DAY

The crowd gathers along BAY STREET as drivers and engineers tune up their racers.

DAHLIA steps out of her roadster. She moves toward JACK, who is working on his car. *transpo.*

DAHLIA

(softly)
Hey.

Jack pulls his head from under the hood. He wipes grimy hands on his coveralls. *mu/h/w*

Dahlia stands with arms folded. Jack is uneasy.

A PORTLY man waddles up to Jack. He tips his hat to Dahlia, who lowers her gaze. *mu/h/w*

PORTLY
Jack, my boy, a lot of folks are counting on you—

JACK
Thank you, sir.

PORTLY
I dare say we've got a good bit of money on you, son. Play your cards right, and you'll be very comfortable.

Portly places a heavy hand on Jack's shoulder. Jack wi

PORTLY
(Leaning in, whispering)
~~~~ it easy, lad. Think of it as ~~~gh the countrysid

# INTERPRETING THE WRITTEN WORD

2

# Script Basics

While this is not a book on screenwriting, it is important for every storyboard artist to be able to identify the elements of a script and to be able to interpret the written word.

Let's start with the basics. Every script has five fundamental elements:

1. Slugline
2. Action
3. Character
4. Dialogue
5. Wryly

Each one of these components provides essential information to everyone involved with the film or episode, from the director on down to the production assistant. A good storyboard artist should be able to glean information from each of these elements.

*slugline*

```
EXT. CITY HALL  — DAY

The crowd gathers along BAY STREET as drivers and
engineers tune up their racers.

DAHLIA steps out of her roadster. She moves toward
JACK, who is working on his car.

                    DAHLIA
            (softly)
            Hey.
```

*action*

```
Jack pulls his head from under the hood. He wipes
grimy hands on his coveralls.

Dahlia stands with arms folded. Jack is uneasy.

A PORTLY man waddles up to Jack. He tips his hat
to Dahlia, who lowers her gaze.

                    PORTLY
            Jack, my boy, a lot of folks are
            counting on you-

                    JACK
            Thank you, sir.
```

*character*

```
                    PORTLY
            I dare say we've got a good bit of
            money on you, son. Play your cards
            right, and you'll be very comfortable.

Portly places a heavy hand on Jack's shoulder.
Jack winces.

                    PORTLY
```

*wryly*

```
            (Leaning in, whispering)
            Just take it easy, lad. Think of it as
            a leisurely drive through the
            countryside.

Portly slaps Jack hard on the back. He gives a tip
and a nod to Dahlia, and waddles off.

Jack stands with clenched jaw.

                    DAHLIA
```

*dialogue*

```
            I'll tell you later.
                    JACK
            What?

Dahlia kisses Jack on the cheek and climbs back
into her Buick. She puts the car into gear and
motors off, leaving Jack in the dust.
```

Spec Script Example: Storyboard artists would look for cues that would help them determine framing height, angle, and movement, as well as setting and time of day.

## Slugline

When looking at the *slugline*, the reader notices three vital pieces of information:

1. The relative location of the camera (interior or exterior)
2. The physical location of the scene itself
3. The relative time of day

The slugline is expressed in this simple fashion— and always in all CAPS:

```
EXT. CITY HALL—DAY
```

What can a storyboard artist glean from this simple line of text? We know from this master scene heading that the scene is to be shot outside, in front of city hall, during the day. That's a lot of information provided with less than a half-dozen words.

---

**Tip**

It is interesting to note that script formats follow very rigid conventions, from the typeface (12-point Courier) to indention and spacing between elements. There is a reason for this: when properly executed, one page of script equals one minute of film.

---

## Action

The *action*, written in the present tense with quick beats, gives the artist a bit more information:

```
Jack pulls his head from under
the hood. He wipes grimy hands
on his coveralls.
```

That provides a lot more information, but it still gives the storyboard artist a great deal of leeway.

## Character, Wryly, and Dialogue

Finally, we have *character*, *wryly*, and *dialogue*, expressed in this fashion:

```
            PORTLY
    (Leaning in, whispering)
Just take it easy, lad. Think
of it as a leisurely drive
through the countryside.
```

Here, you learn who is speaking, how he is to deliver the line, and what he is saying. While the dialogue is not essential for the storyboard artist (this isn't a comic book script requiring word balloons, after all), the dialogue might just provide a clue for the artist with regard to body language and posture. With the parenthetical directions provided by the wryly, you can tell that Portly is trying to intimidate Jack.

You can find storyboard examples from this screenplay excerpt on pages 28–37.

---

**Terms**

*Action:* Also **description.** This is a brief narrative of what can be "seen" or represented on screen.
*Character:* This subheading denotes who is speaking.
*Dialogue:* This indicates what is being said.
*Slugline:* Also **master scene heading.** This tells us where the scene is shot and indicates the time of day.
*Wryly:* Also **parenthetical.** This suggests a direction for the actor.

---

# Script Breakdowns

The storyboard artist can take full advantage of the screenplay or script by breaking it down. In his outstanding course Production Assistant Training Seminar (PATS), taught throughout the United States to those interested in breaking into the film business, Ken Chaplin (see pages 38–39) provides an excellent introduction for breaking down the script. With his permission, we've adapted this simple-yet-effective technique for the storyboard artist.

The assistant directors (ADs) or department heads will take their copy of the script and go over it with a fine-tooth comb, making clear and obvious notations on things they find essential. Here are some things to look for in every script:

- Interior (INT) or exterior (EXT)
- DAY or NIGHT
- Cast
- Extras
- Transportation
- Props
- Set dressing (S/D)
- Special effects (SFX or FX)
- Animal wrangler (A/W)
- Makeup, hair, and wardrobe (MU/H/W)

This is an example of how an assistant director sees a script. Assistant directors are responsible for thinking of everything the director needs in order to pull off the shot.

| CAST | EXTRAS/BG | TRANSPO. | WARDROBE |
|------|-----------|----------|----------|
| Jack | crowd | racers | grimy coveralls |
| Dahlia | drivers | Buick Roadster | Portly's hat |
| Portly | mechanics | Jack's racer | |

**EXT.** CITY HALL — **DAY**

The crowd gathers along BAY STREET as drivers and engineers tune up their racers.

DAHLIA steps out of her roadster. She moves toward JACK, who is working on his car. *transpo.*

                    DAHLIA
          (softly)
          Hey.

Jack pulls his head from under the hood. He wipes grimy hands on his coveralls. *mu/h/w*

Dahlia stands with arms folded. Jack is uneasy.

A PORTLY man waddles up to Jack. He tips his hat to Dahlia, who lowers her gaze. *mu/h/w*

                    PORTLY
          Jack, my boy, a lot of folks are
          counting on you—

                    JACK
          Thank you, sir.

                    PORTLY
          I dare say we've got a good bit of
          money on you, son. Play your cards
          right, and you'll be very comfortable.

Portly places a heavy hand on Jack's shoulder. Jack winces.

                    PORTLY
          (Leaning in, whispering)
          Just take it easy, lad. Think of it as
          a leisurely drive through the countryside.

Portly slaps Jack hard on the back. He gives a tip and a nod to Dahlia, and waddles off.

Jack stands with clenched jaw.

                    DAHLIA
          I'll tell you later.

*transpo.*
                              JACK
          What?                      *sfx*

Dahlia kisses Jack on the cheek and climbs back into her Buick. She puts the car into gear and motors off, leaving Jack in the dust.

                    P.O.S.: JACK'S CONFLICT

The AD may also wish to define the *point of the scene* (POS), in order to abstractly define mood and setting. The POS is often written on call sheets as a reminder of which scene is being shot; however, most storyboard artists rarely, if ever, see call sheets.

The storyboard artist should build on this technique in order to discover cues and clues as to body language and expression, appropriate framing, angle, and movement.

```
EXT. CITY HALL — DAY                         EST. SHOT

The crowd gathers along BAY STREET as drivers and
engineers tune up their racers.              WIDE

DAHLIA steps out of her roadster. She moves toward JACK,
who is working on his car.

                    DAHLIA
              (softly)
          Hey.

Jack pulls his head from under the hood. He wipes grimy
hands on his coveralls.                  AMERICAN

Dahlia stands with arms folded. Jack is uneasy.

A PORTLY man waddles up to Jack. He tips his hat to
Dahlia, who lowers her gaze.    MED.

                    PORTLY
          Jack, my boy, a lot of folks are
          counting on you-

                    JACK
          Thank you, sir.

                    PORTLY
          I dare say we've got a good bit of
          money on you, son. Play your cards
 CLOSE     right, and you'll be very comfortable.

Portly places a heavy hand on Jack's shoulder. Jack
winces.

                    PORTLY       MED. CLOSE
              (Leaning in, whispering)
          Just take it easy, lad. Think of it as
          a leisurely drive through the
 FULL     countryside.

Portly slaps Jack hard on the back. He gives a tip and a
nod to Dahlia, and waddles off.

Jack stands with clenched jaw. CU.

                    DAHLIA
          I'll tell you later.

                    JACK
          What?                           FULL

Dahlia kisses Jack on the cheek and climbs back into her
Buick. She puts the car into gear and motors off, leav-
ing Jack in the dust.
          AMERICAN

              P.O.S.: JACK'S CONFLICT
```

This is an example of how a storyboard artist sees a script. The illustrator is concerned with conveying the POS through well-composed drawings that help the crew understand framing, angle, and movement. Other notes, such as thoughts on wardrobe, help the illustrator set the mood and tone for the crew.

# Spec Scripts Versus Shooting Scripts

This chapter features an excerpt from *The Great Savannah Race*, presented as a *spec script* (or *speculative screenplay*), which is an unsolicited, noncommissioned screenplay written by a screenwriter for submission or consideration to producers and film studios. Since filmmaking is a group effort, the writer intentionally leaves a great deal open to interpretation.

The shooting script comes into play much later in the process, after the screenplay has been broken down. By this stage, the director, cinematographer, and AD have made their decisions on various shots, and these decisions help determine the equipment and manpower needed for each and every shot within a scene, from the number of background performers to the type of lens (telephoto, wide angle, and so on) required for the shot.

It is important to note that projects do not rely solely on a shooting script. Film crews rely much more on breakdown sheets, prep and shooting schedules, call sheets, and *one-liners* generated by the AD and production office. By the time all is said and done, a thick binder (see below, for example) has been generated.

Still, it is important to note the difference between a spec script and a shooting script.

The jam-packed production binder of Jody Schiesser, first assistant director for *Abraham Lincoln vs. Zombies*.

## Terms

**Breakdown sheet:** This document lists important elements (for example, cast, extras, props, and transportation) required for shooting a particular scene.

**Call sheet:** Created from the shooting schedule, a call sheet provides the cast and crew with the information needed for a particular day of shooting, including working conditions, contact information, scenes and script page listings, and cast and crew reporting times.

**One-liner:** This is a condensed version of the shooting schedule listing scene headers and basic information. It serves as a reminder for most crew members.

**Prep schedule:** This document indicates the scheduling of departmental activities (for example, transportation, hair and makeup, costume fitting, and even tutoring and rehearsal) in preparation for principle photography.

**Shooting schedule:** This is a detailed compilation of all elements required for all scenes, broken down by department.

The shooting script shown below is by no means a full shooting script, nor is it the end-all-and-be-all of shot selections for this screenplay excerpt. It merely demonstrates a formal way of breaking down the script.

In all honesty, a storyboard artist doesn't have the luxury of creating a formal shooting script—it's not his or her job. And the shooting script is not likely to be provided to the artist either. A well-marked spec script (as seen on page 23) suits their purposes just fine.

| Scene 36 - **EXT. CITY HALL - DAY** | | |
|---|---|---|
| SHOT | DESCRIPTION | AUDIO / DIALOGUE |
| 1 | **EST. SHOT. XDS.** Crowd gathers as racers tune their racers. | (NAT SOUND) |
| 2 | **WS. FOLLOW.** Dahlia steps out of her car. Approaches Jack. | |
| 3 | **MED - CLOSE.** Jack under hood of car | |
| 4 | **MED.** Favoring Dahlia | Softly. "Hey." |
| 5 | **AMERICAN.** Jack wipes grimy hands on coveralls. Greets Dahlia. | |
| 6 | **WS.** Portly man enters. Interrupts Dahlia. | |
| 7 | **MED CLOSE.** On Dahlia | |
| 8 | **MED. TWO.** Portly and Jack. | "Jack my boy, a lot of folks are counting on you-" "Thank you, sir" |
| 9 | **MED CLOSE.** Favoring Portly. | "I dare say we've got a good bit of money on you, son. Play your cards right, and you'll be very comfortable." |
| 10 | **CLOSE.** Portly places hand on Jack's shoulder. | |
| 11 | **CU.** Portly whispers in Jack's ear. | "Just take it easy, lad. Think of it as a leisurely drive through the countryside." |
| 12 | **AMERICAN.** Portly slaps Jack on the back and exits with a nod to Dahlia. | |
| 13 | **CU.** Jack stands with clenched jaw. | |
| 14 | **FULL.** Dahlia turns to leave. | "I'll tell you later." "What?" |
| 15 | **MED. CLOSE.** Dahlia kisses Jack on the cheek. | |
| 16 | **FULL.** Dahlia climbs in car. Jack is dumbfounded. | |
| 17 | **CLOSE.** Dahlia puts car in gear. | (Engine revs) |
| 18 | **WIDE.** Dahlia pulls off in Buick | |
| 19 | **AMERICAN.** Jack stands in cloud of dust. | (Car driving away) |

A shooting script breaks down each scene shot by shot, but it leaves the ultimate compositional and framing decisions to the director and his or her team.

# "And Now, a Word from Our Sponsor"

A television commercial script is strikingly similar to a shooting script. It is broken down into two columns: one for *video*, which is always on the left and always in all CAPS; one for *audio*, which is always on the right and typed in sentence case.

Unlike film and television, which use a relative means of time keeping where one page of a screen- or teleplay equals roughly one minute of screen time, the commercial script is very restricted to time. Every word—every moment—counts. A 30-second spot (which is really about 28½ seconds long to allow for fade in/fade out) may be limited to 75 spoken words (assuming a speaking rate of 150 words per minute).

Also unlike film and television, every shot is plotted out in the script itself, leaving little room for broad interpretation.

Once the script is drafted, the storyboards are assembled in a single layout that includes all frames with appropriate dialogue. This allows the advertising agency the ability to present the commercial to the client in a fast, efficient, and cost-effective manner. Many advertising agencies go one step further: they create inexpensive *animatics* or *digimatics* using simple programs, such as Adobe Flash or Microsoft PowerPoint.

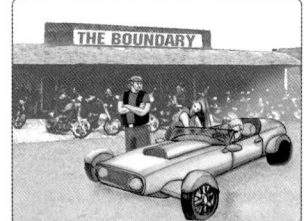

RUGGED (OS): "Alright, brother." RUGGED: "Far out, man."

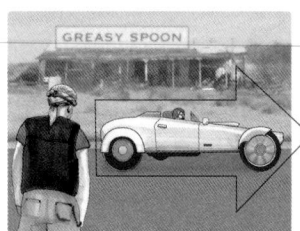
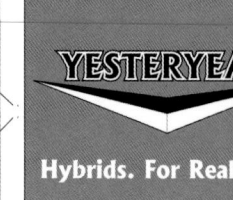

ANNOUNCER: "Got a problem with that?"    FADE MUSIC

A storyboard excerpt for a 30-second spot for the Yesteryear, a fictitious hybrid roadster. This illustration was created especially for *Storyboarding Essentials*.

## Terms

**Animatics:** Also **story reels.** Storyboards are cut together and displayed in sequence, and sometimes they are animated with simple camera movements (such as zooms and pans) and basic voice-overs. Animatics are used to give some sense of how a scene will play out with motion and timing.

**Digimatics:** Also **photomatics.** Similar to animatics, photomatics rely on (stock) photography to tell the story. Digimatics are most often used by manufacturers who wish to see their existing products in action or by corporations who are seeking cost-effective means for issuing corporate communications. For more information, turn ahead to "Photomatics and Digimatics" on page 142.

| VIDEO | AUDIO |
|---|---|
| **OPEN — EXT. ROADHOUSE — DAY** BURLY BIKERS GATHER OUTSIDE OF A RUN-DOWN BAR. | CUE MUSIC: Roadhouse blues. NATSOUND: Revving choppers. |
| **AMERICAN TWO SHOT:** ROUGHNECKS LEAN AGAINST A POST. | RUGGED BIKER: I'm tellin' ya, man. It ain't natural. No real man would be caught dead in one of them hybrids. |
| **CU:** HANDSOME BIKER SMILES. | RUGGED: And do you think chicks go for dudes in a hybrid? Come on, man! |
| **FULL:** RIGHT ON CUE, A SEXY VIXEN SAUN-TERS OUT OF THE BAR... | |
| **MED CLOSE:** AND RUNS HER FINGER ALONG HANDSOME'S ARM. | VIXEN: Let's ride. |
| **MED TWO:** HANDSOME TURNS TO RUGGED. | HANDSOME: Gotta jet. |
| HANDSOME AND RUGGED EXCHANGE MANLY HANDSHAKES. | RUGGED: Alright, brother. |
| **AMERICAN:** VIXEN TOUSLES HER HAIR WHILE HANDSOME EXITS OS. SHE SMILES AT RUG-GED, WHO BLUSHES. | |
| **WS:** THE YESTERYEAR, A SLEEK, RETRO-ROADSTER PULLS UP IN FRONT OF THE BAR. RUGGED IS IMPRESSED. | RUGGED: Far out, man. |
| **MED CLOSE:** VIXEN TURNS AND WHISPERS IN RUGGED'S EAR. | |
| **CU:** RUGGED IS SLACK-JAWED. | |
| **FULL:** VIXEN GETS IN THE CAR. | |
| **MED:** VIXEN WAVES AS CAR PEELS OUT. | |
| **CLOSE:** ON HYBRID LOGO. | |
| **GRAPHIC** (LOGO): YESTERYEAR | FADE MUSIC |
| **SUPER 1:** HYBRIDS. FOR REAL MEN. | |

A traditional layout for a 30-second spot, featuring the fictitious Yesteryear hybrid roadster. Here, word and image are combined into a single narrative used to sell the concept.

# A Difference of Opinion
## The Great Savannah Race

In this installment of "A Difference of Opinion," Joshua Reynolds, an up-and-coming sequential artist, and Katrina Kissell, an up-and-coming illustrator, give their take on the excerpt from *The Great Savannah Race* from page 20. The whole process took each artist about two days from script breakdown through approval to finished boards.

### Joshua Reynolds's Version

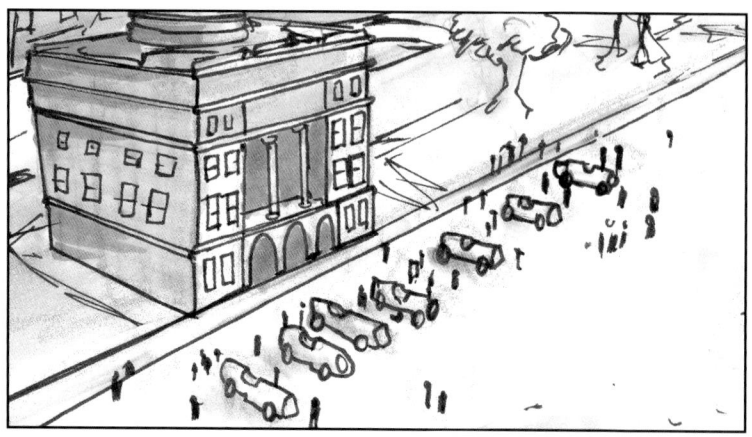

In his establishing shot, the artist, Joshua Reynolds, sets up a Down Shot to introduce the location and the general action of prepping for a race.

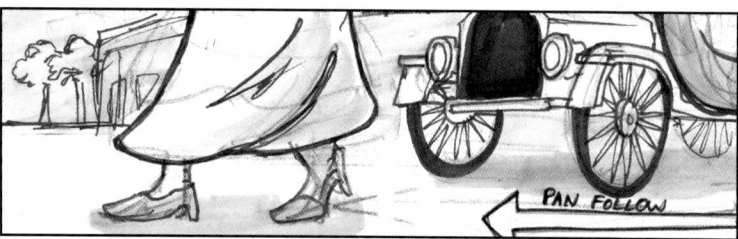

Reynolds sets up some initial mystery as we see only the legs of a woman step out of a car and walk as the camera pans to follow her action.

Again, the artist keeps a sense of mystery as he frames only the lower half of a character whose face is obscured underneath a car.

Over the next two shots, Reynolds reveals the faces of the characters and establishes that they know each other.

Framing up a simple Over-the-Shoulder Shot, the artist is able to introduce a new character to the scene. This allows the audience to clearly see that this man is approaching our two previously introduced characters.

Reynolds then uses a Medium Close-Up Shot to show us the woman's reaction to this interruption.

Over the next four shots, Reynolds pulls the camera closer and closer to the action. This helps to draw the audience into this uncomfortable exchange.

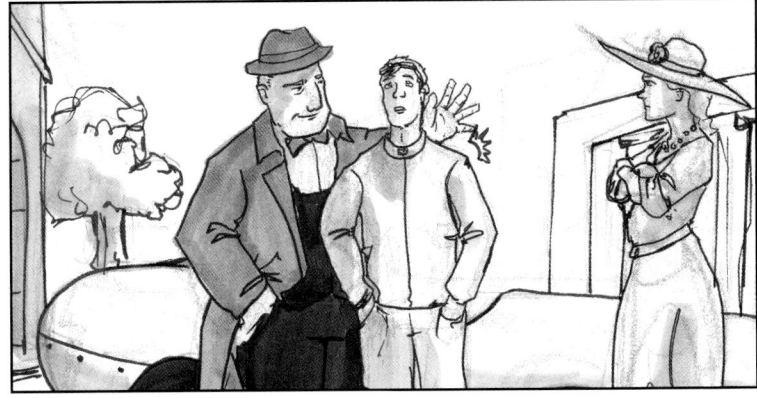

Reynolds pulls the camera back out to reestablish the general location and the three characters.

With a Medium Close-Up, the artist shows the audience that the main racer is focused on the menace the man poses.

This focus helps to add the sense of surprise as the artist cuts to an Over-the-Shoulder to see that the woman is heading back to her own car.

Next, Reynolds uses a series of tighter shots: a Medium Shot to show a quick kiss for luck . . .

...another Over-the-Shoulder to show the woman stepping into her car...

...and, last, a Close Shot of her hand putting the vehicle into gear.

Employing a Full Shot of the car driving away helps to set up the sense of a Point-of-View Shot...

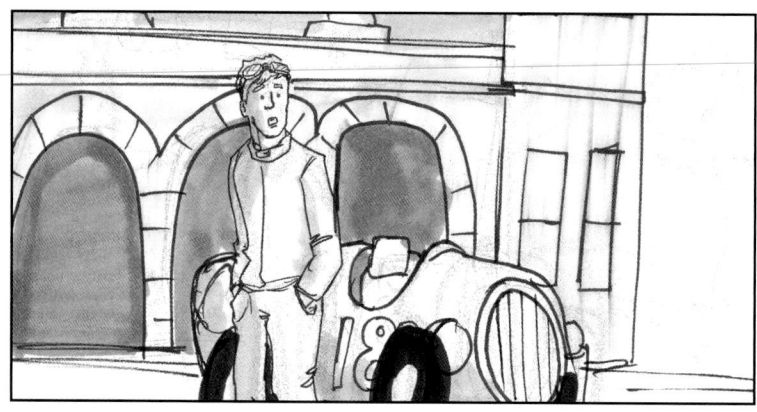

...which is confirmed with the last shot of the scene as Reynolds frames the racer looking off screen in a Knee Shot. This second shot helps to motivate the Point-of-View from the previous shot.

## Katrina Kissell's Version

In her establishing shot, Katrina Kissell frames a tighter Down Shot than Reynolds did. The shot still establishes the location and the action of the pre-race.

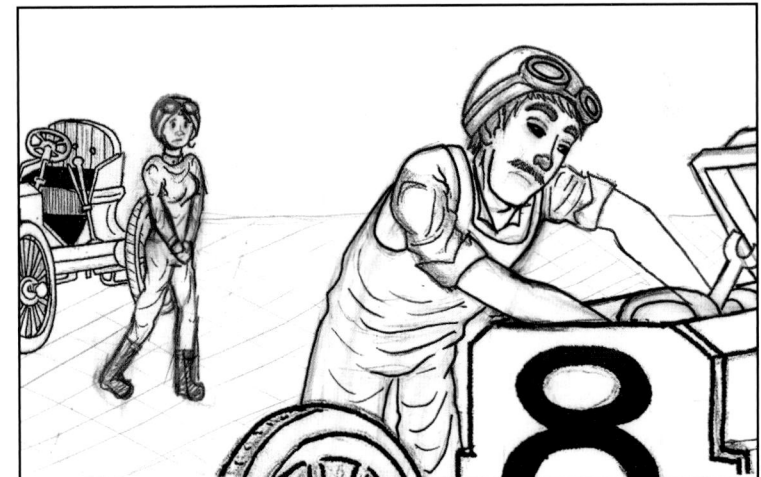

Choosing clarity over suspense, Kissell sets up a simple Over-the-Shoulder Shot to introduce both of the main characters in one shot.

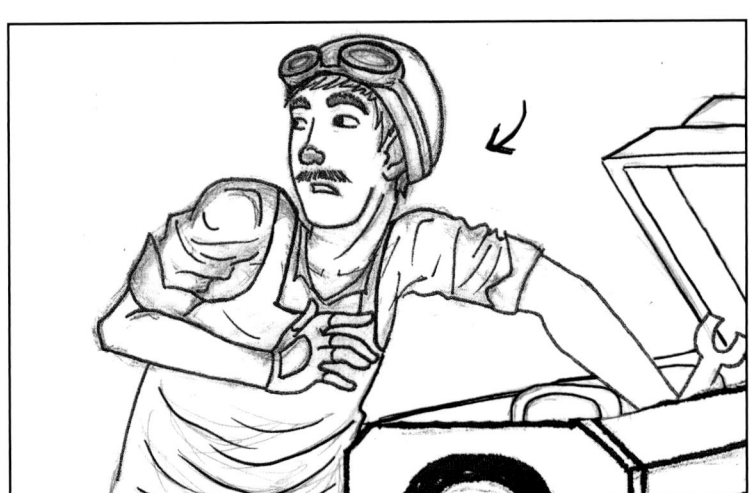

With a slight Push-In Shot, the previous shot is reframed to focus solely on the reaction to the female's presence.

A Medium Close-Up of the heroine.

Kissell then cuts to an Over-the-Shoulder Shot to frame the two together.

Kissell then pulls out to frame the entrance of another character.

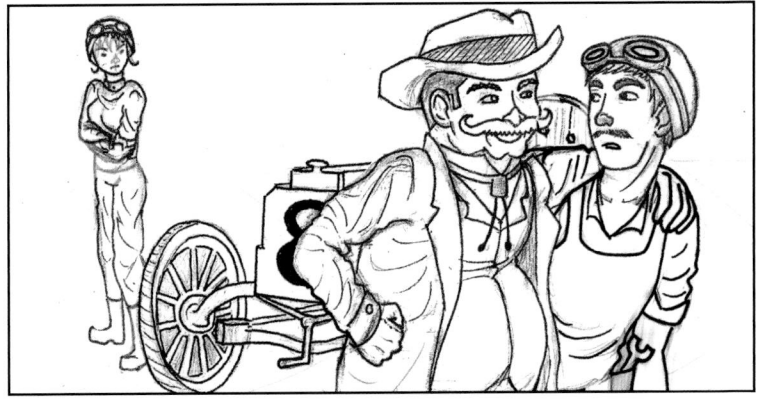

The artist then sets up another clear shot, establishing all of the scene elements again with a particular focus on the exchange with the older man.

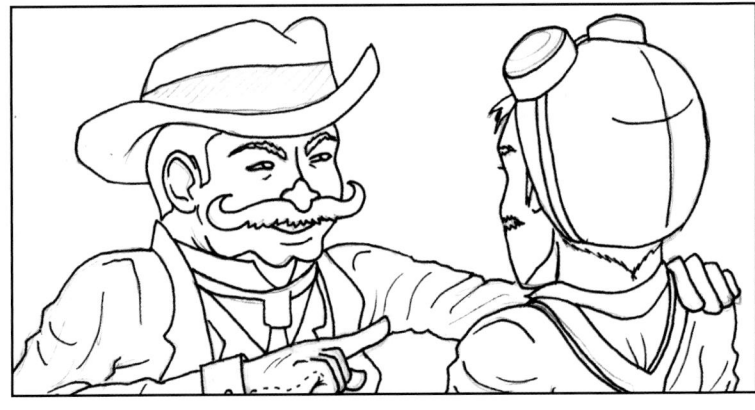

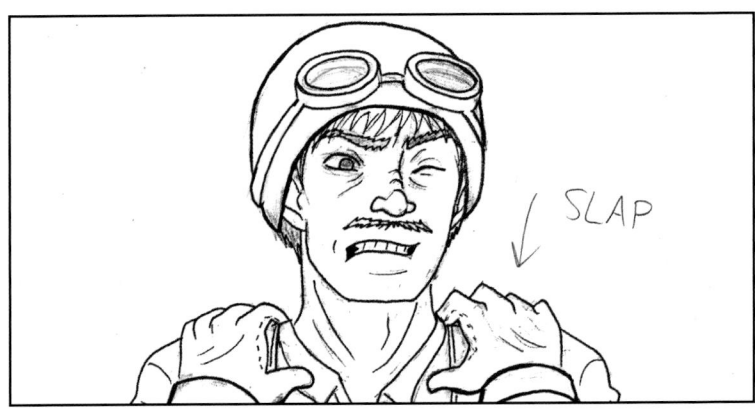

SLAP

Over the next three shots, Kissell moves the camera closer and closer during this unpleasant exchange. The pacing and framing are noticeably different from Reynold's storyboards.

This final Extreme Close-Up emphasizes the point of the scene and heightens the drama of the scene.

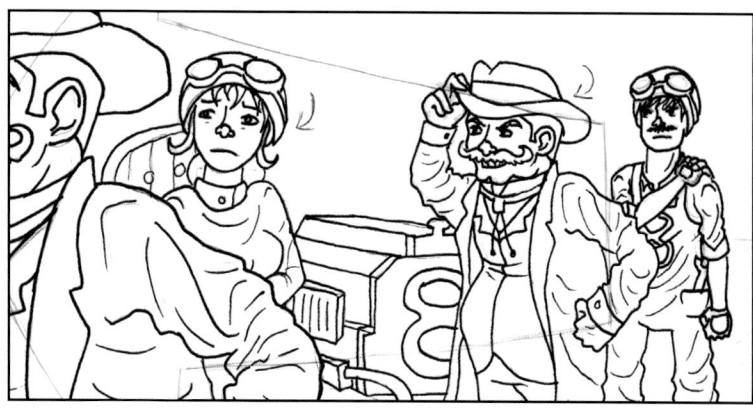

Kissell then cuts back to show and set up the man's exit, and this allows the action of his exit to take place in front of a static camera. She also frames the shot so that the audience can see the two main characters' reactions.

Here, the artist frames the shot as a Close-Up to allow the audience to be drawn to the hero's worried expression.

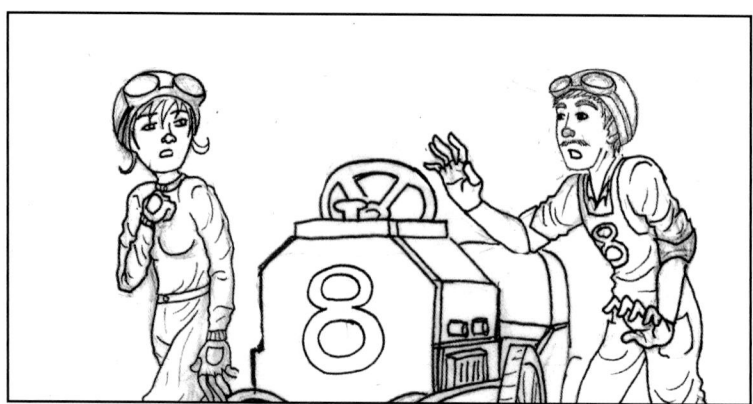

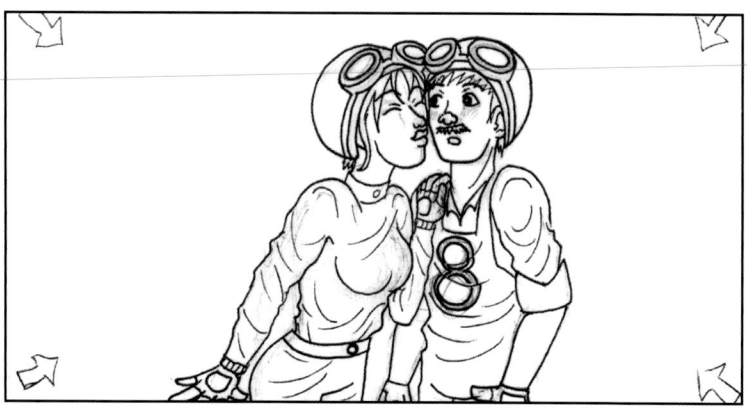

These Medium Shots set up the female character's departure.

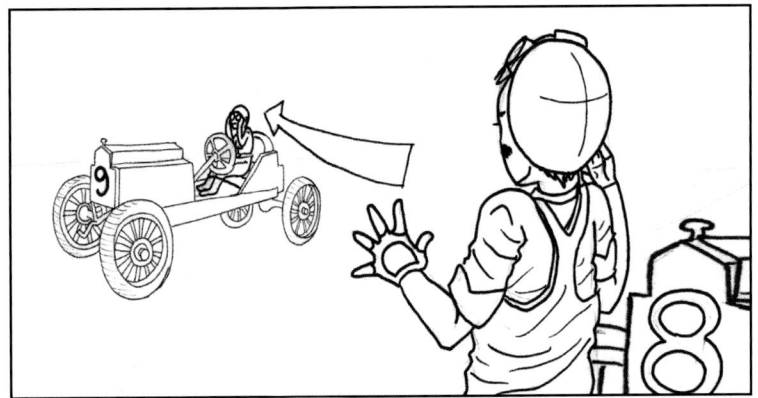

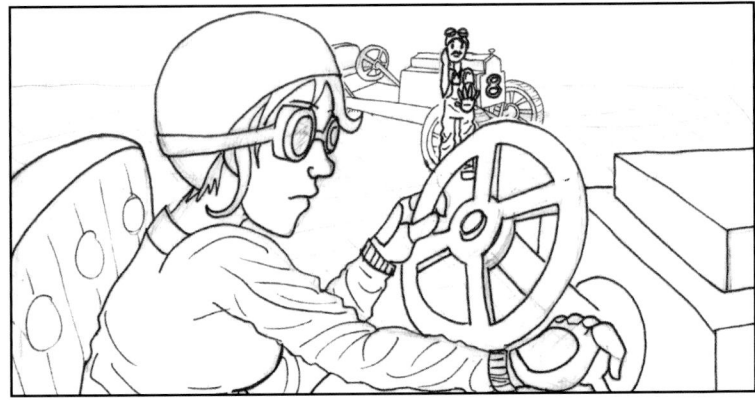

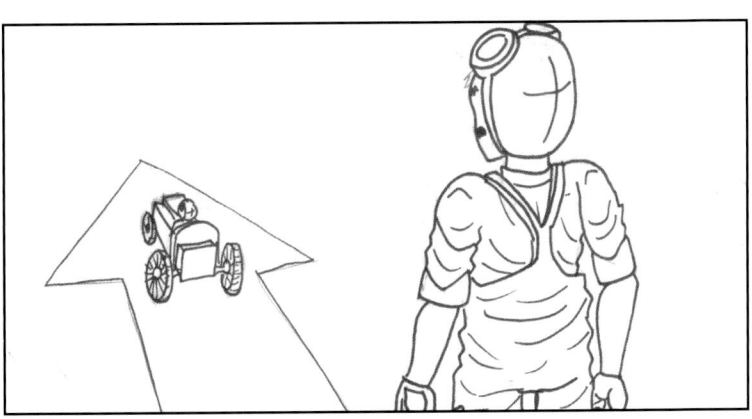

Kissell uses a series of slightly wider shots to frame the actions of the female lead's departure, the kiss for luck, and her subsequent exit from the scene.

Note how the artist is changing the framing of the shots to give each screen focus to both characters, allowing them to connect with the audience.

# Interview: Ken Chaplin, DGA/DGC

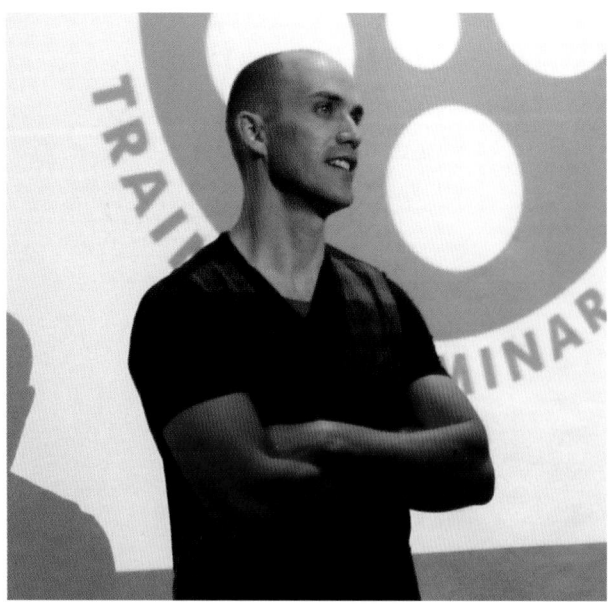

Ken Chaplin at a September 2011 Production Assistant Training Seminar (PATS).

**Ken Chaplin grew up on a farm far removed** from the Hollywood film industry. On a whim, he boarded a plane for Australia in 1997 to work as a production assistant (PA) on one of the most talked about films of the decade: writer and director Terrence Malick's 1998 World War II epic *The Thin Red Line*. With his ability to pack up and go, a phone call sent him on the road to Kansas City, Missouri, for the filming of director Ang Lee's (once a PA himself) Civil War drama *Ride with the Devil*.

Within seven years, he had gained membership into the prestigious Directors Guild of America (DGA). After honing his skills on such projects as *Runaway Jury*, *Roswell*, and *Judging Amy*, he went to Canada and became a member of the Directors Guild of Canada (DGC). He has worked on Canadian-made films such as the award-winning *The Tommy Douglas Story*, *The Englishman's Boy*, and the literary classic *Moby Dick*.

For Kenny's complete filmography, find his profile online at the Internet Movie Database (IMDB): www.imdb.com/name/nm0152247/.

In 2007, Chaplin and his DGA colleague Gary Romolo Fiorelli (the first two *Pirates of the Caribbean* films, *Runaway Jury*, *Body of Lies*) founded the Production Assistant Training Seminar (PATS), which provides outstanding training for those wishing to break into the business.

For information on the Production Assistant Training Seminar, visit the PATS website: www.patrainingseminar.com/. Chaplin is a remarkably focused and enviably energetic professional. Confident yet approachable, he's one of the nicest guys you'll ever meet.

David Harland Rousseau caught up with Chaplin, who was in New York City shooting *4Lies* with director Doug Lodato.

**DHR:** As an assistant director, you have a staggering array of responsibilities, from location scouting to script breakdown and scheduling. In short, you're the guy who makes sure everything runs on time and, hopefully, under budget. How do you keep it all together?

**KC:** I believe that an AD hasn't any power on a film set. He or she allows the flow of the set to occur via the crew. I communicate information. If I prepare and communicate effectively, it is the crew who makes everything run on time.

I rarely make any decisions; it is neither my money nor my creative position to do so. I am a manager, much like a manager at a fast food restaurant. Nothing more.

**DHR:** In your highly successful Production Assistant Training Seminar (PATS), you emphasize "being unforgettable." A huge part of that involves understanding and anticipating the needs of each department.

**KC:** It also involves being partly invisible. The need for validation often gets new PAs and crew members kicked off a film set.

Be aware, and truly observe; anticipate what your boss is requiring—and get there before he or she

does. Move on. Don't wait for the pat on the back. It'll come in other ways.

**DHR:** Of course, solid communication with your team is a must.

**KC:** Patience and questions. Asking each crew member—even in casual conversation at the end of the night over a beer—about the hurdles faced on set each day will give you the awareness of how each department works and why they do what they do.

**DHR:** Break it down: What makes for an unforgettable storyboard?

**KC:** Camera angles, equipment needed (crane, lens, and so on), and area at location viewed (where do we *not* see?).

**DHR:** In your role as AD, how do storyboards fit into the production of a film?

**KC:** Storyboards are effective for action or stunt sequences, scenes with difficult camera moves, or shots involving many cast members. There isn't a need to storyboard a couple drinking coffee at a table because the camera setup is fairly rote.

Storyboards can then help other departments understand what is required in budgeting, equipment, manpower, the positioning of company trucks, the number of extras, and so on. These boards permit the director and cinematographer to communicate their needs and desires before the day begins.

**DHR:** How often have you relied on storyboards?

**KC:** Storyboards are theoretical, and they are often a starting point for discussion—but they can be useful tools on set.

Our brains aren't big enough to remember all the shots required for making the scene, so on larger action sequences I'll tape the storyboards onto poster board and have those standing by for the director, director of photography (DP), and script supervisor to cross off as each piece of the scene is shot.

**DHR:** Do storyboards need to be well rendered?

**KC:** Why? The boards are simply an initial plan, a road map. They are rarely followed note for note. Drawings of stick figures can convey the information required.

No. No one looks at storyboards after the fact, except film geeks. Storyboards are *not* meant for storytelling or for being pretty to look at.

**DHR:** Even so, I imagine reproductive quality is a must.

**KC:** Storyboards are functional. A clear drawing that allows the office PA to get a good photocopy for the crew is all that is needed.

**DHR:** What makes storyboard artists unforgettable?

**KC:** Understanding that their function is simply to communicate the director's or DP's idea of how each scene is to be shot and understanding that this will help the department head and crew budget, plan, and execute their duties on the day of shooting.

**DHR:** A surprising number of up-and-coming filmmakers are somewhat dismissive of the storyboarding process, claiming that it takes too much time or perhaps costs too much money. What would you say to emerging directors and cinematographers who prefer to shoot "on the fly"?

**KC:** Use storyboards for the prepping and planning of action sequences or scenes involving large crowds or a large cast. This saves time and money tenfold.

# Rough or Polished Finish

Storyboarding employs different facets of drawing, from rough sketches to polished illustrations. In order to determine the level of finish required for the job, the illustrator must understand the needs of the production, because certain drawing fundamentals greatly aid in visualizing various shots.

Different areas of specialization require more experience in drawing and design. Animation and visual effects demand a strong understanding of movement and timing. Advertising promotes specific products, so an awareness of color is important here. Compare each area of specialization in the box below and note the concentrations within each category of storyboarding.

## Visualization Fundamentals

### ESSENTIAL
- Understand composition.
- Know perspective.
  - Eye level and camera height
  - Linear perspective and camera angle
  - Atmospheric perspective and focal length
- Describe form with line.
- Quickly communicate a figure's action with simple gestures

### ANIMATION
- Master anatomy and life drawing.
- Know the principles of motion and exaggeration.
- Understand how timing affects a character's performance.

### ADVERTISING
- Grasp color theory and rendering.
- Understand graphic design and the relationship between text and images.

### VISUAL EFFECTS
- Understand light, shadow, and the element of value.
- Master composite shots (live action and effects elements combined).
- Know the principles of motion and timing.

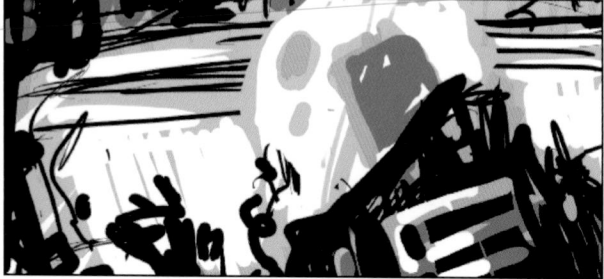

The level of finish or "polish" that a storyboard requires can vary from production to production, a loose storyboard may be all that's required.

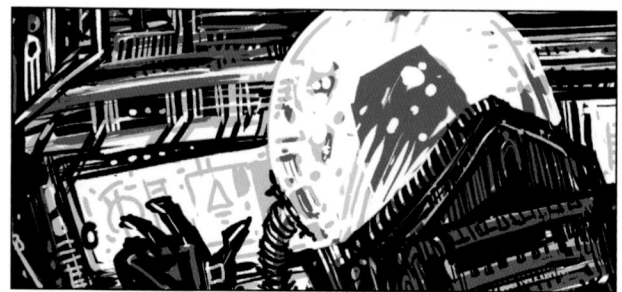

Other times a more fleshed-out illustration may be needed to establish a strong light source and to clarify details.

# Little Drawings, Big Ideas

All storyboards start as small thumbnail sketches done in the correct aspect ratio. (For more on aspect ratios, see page 74 in the next chapter.) They should be handled loosely since composition and timing are primary concerns.

A professional illustrator will produce multiple solutions for any shot before drawing larger, rendered storyboards. In some cases, it may not be necessary to move beyond the thumbnail stage. At this stage the selected thumbnail compositions are marked with their corresponding shot numbers. Some illustrators use a highlighter or a heavier outline frame sketched around their final choices in lieu of numbering them. Note the additional notations on the left-hand side of the thumbnails below; these are used to keep track of the shots that need to be finished that day.

Thumbnail sketches can be sufficient for the needs of the production; some extra care needs to be exercised to ensure legibility.

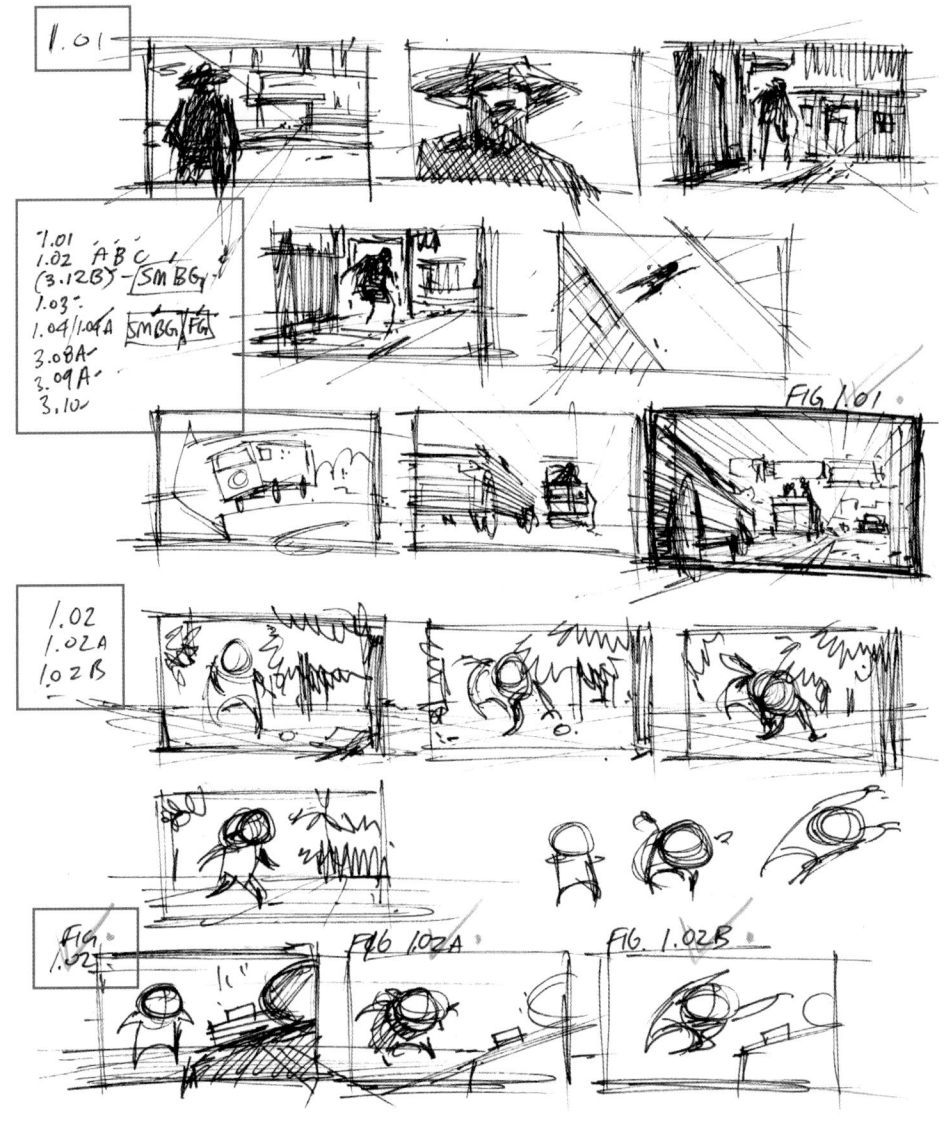

## Editorial Storyboards

For editorial storyboards, after the completion of thumbnails, the illustrator will block out the layout. This involves creating perspective guides and drawing the forms of the major elements in order to replicate and improve upon the compositions created in the thumbnails. This stage is normally done with a light drawing tool (such as a 2H or non-photo blue pencil), which allows for the gradual building of a drawing.

Once the layout is complete, details are added and clarified using a darker drawing tool (such as a 4B pencil). This stage is part cleanup, part polish. For most live action productions, this completed stage serves the storyboard's primary purpose: visualizing what the camera sees. It is not necessary to work the drawing past a developed sketch.

An indication of lighting can be useful. While not always necessary, value enhances the mood and can help to thoroughly visualize the shot. Editorial storyboards are typically presented in gray scale and are quickly toned using markers or digital applications.

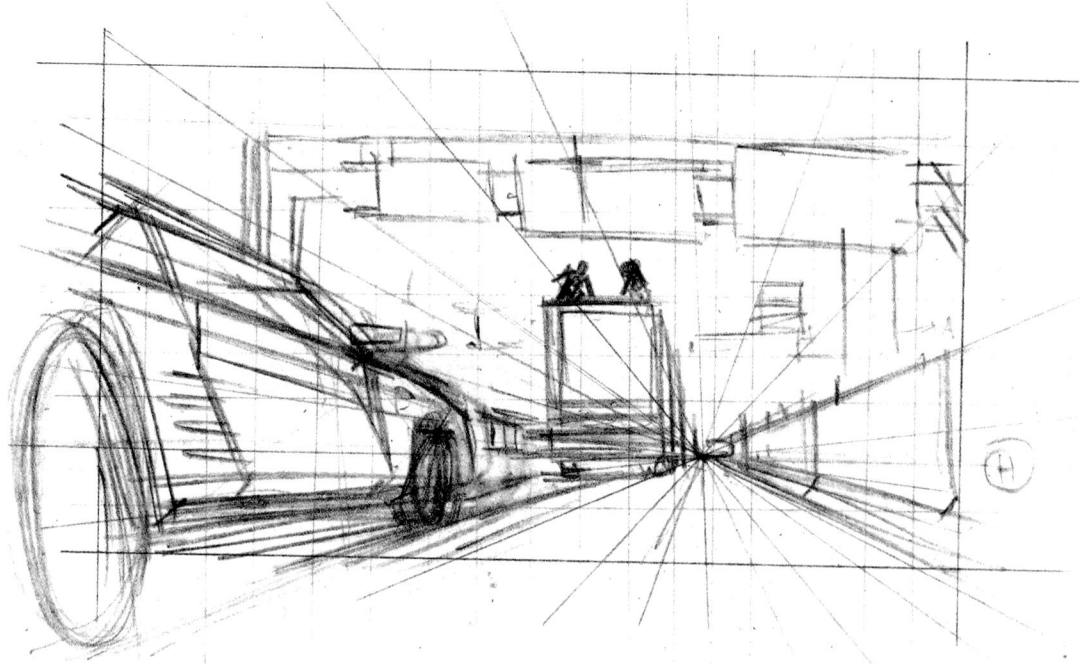

Note the perspective lines of this quick layout.

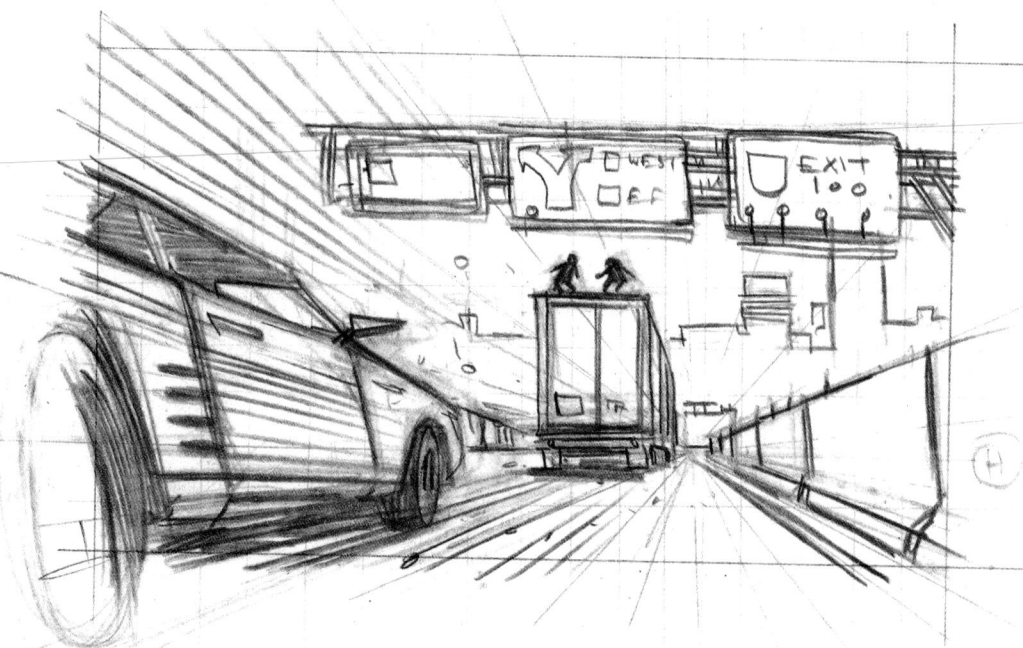

Note what the illustrator chose to emphasize in this penciled storyboard.

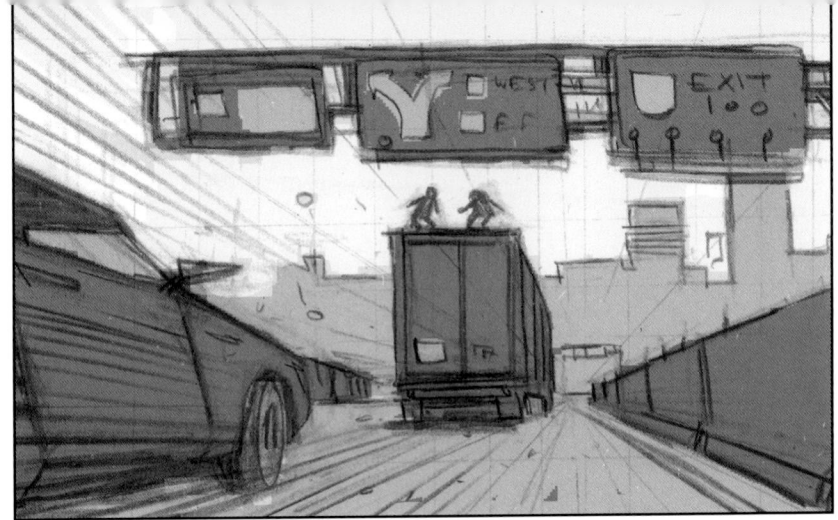

A loosely rendered gray scale storyboard allows for a quick read by the crew, and it reproduces well.

## Animation Storyboards

An animation storyboard proceeds in a similar fashion: thumbnail sketches, followed by the initial layout. Since animation focuses on issues of storytelling told through timing and character development, animation storyboard artists will use the same background throughout the sequence. As such, the first drawings will be of that background only. This involves roughing in the perspective guides and lightly sketching any foreground elements.

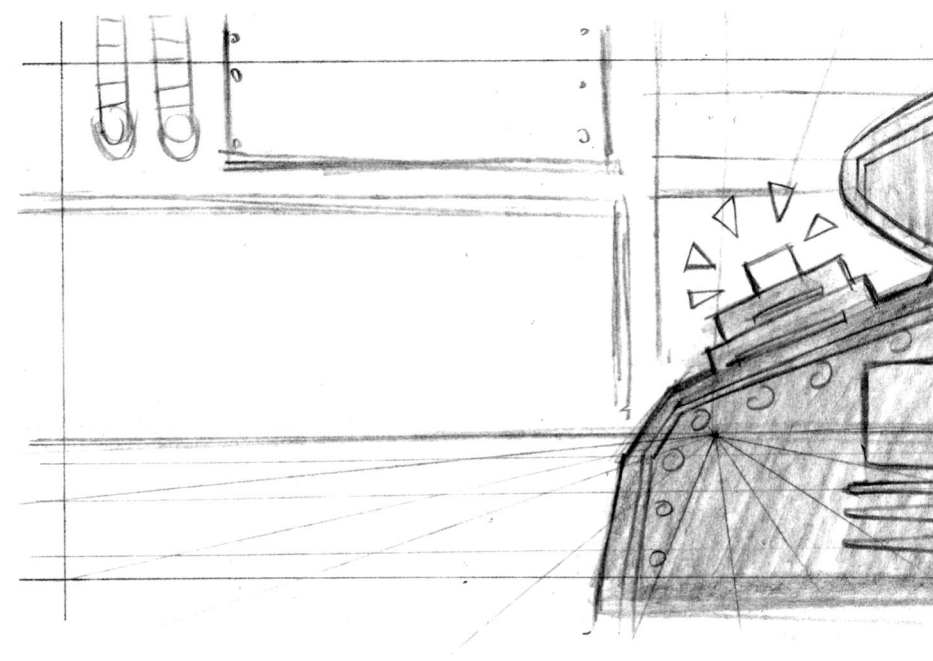

**MIDDLE:** Here, the illustrator has drawn in background and foreground elements that will be used in successive panels. The original drawing is far lighter than depicted here and was darkened in order to show some of the delicate lines.

The drawing of the background is completed with a quick cleanup pass with a darker drawing tool. This pass does not need to tighten the drawing so much as to clarify it.

**RIGHT:** Note how the contour lines separate the foreground from the background in this illustration.

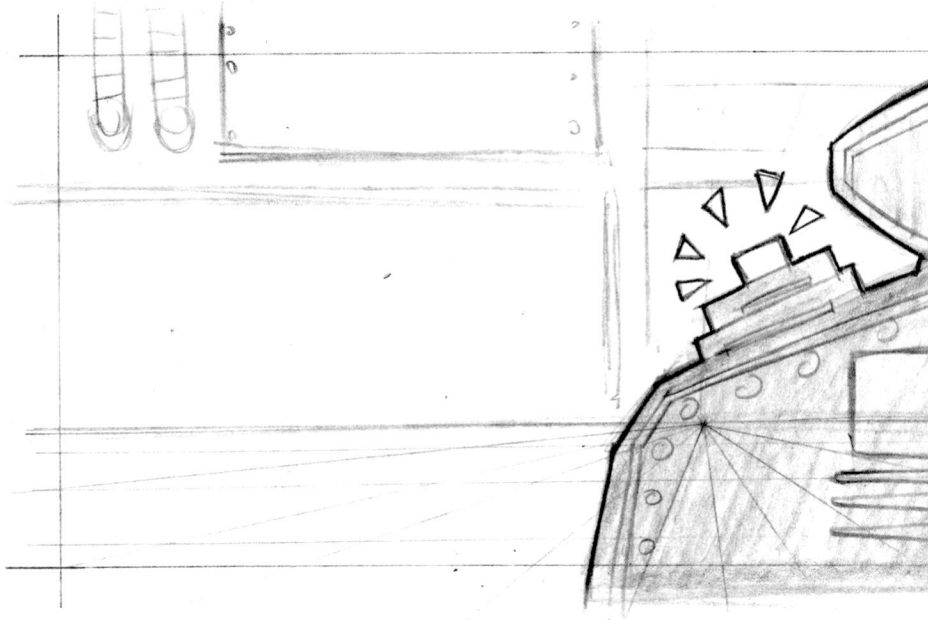

At this point, the illustrator roughly blocks in the basic shapes of the character. The main goal at this stage is to frame the figure and then create a believable performance. Below, the illustrator has created an active character that lives and moves comfortably within the panel.

The start point of the performance is drawn in.

The windup, or anticipation, occurs; this is when a character in animation moves first in the opposite direction of the intended action.

The character leaps into action; the windup emphasizes and exaggerates this movement.

These drawings are clarified and combined with the background to create the final sequence. This compositing may be done using a practical cut and paste, or it may be accomplished using digital applications.

An illustrator will always confirm the needs of the production before proceeding to a rendered finish, in order to maximize productivity.

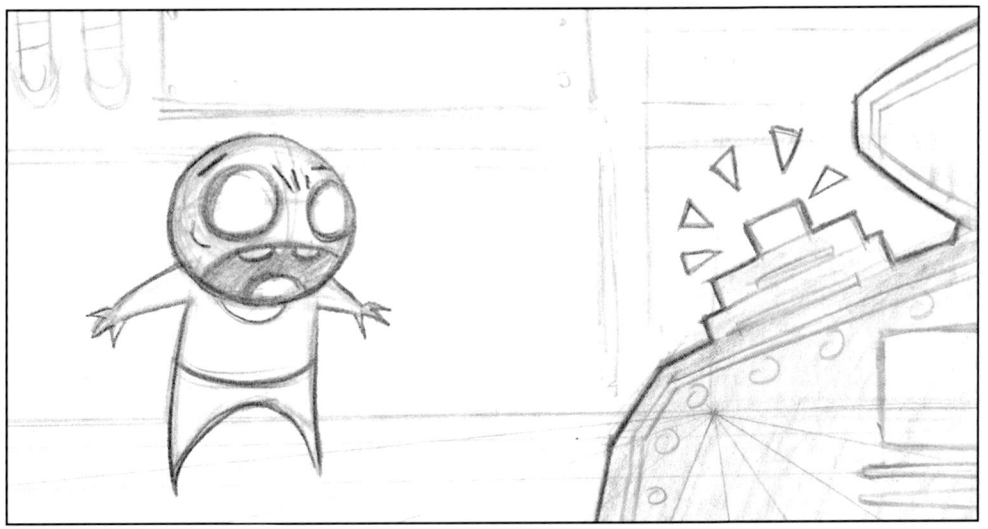

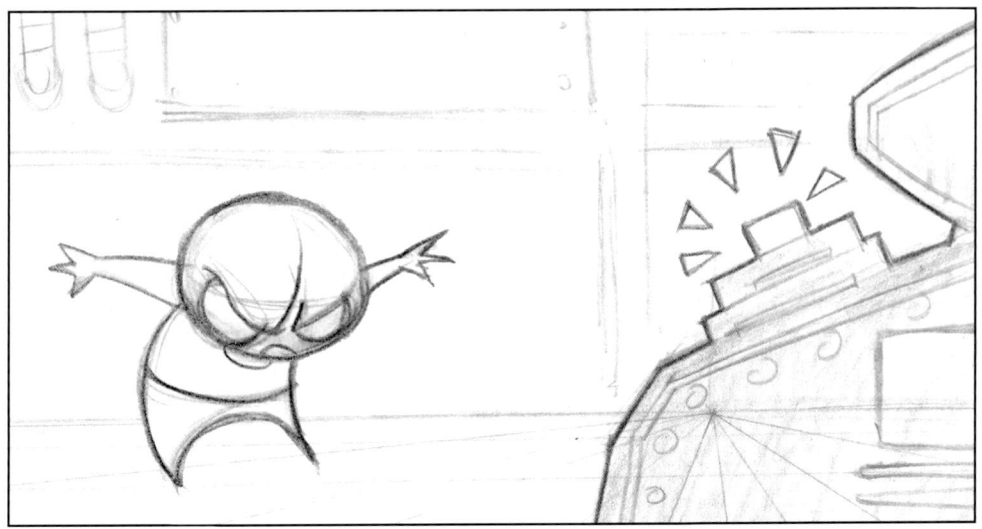

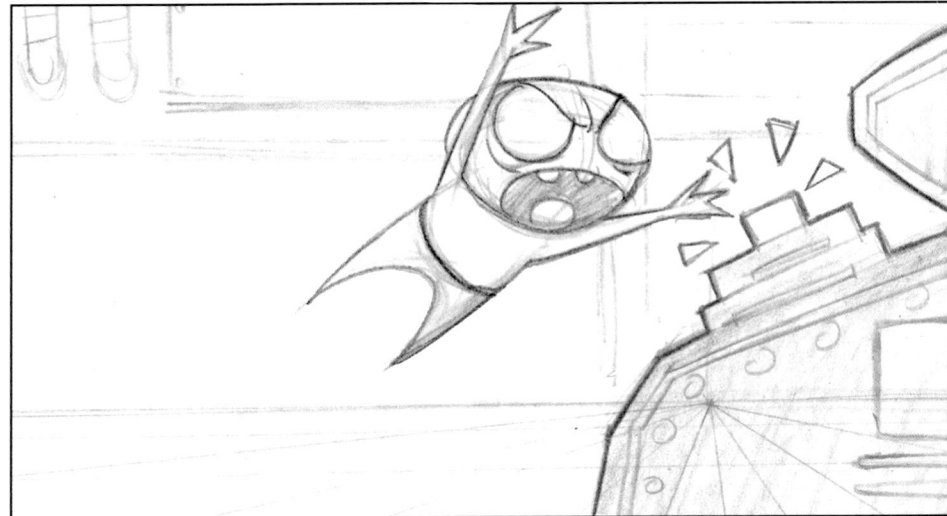

Combining figure and scene creates key frames. Now the character's performance and the background art can come together to finish the storyboard for this particular scene.

## Presentation Boards

Comp, or presentation, boards for advertising are among the most illustrative storyboards produced. After all, the client anticipates accurate renderings of a specific product. With high expectations and short deadlines, illustrators often rely on stock photos in order to save time. The artist should consider leaving room in the illustration for graphic elements, such as logos.

As always, the layout references the initial thumbnail sketch and is drawn lightly. Details are added as contour lines are darkened. The art is then scanned in and cleaned up digitally. Tones and photographic elements are introduced at this stage as well.

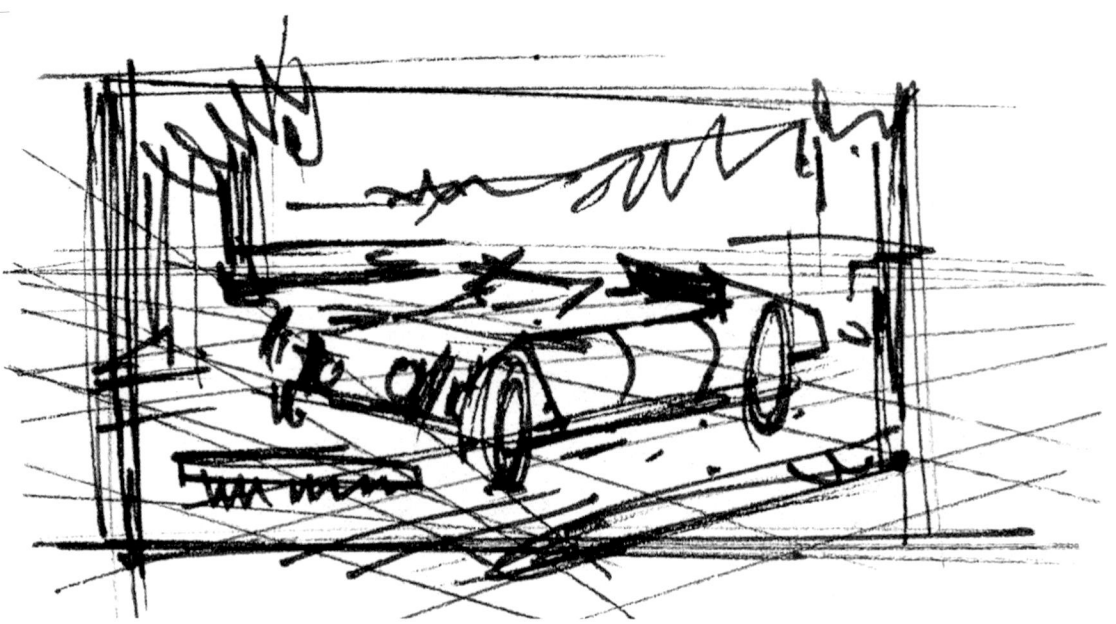

With a clear idea in mind, the artist quickly roughs out the composition in a thumbnail sketch.

Again the perspective lines are placed first in this lightly rendered illustration.

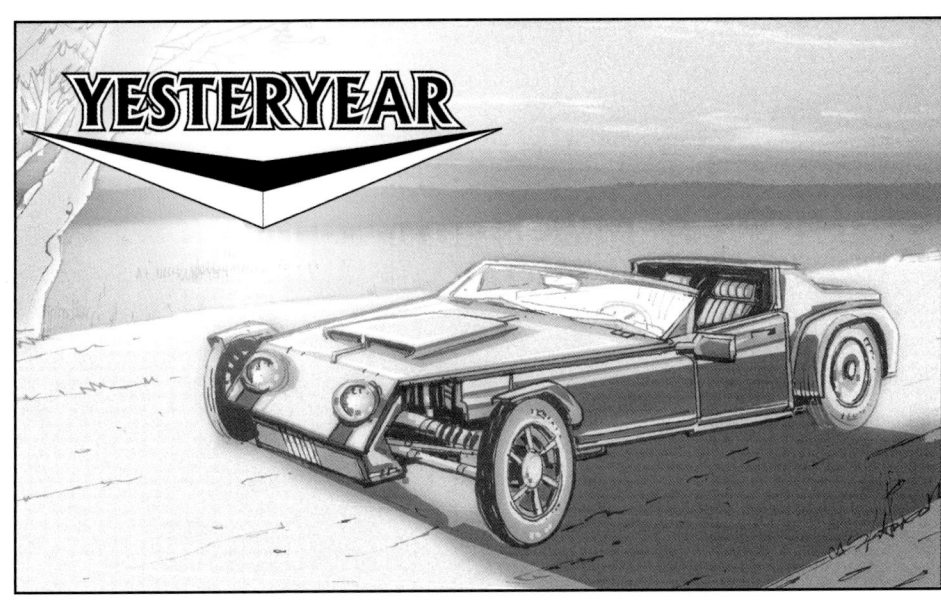

**TOP:** Here the illustrator tightens up the drawing and prepares it for rendering.

**MIDDLE:** Notice the composite of drawing and photography in this illustration.

**BOTTOM:** The provision and inclusion of a high-quality logo create a stronger visual impact, and it is common in comp boards.

## Previz Storyboards

Previz storyboards combine elements of live action (framing height, camera angle, and focal length) with elements of animation (motion and timing).

The example on these two pages shows a blasted landscape. Without warning, a mechanical monster bursts through the earth's crust! To accomplish this visual effects sequence, the artist draws two separate sketches that are eventually combined into one action-packed illustration. Because so much of previz involves motion and timing, both images (the background and the final composited image) must be considered together as a sequence; it is the combination of action and reaction that tells the story.

The artist blocks out the background with expressive strokes of a pencil. The artist roughs in the mechanical beast and includes a strong directional arrow.

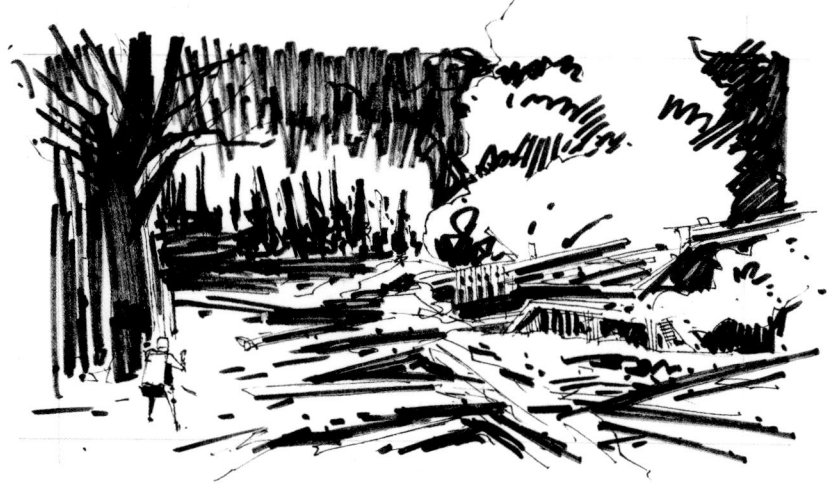

Using a Sharpie marker, the artist blocks in spot blacks for the background . . . and again for the mechanized monster. (Note how the arrow frames the machine.)

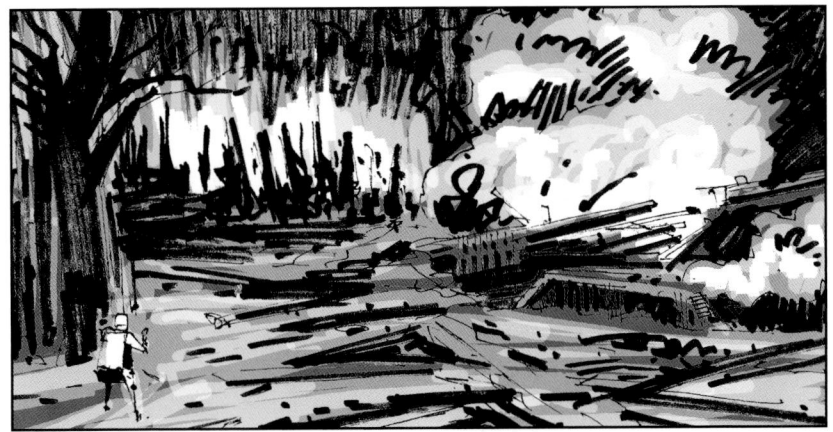

Early planning of lighting is important in preparing special effects sequences. Here we see how mood and atmosphere are created by the artist with a few quick passes of a gray scale marker or two. In this final pairing, you can see live action and visual effects elements combined into one illustration.

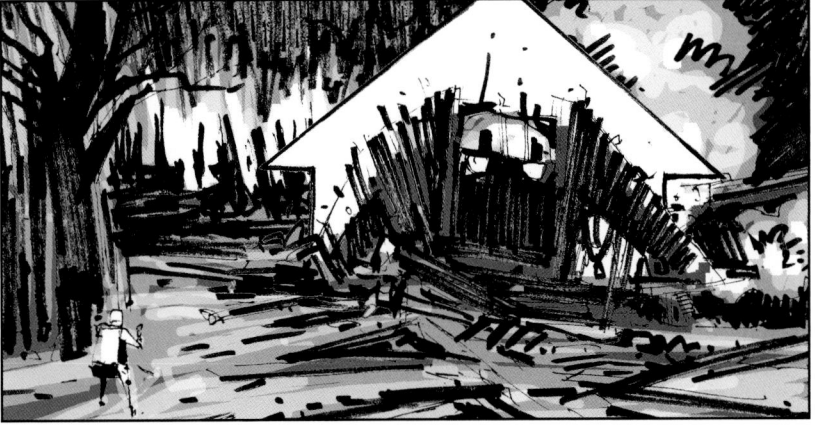

# The Right Tool for the Job

While this chapter does not offer instruction on the basics of drawing (there are many excellent texts out there for that purpose), it does provide an idea of acceptable levels of rendering for each of the four main categories of storyboarding.

A good illustrator always renders each storyboard clearly and cleanly, with a mind on reproductive quality; storyboards should survive a trip or two through a photocopier or printer. With that in mind, mediums vary from job to job. Even though a growing number of storyboard artists rely on a variety of digital programs, most storyboards are created using pencils, pens, and markers.

There are reasons for this. First and foremost is the need for speed. Storyboarding is collaborative in nature. In a matter of minutes—with little more than a stack of paper and a Sharpie—a talented drafter can crank out a handful of boards in the company of colleagues and investors. Mobility and portability are other considerations. Many storyboard artists work on set with the director or cinematographer. By the way, "on set" could be anywhere from a high-tech soundstage to a desolate desert; a stable power supply for digital media is not always assured. Affordability and convenience are also important considerations. Paper, pencils, and markers can all be purchased at a local drugstore for a few dollars—and you never have to upgrade!

Three popular mediums—pencils, Sharpies, and gray scale markers—all have features of speed, portability, and affordability in common, yet they have different strong suits and limitations. In the end, it comes down to personal preferences based on the artist's approach to technique and style.

Some artists take great comfort in the versatility and value range of the unassuming pencil. They love the subtlety and control afforded by this centuries-old implement. Other artists find that the pencil provides too much flexibility and too many editing options; they fuss and obsess over making the drawing "perfect." Artists with such a mindset will create beautifully polished and fully rendered works, but they will also find themselves struggling to make their deadlines.

Artists who are confident and expressive tend to gravitate toward markers and pens. They love mark-making, and they rely on a keen compositional sensibility that allows them to make bold decisions. They also appreciate never having to break their stride by having to stop to sharpen their pencils.

The strong suits and limitations of these popular drawing mediums—pencils and markers—will be reviewed on the following pages, along with step-by-step illustrations that will help the reader understand the process of building a drawing using a given medium.

## Tip

The level of polish often depends on where the screenplay is in the pipeline. A producer seeking a green light on a spec script may need tightly rendered boards to help sell the concept to investors, while a director with a shooting script needs to crank out the boards as fast as possible in order to meet impossible deadlines.

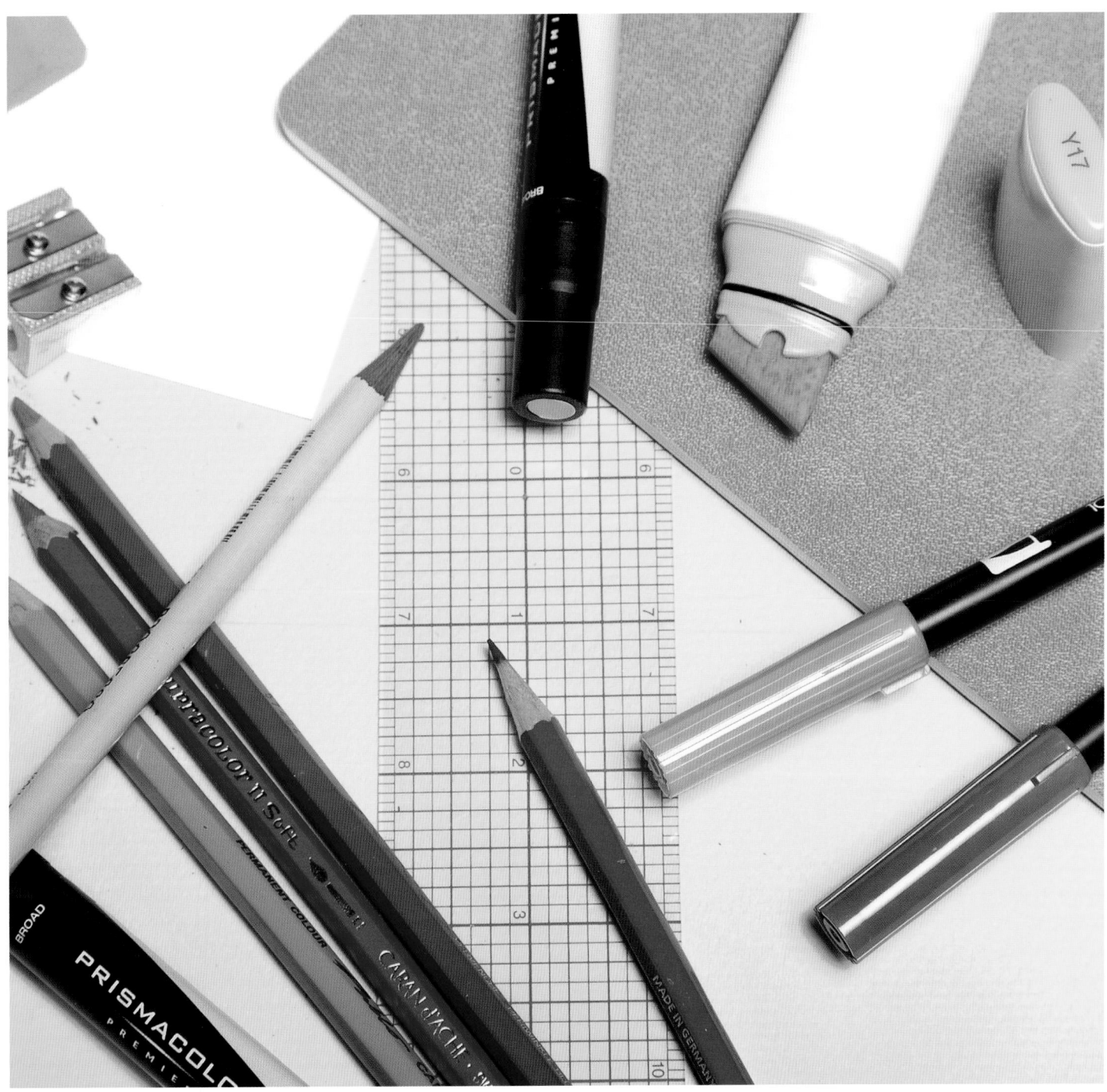

The simplest of drawing tools are used
to create the most dynamic storyboards.

## The Humble Pencil

Pencils have been around for centuries. In their most basic form, a mixture of graphite and clay (the "lead" of the pencil) is rolled into slender rods and sandwiched between two half-cylinders of wood. The hardness rating, which uses a number (2, 3, 4, 5, 6, 7, 8) and letter (H, F, B) system, goes from 8H to HB to 8B, depending on the ratio of clay to graphite. Pencils with more clay than graphite are considered "soft" and start with a rating of HB. Many storyboard artists rely on the trusty 4B pencil for most of their toning needs. Pencils with more graphite than clay are considered "hard" and run from HB to 8H. Many artists use a 2H pencil for lightly blocking out perspective lines.

### Pencil Pros

- Remarkably versatile
- Incredibly affordable
- Available in a wide range of values
- Easily correctable with the help of an eraser

### Pencil Cons

- Require the use of extra tools, such as sharpeners and erasers
- Require constant sharpening
- Produce lighter or darker values, depending on type
- Smudge easily, reducing reproductive quality

The artist begins by blocking out the scene with an H-series pencil, which allows the building of basic forms in perspective. Because the H-series pencil is extremely light, mistakes are easily erased and corrected.

With a B-series pencil, the artist builds value. This stage allows the creation of a sense of light and shadow play in the film shot. This is important, as value contrast can be used to guide the eye in a composition.

The artist cleans up the drawing by redefining lines with a soft pencil. This final step of cleanup is important, because the reproduction quality of the boards is very important. These final lines ensure that the art will photocopy clearly.

## The Simple Sharpie

In 1964, just over a century after its founding, the Sanford Ink Company tapped into the growing popularity of the marker and introduced the Sharpie fine point—the first pen-style permanent marker. This quick-drying and nontoxic marker writes on just about anything. Twenty-five years later, Sanford introduced the Sharpie ultrafine point—the first marker to actually handle like a pen.

Sharpies create rich, black lines and are perfect for blocking out *spot blacks*. A talented illustrator can instantly communicate bold ideas with a few simple strokes. And the marker's durability makes it an excellent choice for work in the field.

## Sharpie Pros

- Durable
- Affordable
- Incredibly fast to draw with
- Versatile in terms of the line weights they produce, which is true even of the basic Sharpie fine-point pens
- Able to produce outstandingly reproducible copy

## Sharpie Cons

- Have limited value range
- Can bleed through inferior papers
- Are virtually impossible to correct
- Have a strong odor, despite their nontoxic classification

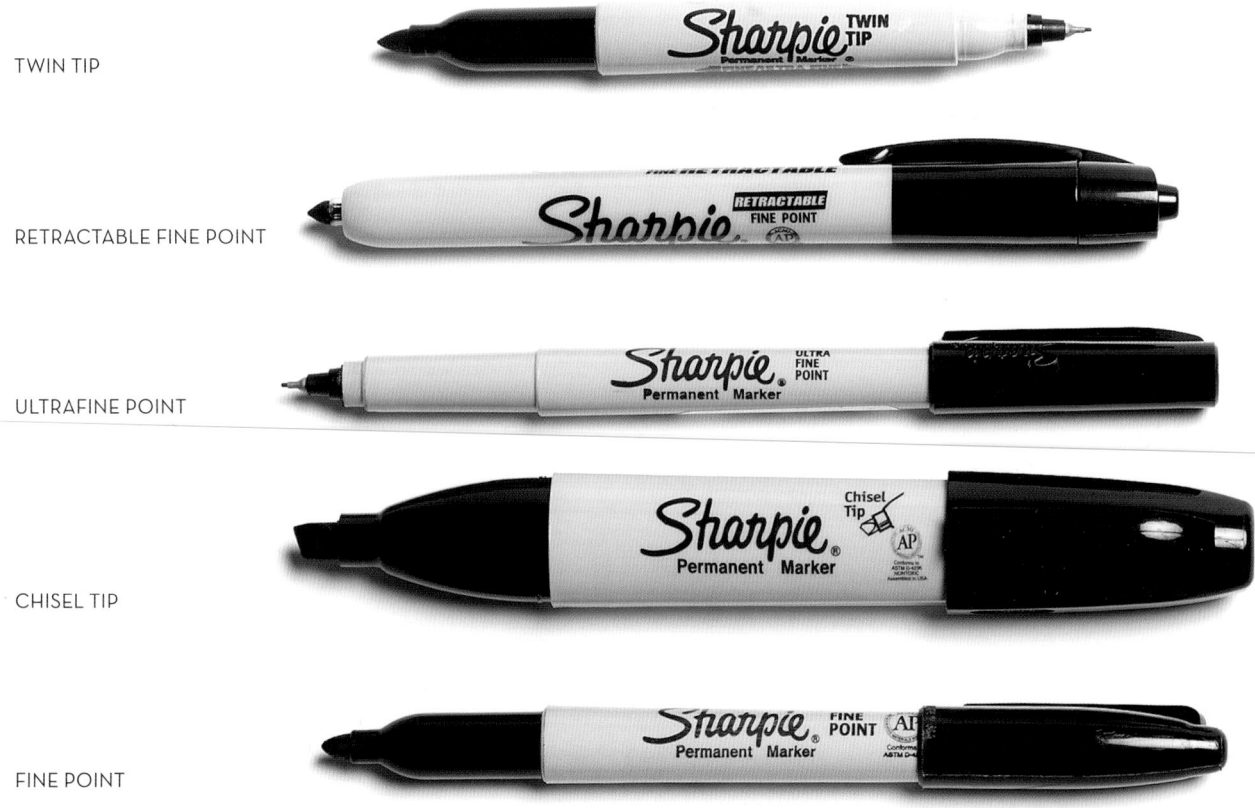

TWIN TIP

RETRACTABLE FINE POINT

ULTRAFINE POINT

CHISEL TIP

FINE POINT

To begin blocking out the scene, the artist uses a Sharpie ultrafine point. The Sharpie is less forgiving than an H-series pencil, but it can speed up a confident artist because less refinement of the image is necessary.

At this point, finer details are added in with a Sharpie fine point, defining and redefining lines. The storyboard becomes easily read and communicates the basic information of the shot.

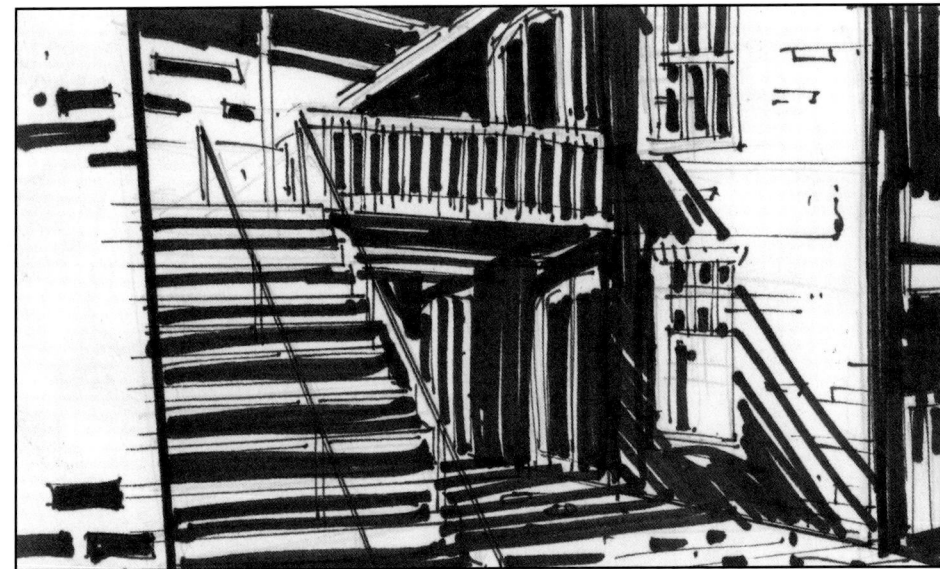

For strong contrast, the artist blocks out spot blacks, which allows the artist to use value contrast and the play of light to lead the eye in the composition.

## Going Gray

A number of manufacturers produce high-quality gray scale markers. As far as brand selection, it's really a matter of personal preference, since almost all markers come in sets of twelve. But here's a dirty little secret: you don't have to buy the twelve-pack to get outstanding results. First of all, most sets come with three—yes, three—black markers, plus other markers ranging in value from 10 to 90 percent gray. An experienced illustrator will tell you that you will never burn through that many black markers; others prefer the richness of the Sharpie anyway. As a result, some illustrators recommend buying "every other" marker in the set. For example, they may double up on the lighter 20 percent gray markers (as they tend to burn out faster) and then add 40, 60, and even 80 percent gray markers to boost value and push contrast.

Gray scale markers come in different "temperatures," so to speak, but they are generally considered "warm" or "cool." Choosing one over the other is a matter of personal preference—with one caveat: once an illustrator chooses a particular tone of gray scale marker, that choice is more or less locked in.

Browse the local art supply store and see which gray scale markers are kept in stock; decide whether you can quickly replace any given value in that gray scale temperature range. For example, if the shop carries rows of cool gray but only a few handfuls of warm gray, go with cool. No one likes to come up empty-handed when facing a looming deadline!

### Gray Scale Marker Pros

- Are available in a full value range
- Can produce copy with excellent reproducibility
- Allow broad coverage, enabling the illustrator to quickly block out basic shapes

### Gray Scale Marker Cons

- Are moderately expensive
- Are sometimes limited in availability
- Require frequent replacement, especially when using lighter-value markers (30 percent gray and below)
- Work best (and last longer) on smooth surfaces, such as bristol board
- Might necessitate intermediate drawing ability along with a strong understanding of value because of the need to constantly shift between different markers

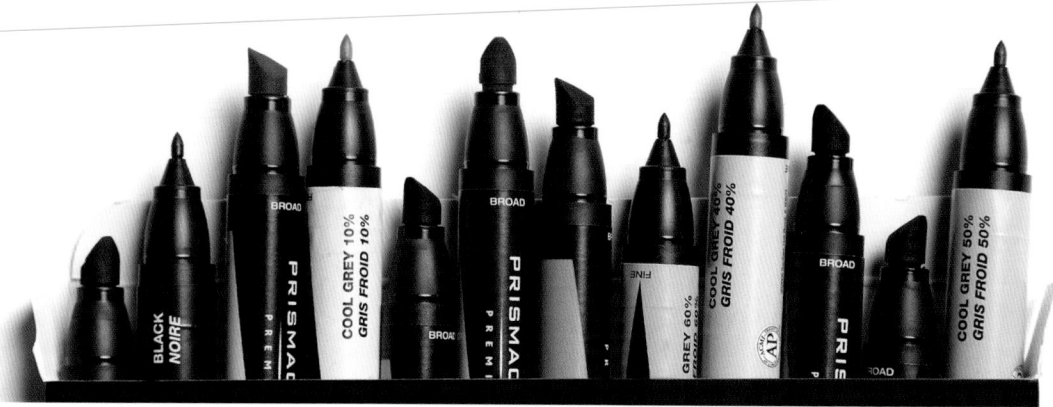

With the fine point of a 10 percent gray marker, the artist blocks out the scene. The 10 percent cool gray is so light that it won't even photocopy, so the artist is free to make errors and draw quickly with confidence.

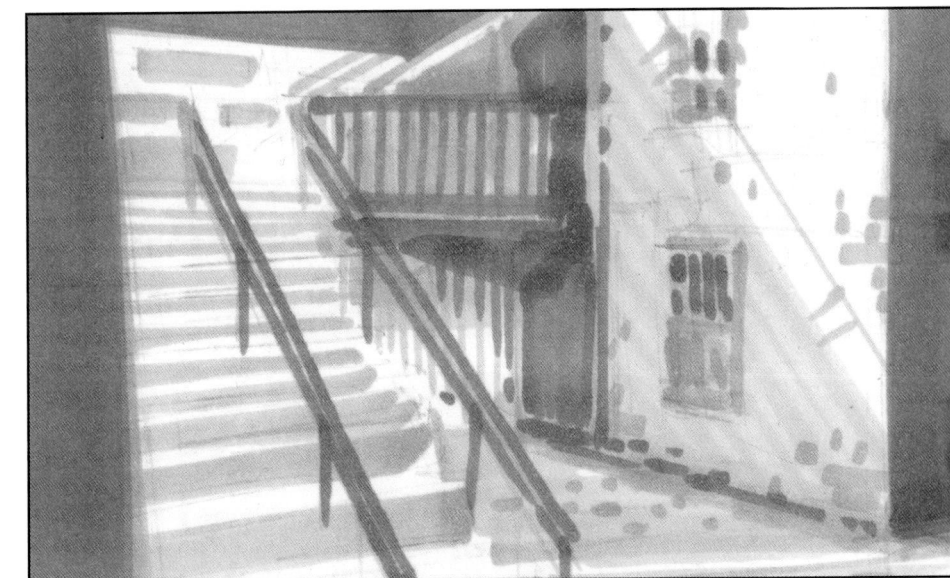

The artist then begins building value. The markers allow the artist to build several mid-tone and shadow values that will reproduce well on a photocopier.

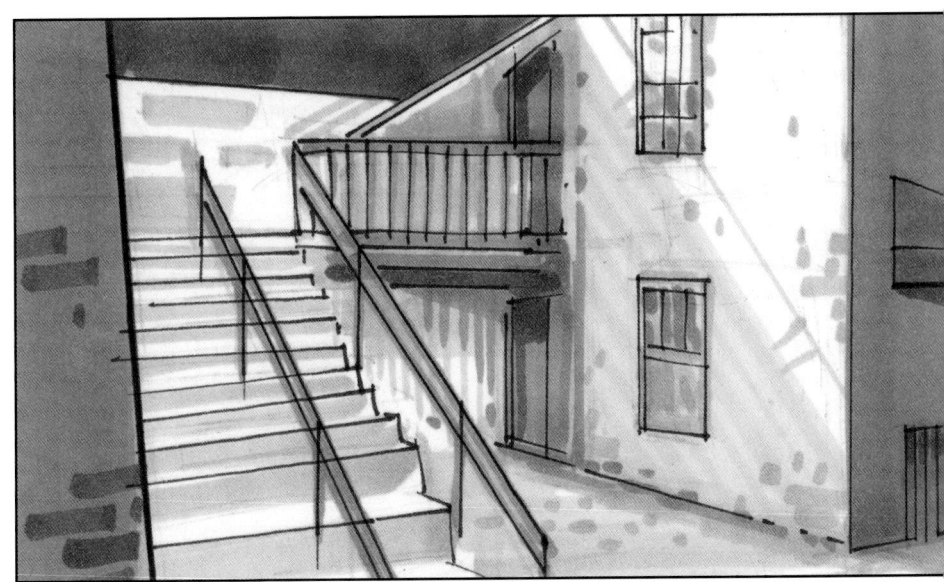

Then with a black, fine point marker, the artist defines lines and contours. These lines hold the final art together and create clarity and legibility for the storyboard.

# Compositing

When meeting tight deadlines, a good storyboard artist knows how to take shortcuts without cutting corners. In this example, the artist used value to emphasize mood and lighting and chose gray scale markers for speed.

The artist blocks out the double doors with a few quick passes of the marker. Drawing this image separately gives the artist freedom of movement when rendering the door

Wanting to save even more time, the illustrator draws the imposing figure of the menacing thug on a separate plate, which will be combined with other elements.

Because the directional arrow is white, the illustrator saves even more time by drawing this image on another plate. It too will be combined with other elements.

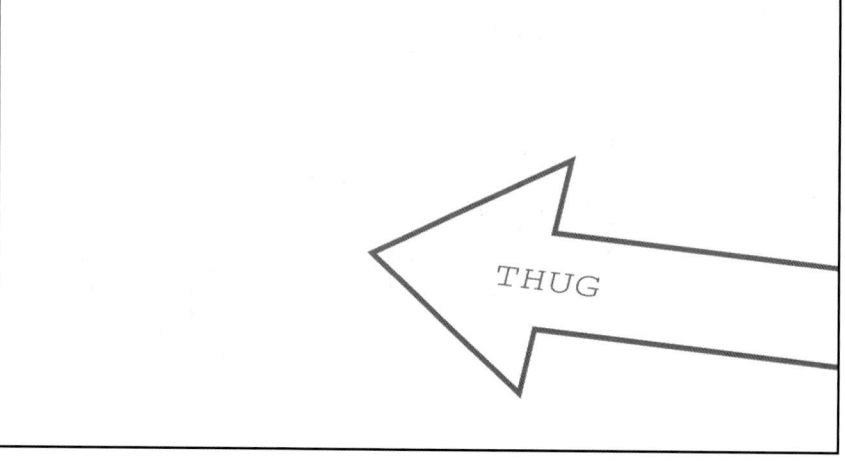

The damsel is drawn on yet another plate. Having to carefully tone against the lighter edges of the figure bogs down the pace of the illustrator and could reduce the clarity of the image.

Here we see the damsel leaning against the door, believing she has escaped the madman. (Note the clean edges of the composited illustration.)

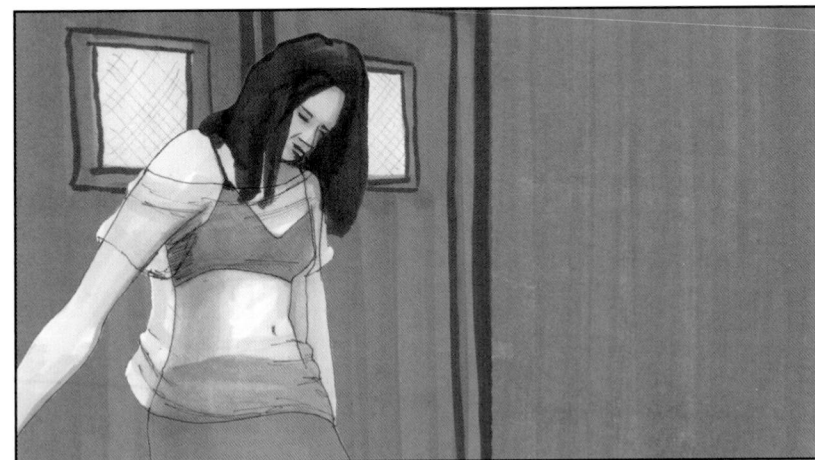

In this intermediate step, we see the figure composited onto the shot—but the illustration does not tell the whole story to the director or cinematographer.

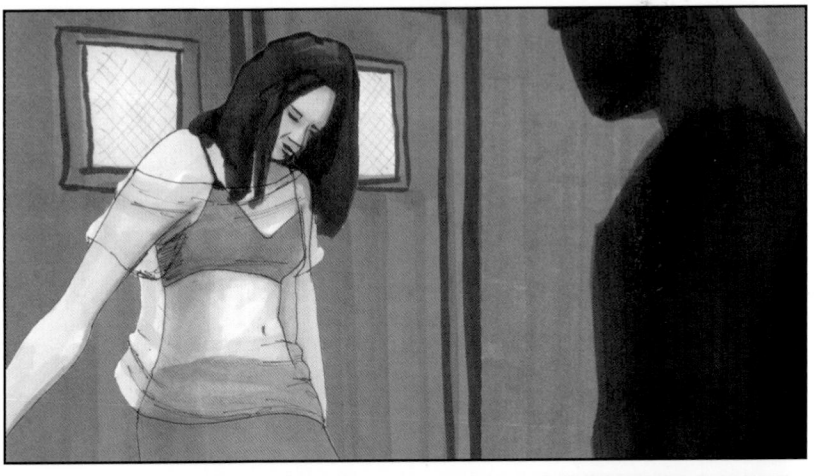

With the addition of the directional arrow, the cinematographer now understands that the thug quickly enters the frame. When considered along with the panel above, the crew understands that the damsel barely has a moment to breathe before her untimely demise.

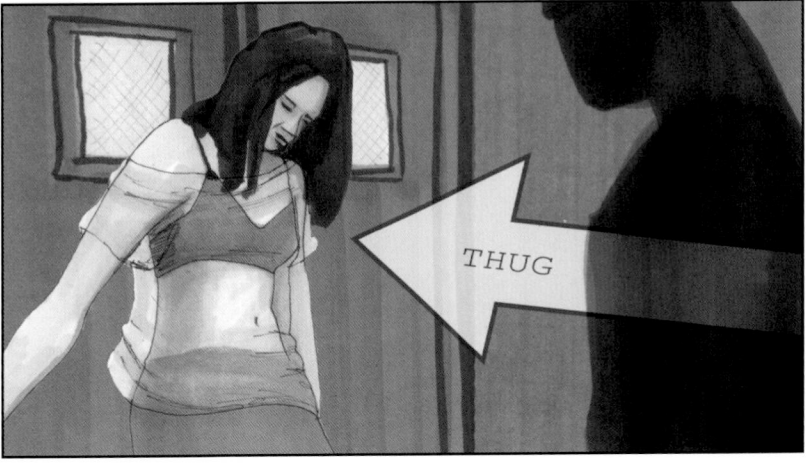

THUG

# A Difference of Opinion
## *Un-Deadwood*

In this installment of "A Difference of Opinion," Sarah Kelly and Sam Reveley, both up-and-coming sequential artists, give their take on an excerpt from *Un-Deadwood*, aka "The Good, the Bad, and the Undead."

### Sarah Kelly's Version

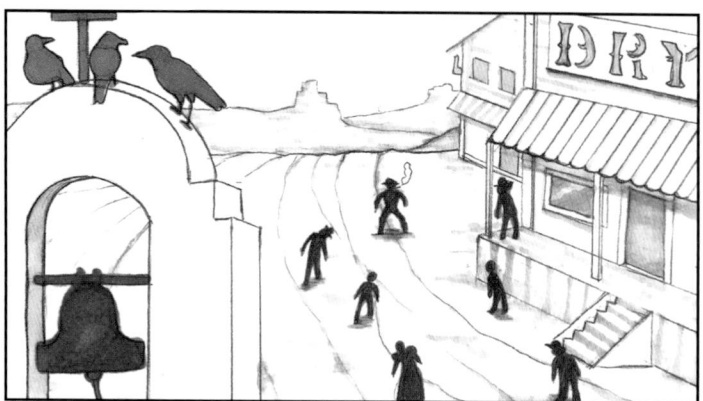

In her opening establishing shot, Sarah Kelly introduces the audience to the location as well as to a variety of hostile figures threatening a lone cowboy, while keeping the camera at a normal eye level.

The camera comes in for a Medium Close-Up.

This is followed by an Extreme Close-Up as our hero gunslinger raises his eyes.

This Extreme Up Shot sets up an ominous mood not only with its subject but with its canted angle.

A low angle reveals that the menacing figures are closing in on the gunslinger.

And then an Up Shot reveals that these are the undead, as our hero draws his sidearm in the foreground and begins to dispatch these monsters.

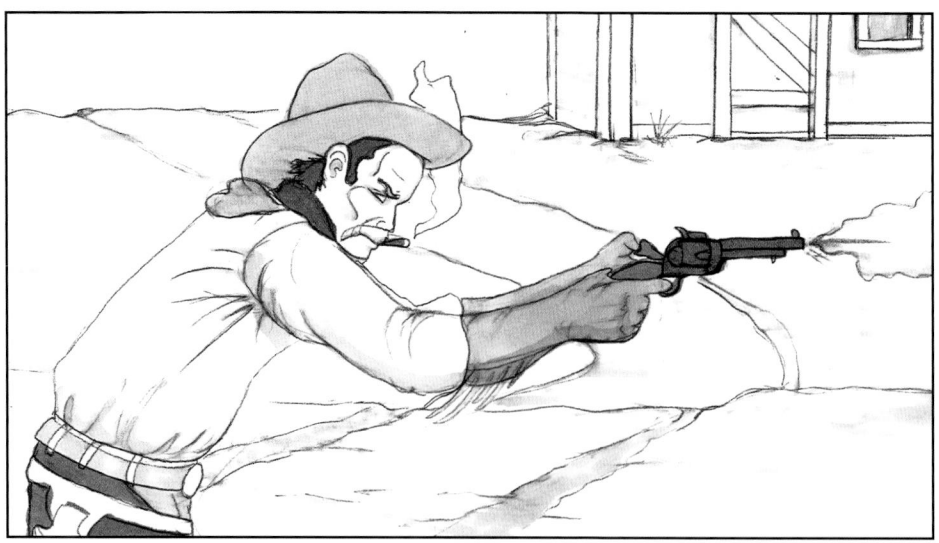

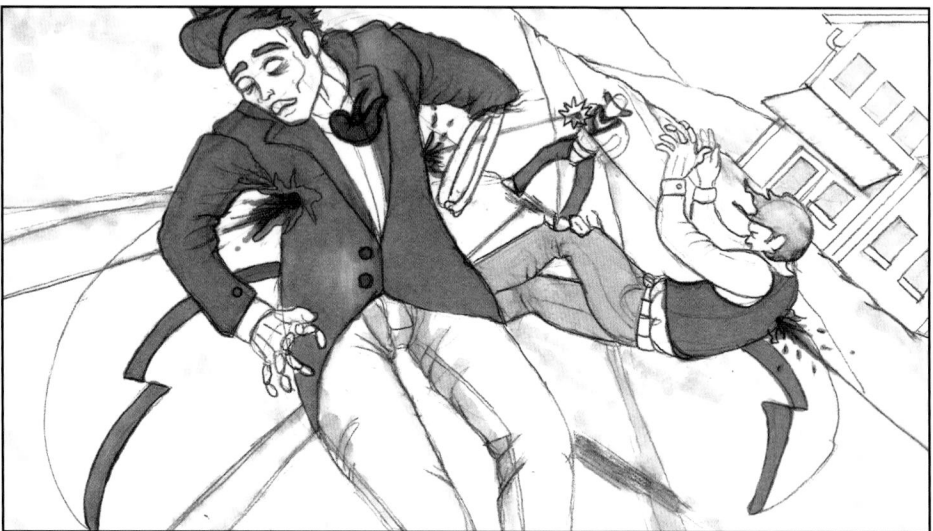

A canted High Hat Shot pushes the action on a strong diagonal and heightens the suspense.

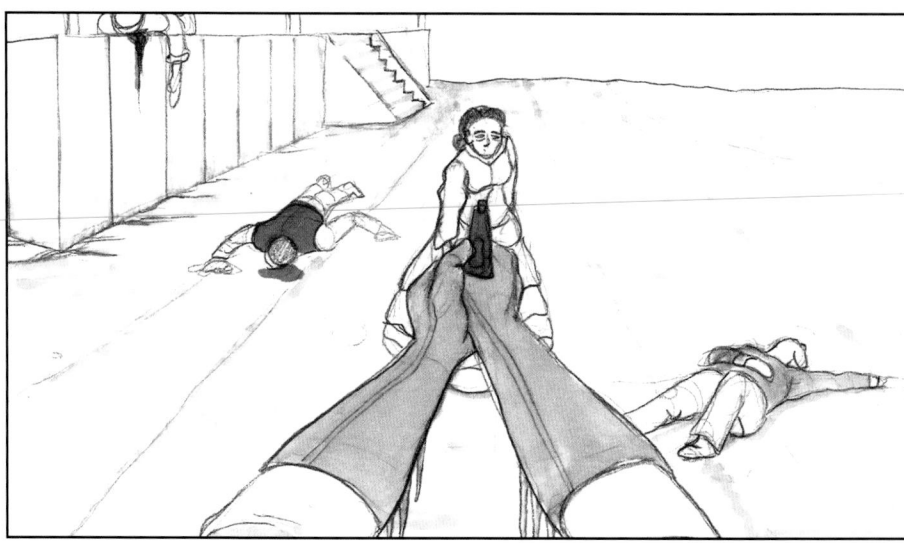

Note the use of perspective and the foreground to literally point to the last fiend standing.

Screen direction is maintained despite the use of a reverse angle.

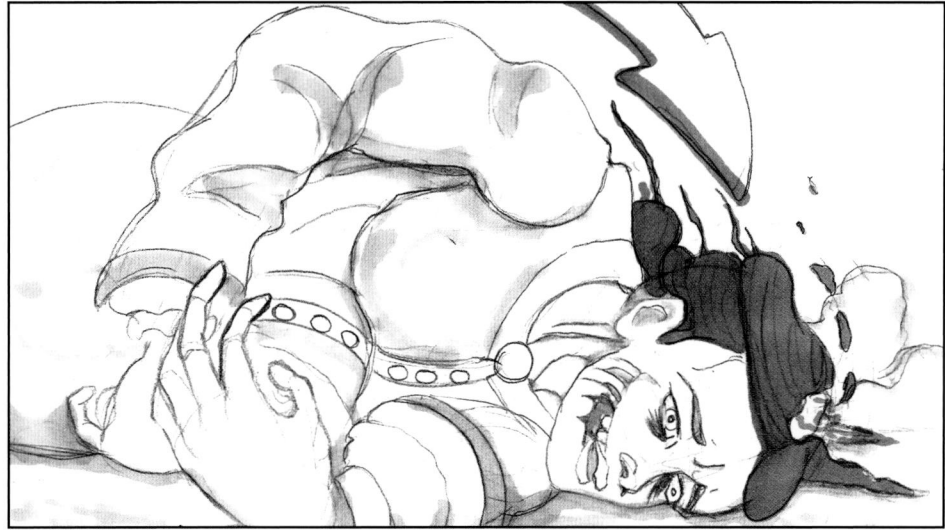

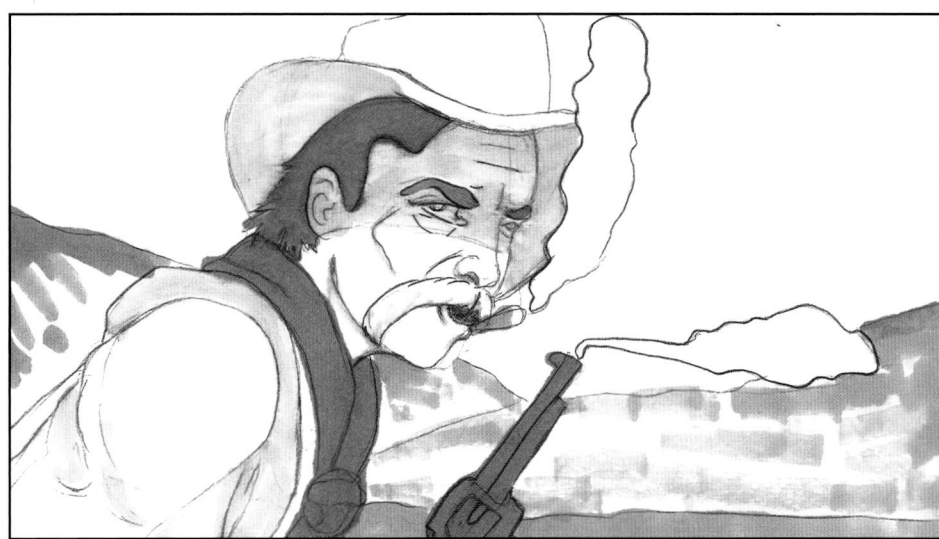

Returning to the Medium Close-Up that revealed our hero brings a nice sense of closure to the scene.

## Sam Reveley's Version

**RIGHT:** Sam Reveley employs a high-angle Wide Shot to establish the location and characters in her establishing shot. While this approach may not build as much suspense, it shows the audience more of the space these characters occupy.

**BELOW:** The camera comes in for a Medium Close-Up.

**BOTTOM:** This is followed by an Extreme Close-Up on our hero gunslinger. Note the subtle performance difference in Reveley's boards.

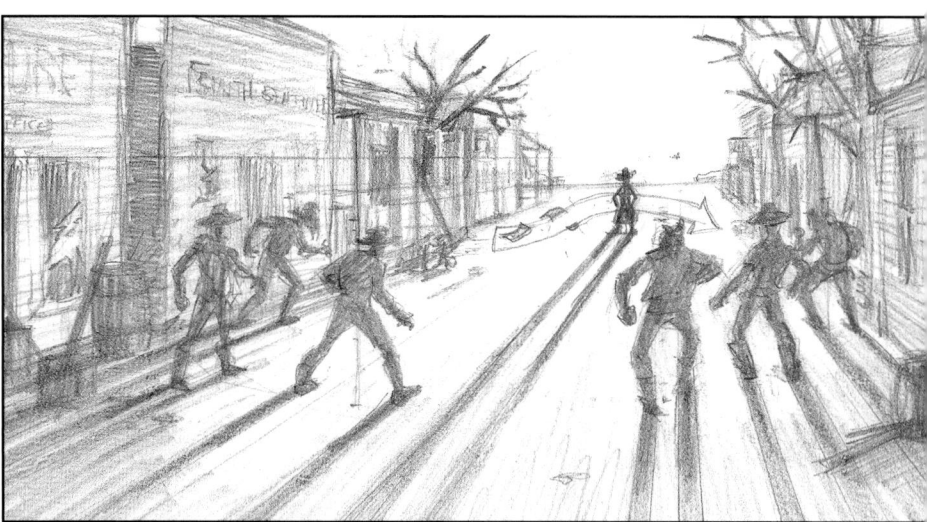

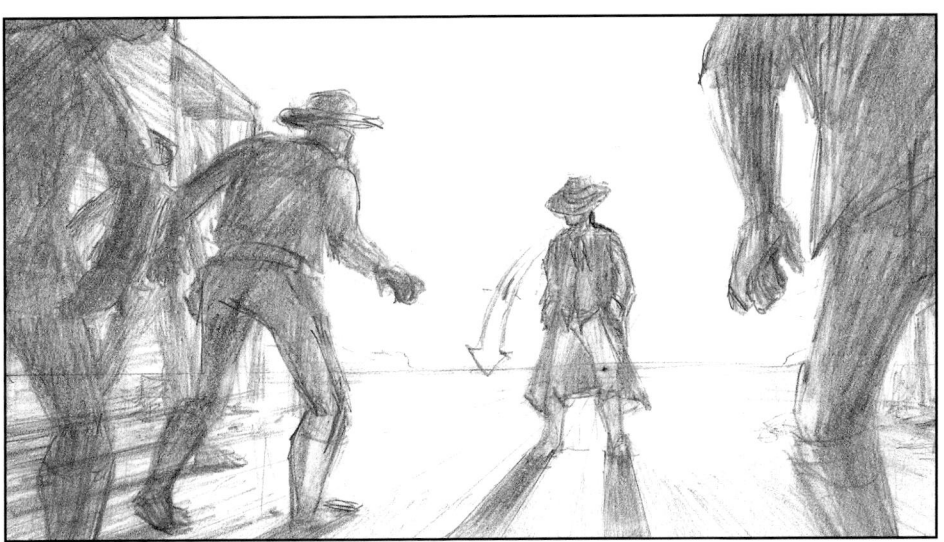

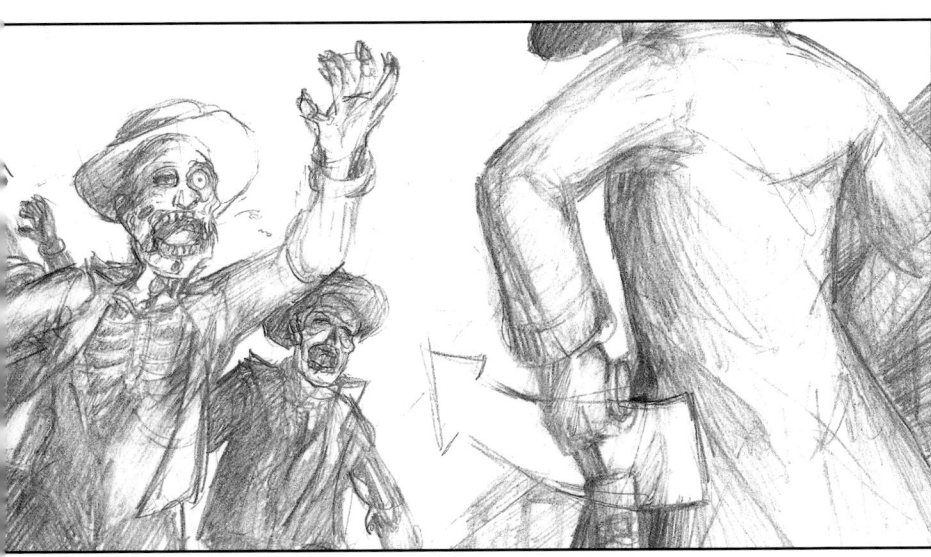

A classic variation of the Over-the-Shoulder Shot is used. The "Hip Shot" has long been a staple of cowboy films.

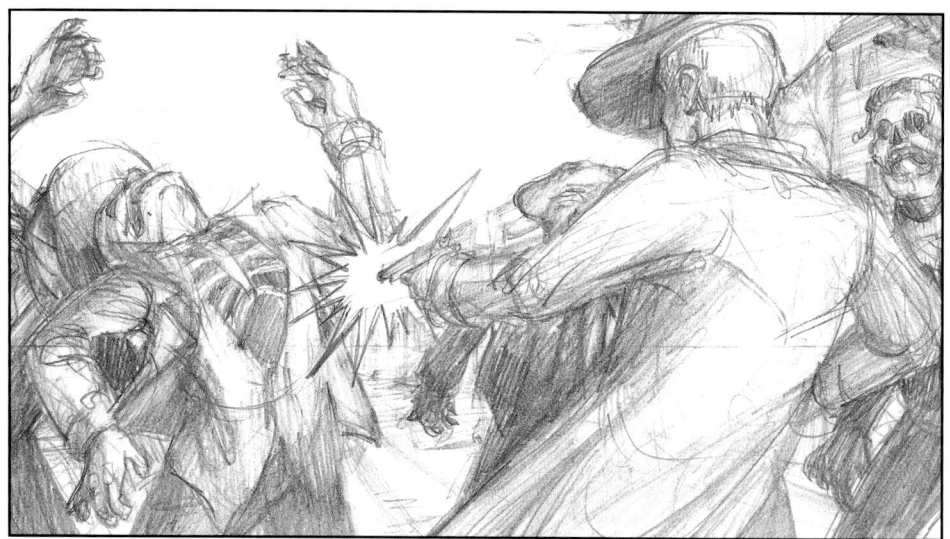

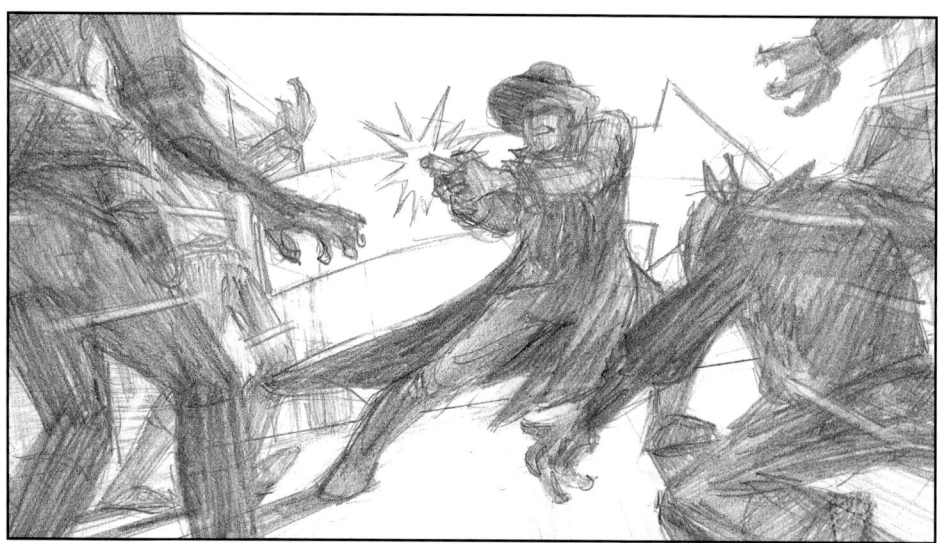

**TOP:** A clearly staged Medium Shot shows the gunslinger open up with his six-shooter.

**MIDDLE:** As a canted shot helps to reinforce the chaos, bullets fly through the pack of zombies.

**BOTTOM:** With the hands in the foreground as the gunslinger takes aim at the last fiend standing, the artist is clearly indicating a POV Shot.

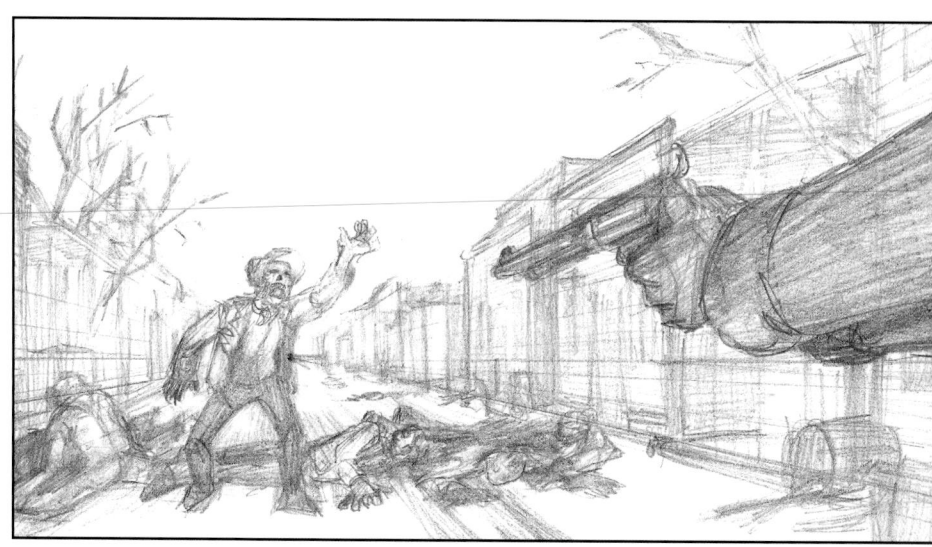

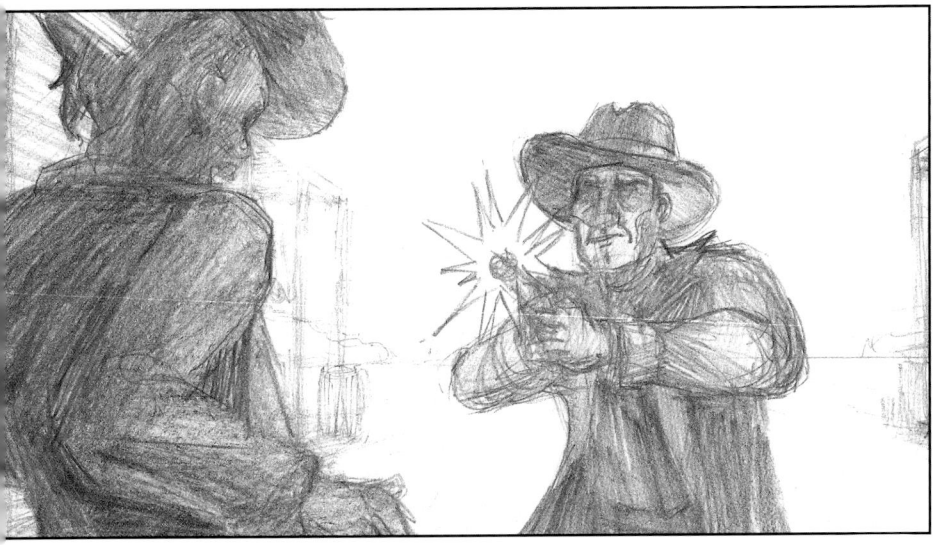

**LEFT:** Reveley places the camera low and lets the action play out as a bullet hits the final zombie and she crashes back toward the camera's position.

**MIDDLE AND BOTTOM:** With the final Medium Close-Up, the artist chooses to play the character with more bravado as he blows the smoke from his pistol.

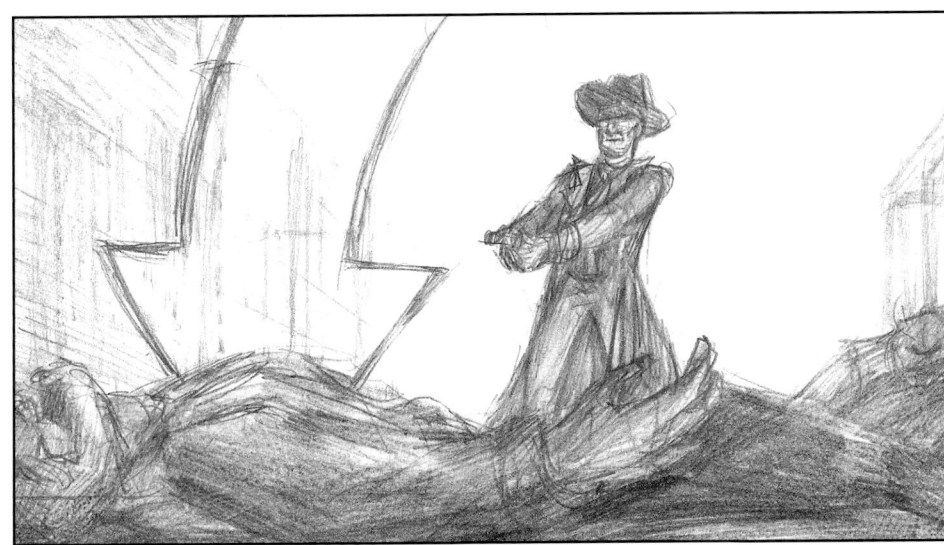

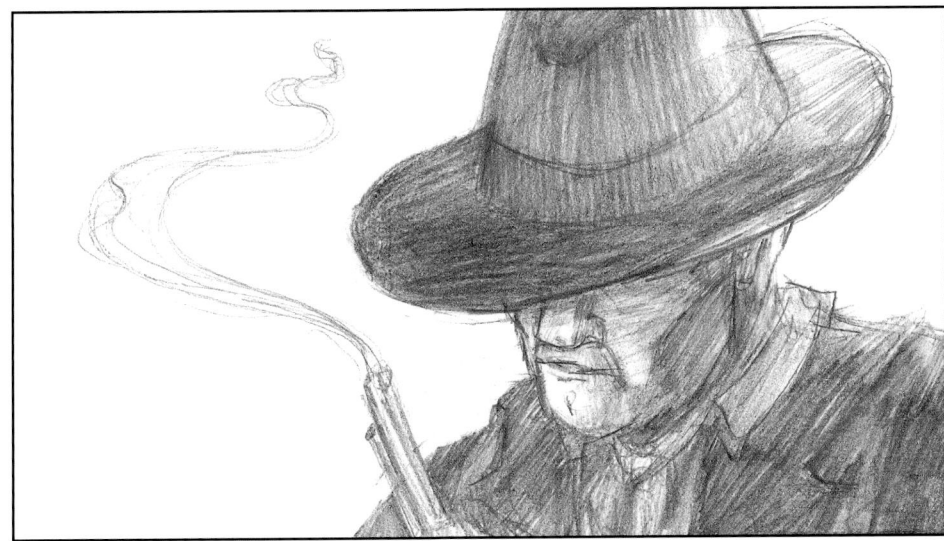

# Interview: Keith Ingham, Storyboard Artist and Animator

**Keith Ingham has worked as a credited storyboard** artist for Don Bluth Entertainment, Teleproductions Gaumont, and Nitrogen Studios. He has also directed animated features for Bardel Animation, Sextant Entertainment, and Walt Disney Television Animation Canada. The award-winning animator has taught at Savannah College of Art and Design (SCAD) since 2009.

David Harland Rousseau caught up with Ingham as he was prepping for courses he was teaching at SCAD Atlanta.

**DHR:** Keith, you've been working in animation since the 1970s. You must have seen some dynamic changes.

**KI:** Indeed. Technology has changed considerably. Paper and pencils have given way to Cintiqs and software. Delivery of a finished board has gone from FedExing pounds of paper to uploading digital files to an FTP site. But apart from new tools and procedures, the actual craft of first visualizing action and content as a drawing has changed little. The concepts of staging a sequence, framing a shot, posing, and composing remain the same.

The artist must be able to not only communicate the script but also do it in a compelling, engaging, and entertaining way.

**DHR:** I noticed from your filmography that you started as an animator, transitioned to storyboarding, and then became a director. Would you say this is a common path for those interested in storyboarding for animation?

**KI:** More or less, yes. I can speak for only my own process and developmental path, but doing all those other jobs helped immensely in understanding how to be better at boarding. A board artist is, in a way, a director. A storyboard artist is the first to visualize the story. Getting feedback and revisions on your storyboard from a director can really help you as an artist to understand the overview of the storytelling process and what is needed to accurately depict character, mood, and style.

**DHR:** Is there a place in animation for those who only want to storyboard? Or should artists and illustrators gain experience as animators?

**KI:** Great question. Yes, there is a place in animation for those who only want to storyboard, but I would add that the wider the range of experiences one has in the animation process, whatever the medium, be it 2D or computer graphics (CG), will contribute directly to being a better board artist. For example, having been an animator helped me to know how to effectively pose characters. Doing layouts helped me understand how shots were to be executed in production, and this would be reflected in the way the shot was depicted in the storyboard. Being an effects

animator gave me a much deeper understanding of the camera and photographic techniques.

**DHR:** You've worked on challenging animated TV series, such as *Beetlejuice* (1989) and *The Neverending Story* (1995–1996). Share your thoughts on storyboarding for television.

**KI:** I get very jazzed about the creation of a moment on the page, and subsequently the screen. Each process, be it for a TV series, an ad, or a feature film, has its own challenges, demands, rewards, and joys. Boarding for television is always very driven by schedule and a specific amount of time to get a show visualized and working. It is a very demanding process, and different productions have different delivery needs. The show you might be storyboarding is one of many and is scheduled to be in full production at a certain time, so it is imperative to respect the schedule. A well-posed-out, 22-minute board, depending on how much action is in the story, can be anywhere from 350 to 400 shots. Consider that there is more than one pose or panel for each shot, and you can appreciate how many drawings and panels are involved.

**DHR:** Tell me about working with Don Bluth. [Don Bluth is a prominent figure in animation, having started his career with Walt Disney Studios in the 1950s. He began as an "in-betweener" and went on to be an animator, producer, director, and studio owner. Bluth has directed a number of highly successful animated features and is still active in the animation and gaming industries.]

**KI:** Working with Don was very illuminating for me. His enthusiasm for the craft of animation and his ideas were infectious. Before Don allowed any storyboarding of action, he asked that the artist design the set in which the action was to take place. This was not as easy as it sounds. I had to come up

with one that would service the story and provide opportunities for entertainment. Don knew that a better telling of the story would evolve from a better understanding of the world in which the story took place.

Don also wanted the artist to be thoroughly engaged in the creative process. If you did not get his full attention in the first few moments of your storyboard pitch, then he was gone, much like the audience would be if such storytelling made it to the screen.

**DHR:** Over time, you worked your way to becoming an associate director for Walt Disney Television Animation Canada. This was no small feat. Was this always a goal of yours?

**KI:** No, not really. When I was a kid, I wanted to work for Disney because I liked their movies so much, but I really didn't understand what was involved. I found myself working at Disney Canada because of the culmination of my experiences at other studios.

**DHR:** If you had to break it down, what was the one thing you learned from your experience as a storyboard artist?

**KI:** Hmm . . . more than one. Always think about what you are doing. Don't distract yourself during the initial creative aspects of making the board. There is a great deal to think about. Getting started is hard, but waste no time because it'll go by really fast. Listen carefully to what is being asked of you by an employer, a director, or a production manager. You will not be able to coast through any board relying on formulaic approaches. Know that your work will be revised and don't take that personally. Don't fall in love with your work because it is going to change and grow, and you have to be open to that. Above all, have fun and enjoy what you're doing, and it'll show in your work.

## Numbering

Numbering consists of three basic components: scenes (for live action) or sequences (for animation), shots, and then panels. Each new scene or sequence resets the numbering of the storyboard panels.

If you have no idea what the scene, sequence, or even shot number is, simply focus on numbering the panels for a given scene or sequence; include an obvious title for the scene, such as "Foot Chase." Since so much of storyboarding for live action revolves around action sequences and complex setups, this descriptive labeling is very appropriate.

Practically speaking, many storyboard artists will recommend leaving room for inserts by using a three-digit numbering system. For example, the first panel for the foot chase action sequence may be labeled as Foot Chase 001. This numbering system also provides a smooth transition from paper files to digital naming conventions. After all, unless you are on set or in the production office, odds are pretty good that you will be sending digital files to your clients.

Look to the examples of these next two pages for some basic file naming guidelines.

If you do not have scene numbers provided to you, use a descriptive name, such as Foot_Chase_01.jpg, for the scene or sequence.

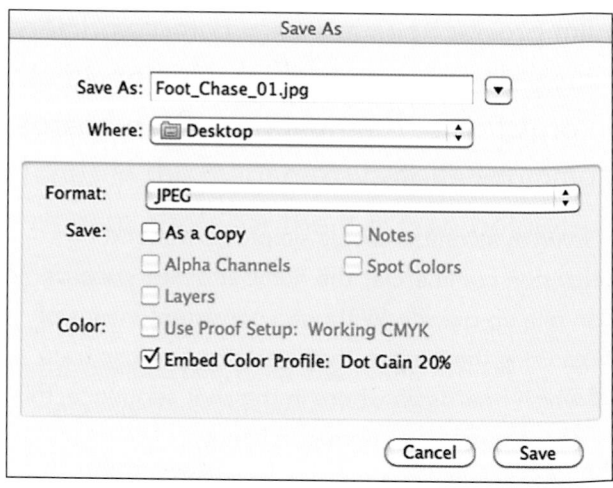

**RIGHT:** If you have the scene numbers provided to you, number your files starting with the scene number, followed by the panel number: 02_01.jpg.

If you know there will be more than one hundred boards, start with double zeroes and give the files names such as 02_001.jpg.

Of course, these files would be nested within an appropriately named folder that would include a working title and/or the artist: Storyboard_Movie_Rousseau_Phillips_2011.

By the way, the reason for using zero and double zero prefixes is simple: the computer will order files numerically, and then alphabetically. Given this, a file named 2_1.jpg may find itself next to a file named 2_11.jpg or 22_1.jpg, which could cause confusion if the recipient is in a hurry.

Tip

Never make up scene numbers. Leave the scene number blank until you are given the scene numbers by the production team.

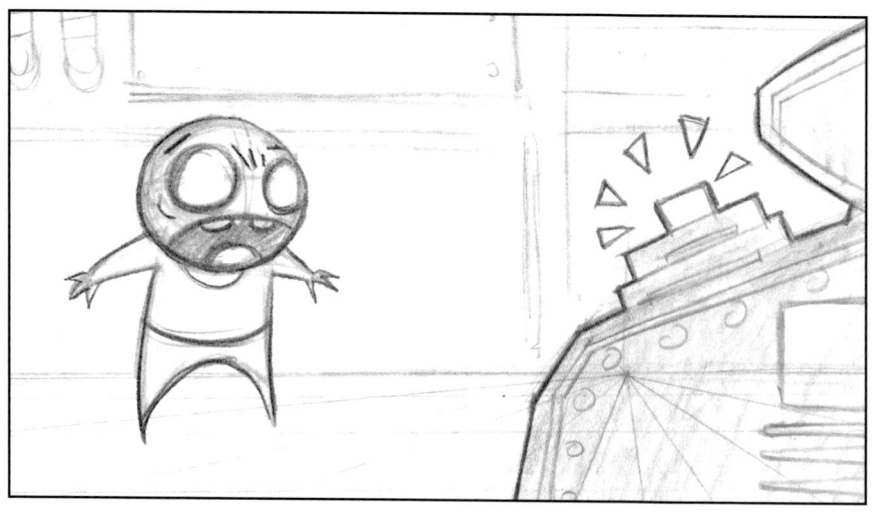

**SCENE: 1**  **PANEL 1**

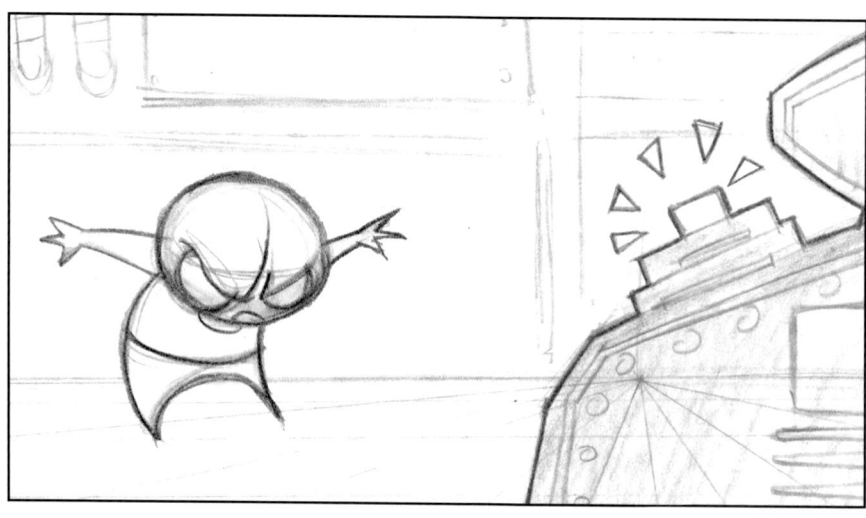

**SCENE: 1**  **PANEL 2**

Note how the word *panel* instead of *shot* is used. In animation, individual storyboards in the scene are labeled as panels.

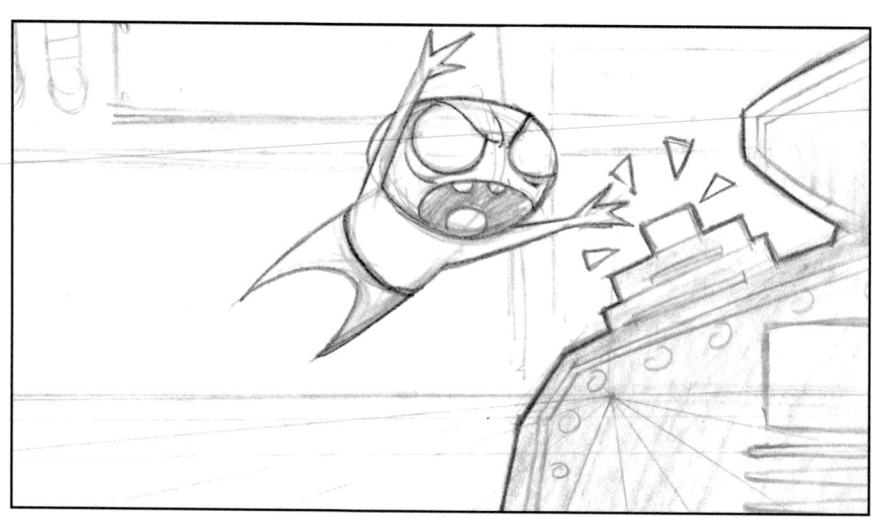

**SCENE: 1**  **PANEL 3**

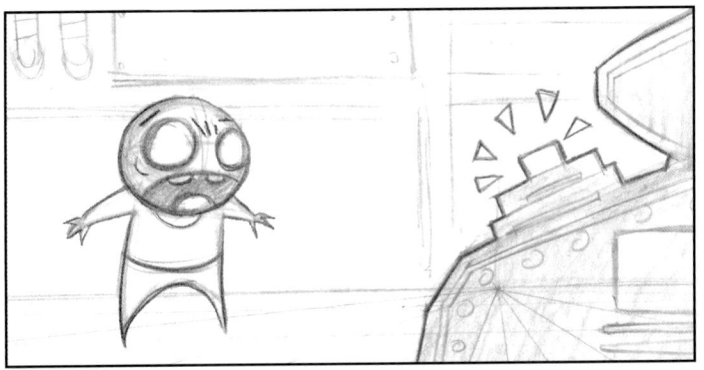

**SCENE: 1**　　　　　　**PANEL 1**

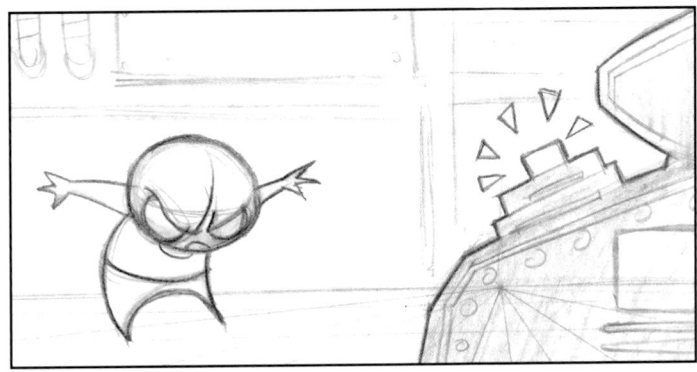

**SCENE: 1**　　　　　　**PANEL 2**

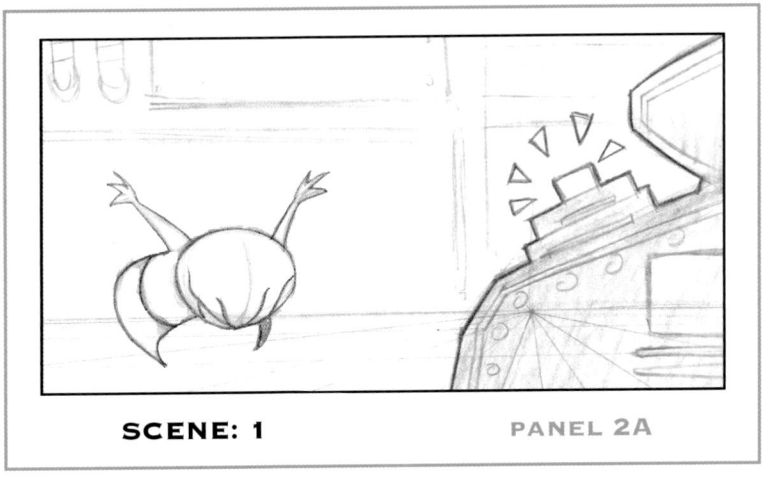

**SCENE: 1**　　　　　　**PANEL 2A**

The extra motion needed before the leap is an example of an insert shot for animation.

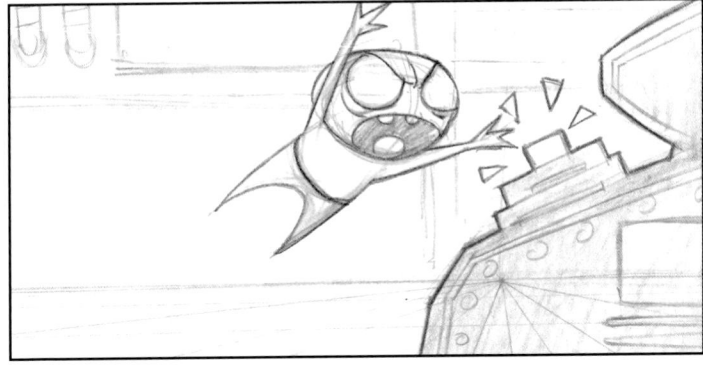

**SCENE: 1**　　　　　　**PANEL 3**

# Exercise

 ## Numbering

Here are several panels from a short animation sequence, "Shocking Secret," illustrated by Lavinia Westfall. The first six are considered part of the "original" sequence. The next three are "insert" shots. Feel free to photocopy this page and then cut out each panel. Arrange the first six panels so that the continuity makes sense, and then number them accordingly. Then, find the appropriate insert shots; rearrange the panels so that the overall continuity makes sense, and then number the inserts accordingly.

01

02

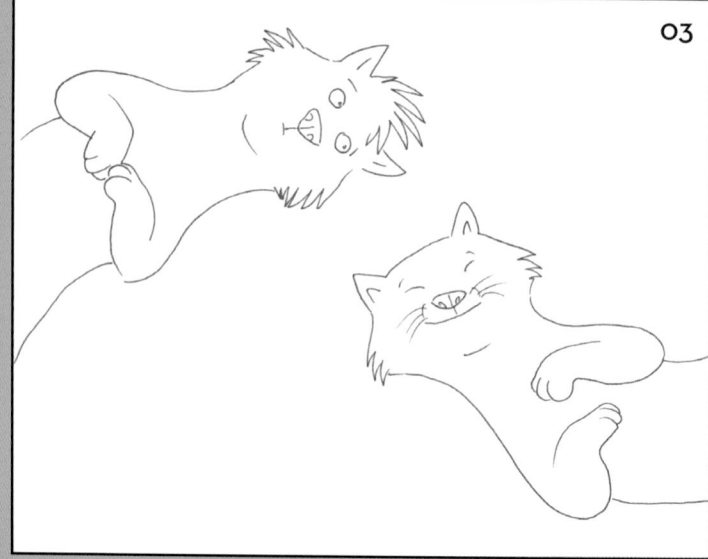

03

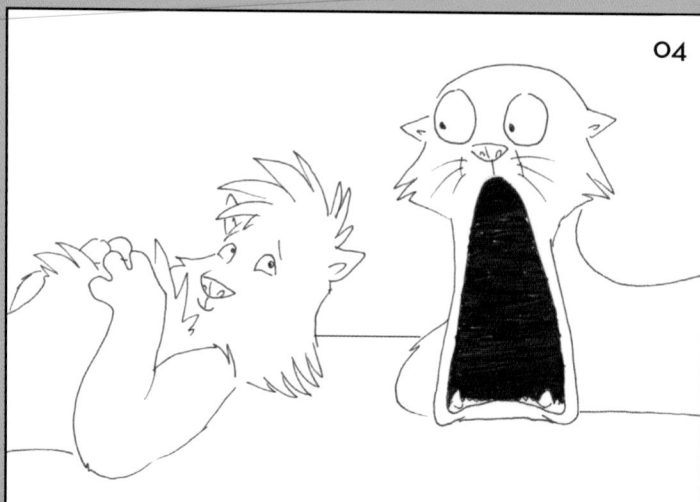

04

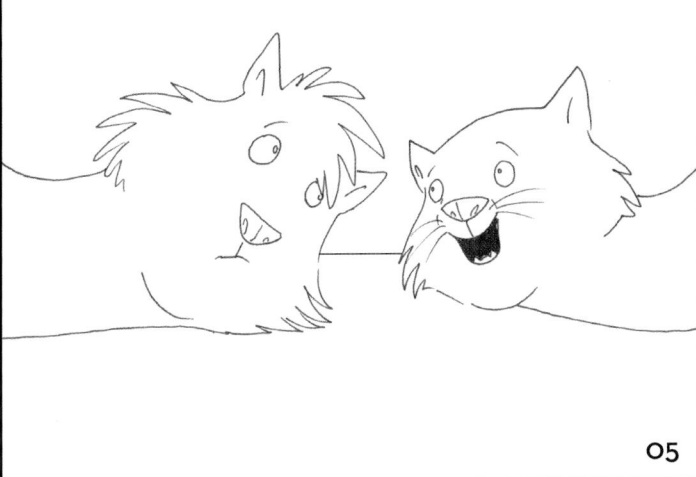

05

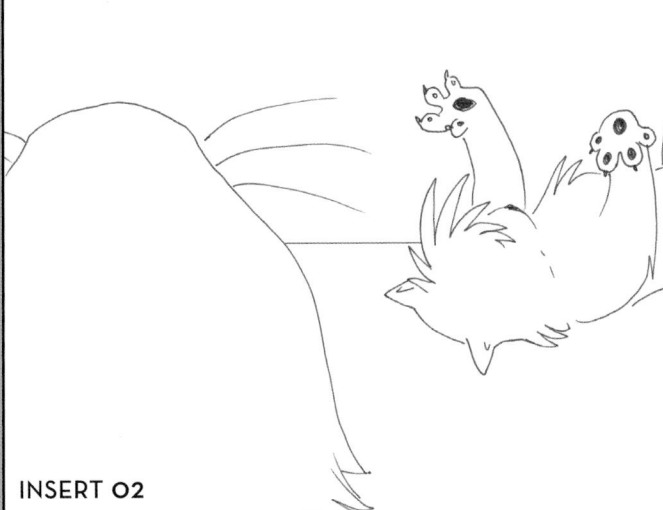

INSERT 02

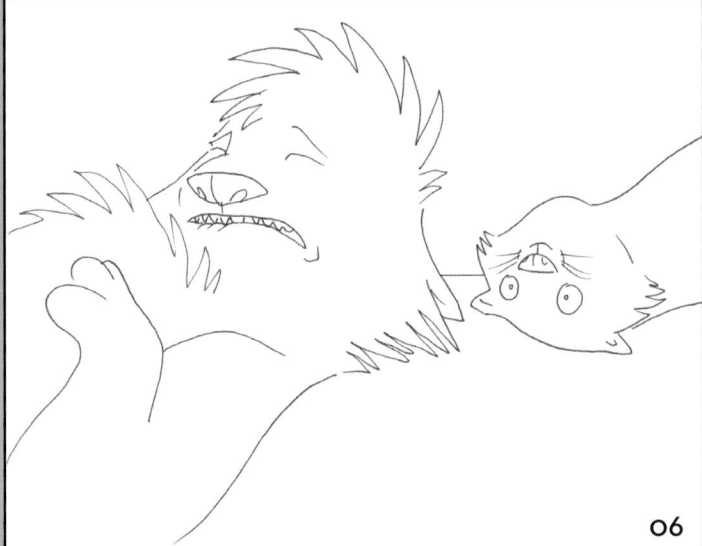

06

INSERT 03

INSERT 01

# CONTINUITY

5

# What Is Continuity?

*Continuity* is defined as an uninterrupted sequence without significant change.

Motion mediums, whether live action or animation, rely on the basic principle of continuity in order to engage the audience and retain the attention and interest of the viewers. As one might imagine, the successful storyboard artist will be able to establish an uninterrupted sequence that connects with the audience. A needless or careless shift in the succession of images breaks this connection.

While animation and live action strive to maintain continuity, animation tends to be less susceptible to obvious mistakes. After all, animation is planned in great detail and reviewed every step of the way, from storyboards to the final cuts. With live action, the tight deadlines, compressed shooting schedules, and limitations set by shooting permits exert enormous pressure on the cast and crew. If the crew has to pick up a shot on the fly and has been "runnin' and gunnin' " without the aid of a competent continuity director or (even better) a handy set of storyboard sides, they may find they have earned the enmity of both director and editor.

Competent storyboard artists and cinematographers will have a strong understanding of the axis and the 180- and 30-degree rules. They will always have a couple of tricks up their sleeves to neutralize a transition. Above all, successful sequences will never "cross the line" or "break the action" unless it is an essential change required by the script or called for by the director for dramatic purposes.

## Terms

**180-degree rule:** Rarely, **rule of right.** Characters in the same scene should have the same right/left relationship regardless of camera position. The camera should never "cross the axis"—an imaginary line determined by the position of the characters relative to the position of the cameras. Violating this rule is also called **crossing the line** and **breaking the action.**

**30-degree rule:** The point of view must shift at least 30 degrees around the axis, while still abiding by the 180-degree rule, in order to avoid the inadvertent creation of a jump cut.

**Axis:** Also **180-degree line.** This imaginary line is established by the position of two subjects that determine camera angles for a given scene.

**Jump cut:** Also **shock cut** or **smash cut.** This is a sudden and often jarring cut from one scene, shot, or sequence to another without benefit of intervening devices or transitions such as a **fade, dissolve,** or **wipe.**

**Sides:** Commonly, sides are excerpts from scripts used by actors to audition for specific roles. With regards to production, sides are reduced, photocopied script pages that are distributed daily to key personnel by the staff of the assistant director (AD). **Sides** may also refer to reduced, photocopied storyboards that are also distributed to key personnel.

# Axis and Allies

Picture this: David Harland Rousseau (DHR) finds himself standing in a doorway. He straightens his tie as a production assistant (PA) runs a tape measure from his nose to the lens of a camera positioned near the doorway, to Rousseau's right.

The PA ducks as she passes by Rousseau. She soon returns, escorting a stand-in for actress Jaime Ray Newman (JRN), one of the leads for the Touchstone pilot *Hollis and Rae* (2006), written and directed by Callie Khouri, who won the 1992 Academy Award for Best Screenplay Written Directly for the Screen for the film *Thelma and Louise*.

What's going on? The PA needs to provide the cinematographer and camera operators with focal length distances in order to set the focus before the lead actress takes her place on the mark. These measurements also allow for slight adjustments in focal length should the director or cinematographer call for a *rack focus*.

Once the stand-in is in position, the PA runs the measuring tape from the nose of the stand-in to the lens of a second camera positioned just a few feet behind Rousseau's right shoulder. The blocking of the actors draws an imaginary line in the proverbial sand, creating the *axis*—an imaginary line established by the position of two subjects that determines camera angles for a given scene.

The image on the right illustrates the blocking of the actors and the positions of the cameras relative to the actors standing in the doorway. Both cameras are fixed in position but are free to *pan* or *zoom* as necessary.

The hot set is locked. Barring any meaningful movement on the part of the actors during the scene, the director determines that the starlet will always be on the right side of the screen. Because this particular scene takes place during an ongoing wedding reception, no establishing shot is necessary. A simple *Two-Shot* determined this visual contract with the viewer.

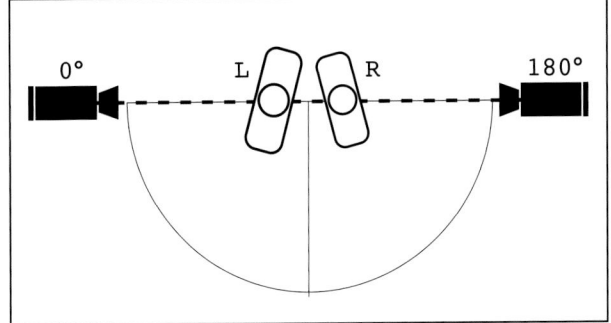

**The axis:** Here the movement of the camera is limited to one side of this imaginary line, the axis, created by the blocking or positioning of subjects captured in the frame.

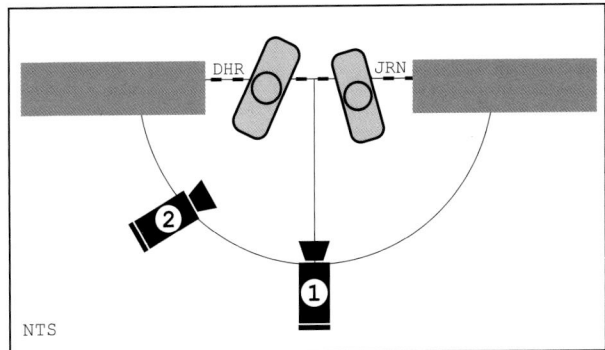

**Blocking and camera position:** Here you can see the blocking of the actors in the doorway. Rousseau (DHR) is on the left. Newman (JRN) is on the right. Note how both cameras are positioned on the same side of the actors, thus preserving the 180-degree rule.

---

## Term

*Rack focus:* A shot where focus is changed while shooting in order to shift the emphasis from the subject in the foreground to the subject in the background, or vice versa.

During the scene, Hollis Chandler (Newman) is stuck in a going-nowhere conversation with a rambling reception guest (Rousseau). Her friend, Rae Devereauz (Laura Harris), is trying to get the attention of Hollis. While the actions of Rae occur off screen (OS) and are shot separately, Newman must react to the off screen antics. Her reactions may call for a Close-Up (CU) or Medium Close-Up (MCU). For variety, the director may choose an Over-the-Shoulder (OTS) Shot, or he or she may simply cut back to the Two-Shot. Shots of the guest would most likely be picked up by Camera 1.

An example of a simple Two-Shot.

A Close-Up (CU).

A Medium Close-Up (MCU).

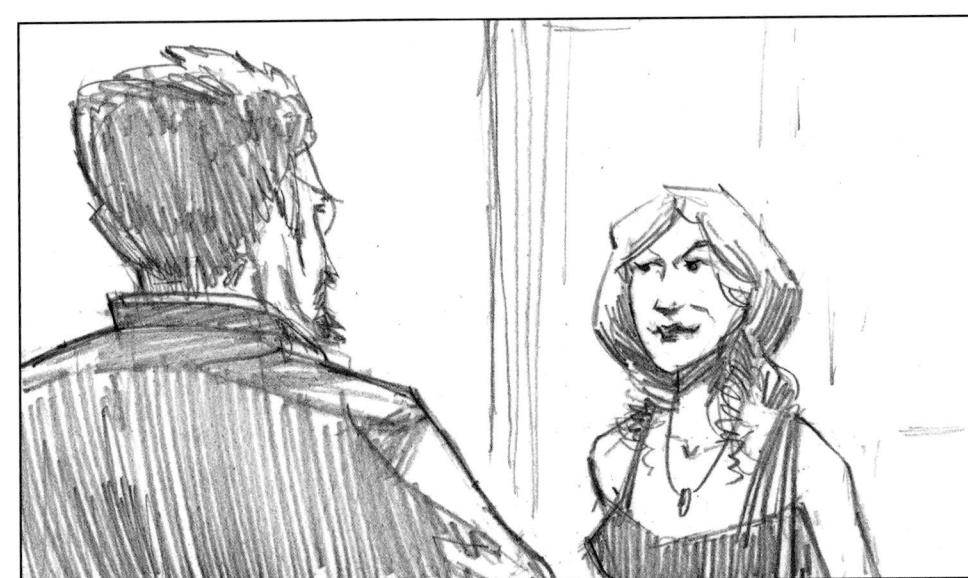

An Over-the-Shoulder (OTS).

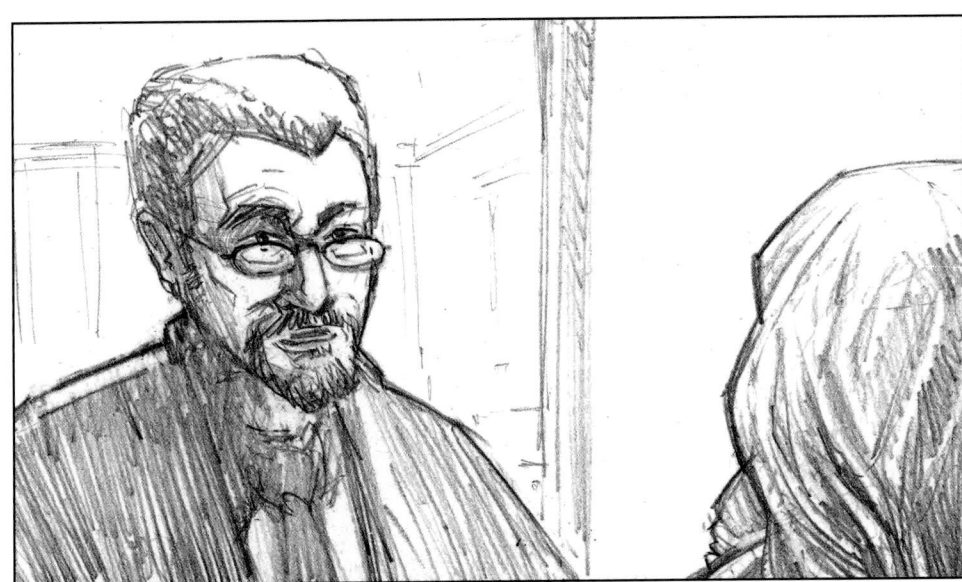

An OTS, Medium Close (MED)
Shot on the guest.

## Breaking the Axis

In every shot, the viewer can easily understand what's happening—but take a look at what happens if someone drops the ball. Note the initial positions of the actors in the established Two-Shot.

Let's assume that Camera 2 was inadvertently positioned on the opposite side of the doorway.

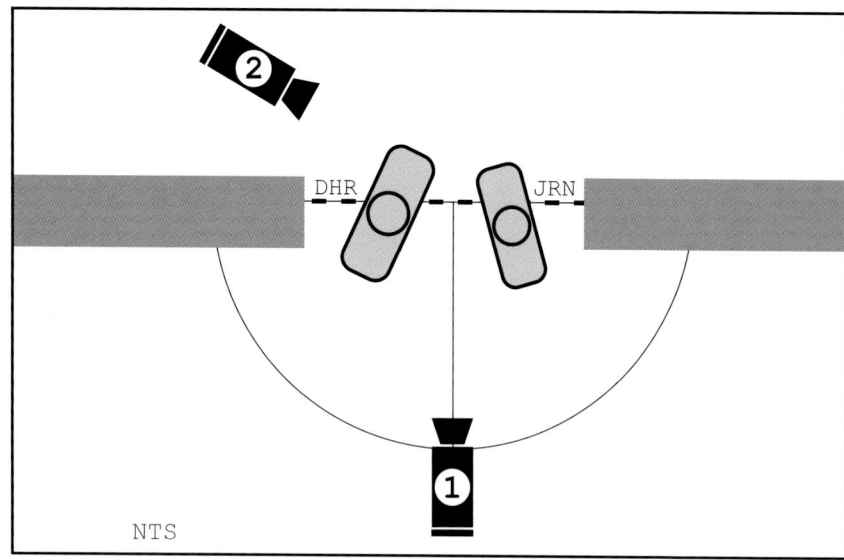

Camera 2 breaks the axis.

Let's look at a sequence featuring this camera position. Note how the constant shifting between points of view is jarring enough to unsettle the viewer, severing the visual connection established with the audience. It brings the viewer's comprehension of the action or movement to a grinding halt as the brain pauses to process the visual incongruity. It is therefore called *breaking the action.*

### Term

**Breaking the action:** A violation of the 180-degree rule, when the point of view crosses the axis.

# 30 Degrees of Separation

Ahhh... who doesn't love those slapdash sci-fi flicks so often lampooned on *Mystery Science Theater 3000*?

After all, once the viewers get past the stiff performances, the trite storylines, and the lackluster writing, they get to wade through 90-something minutes of low-budget special effects and grainy film. Then, they are in for a real treat: they get to bear witness to a cardinal sin in cinematography: the *jump cut.*

A jump cut usually occurs when the point of view shifts fewer than 30 degrees around the axis. Certain genres, such as horror or psychological thrillers, intentionally use this in order to create a jarring effect. For example, the audience sees that the villain is several feet away from his prey, but then—and without a discernible transition—he is suddenly upon the victim! Or in psychological thrillers, the protagonist may be under the influence of some mind-altering drug that distorts his view of reality. This technique is used sparingly, and its purpose and function are obvious to the viewer. Most of the time, however, the jump cut is, at best, a gimmick; its inadvertent use is a hallmark of inexperienced filmmakers.

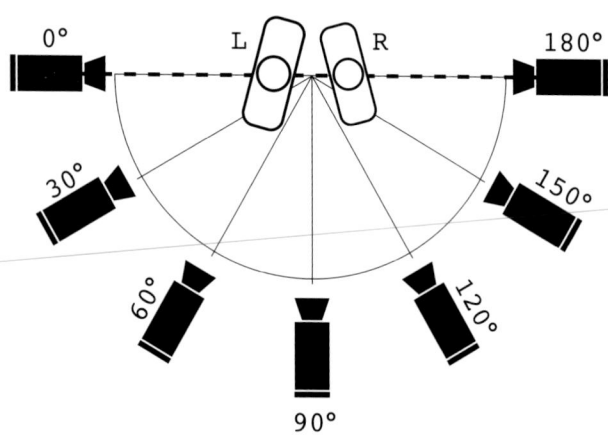

**The 30-degree rule:** The point of view must shift in increments of at least 30 degrees around the axis, while still abiding by the 180-degree rule.

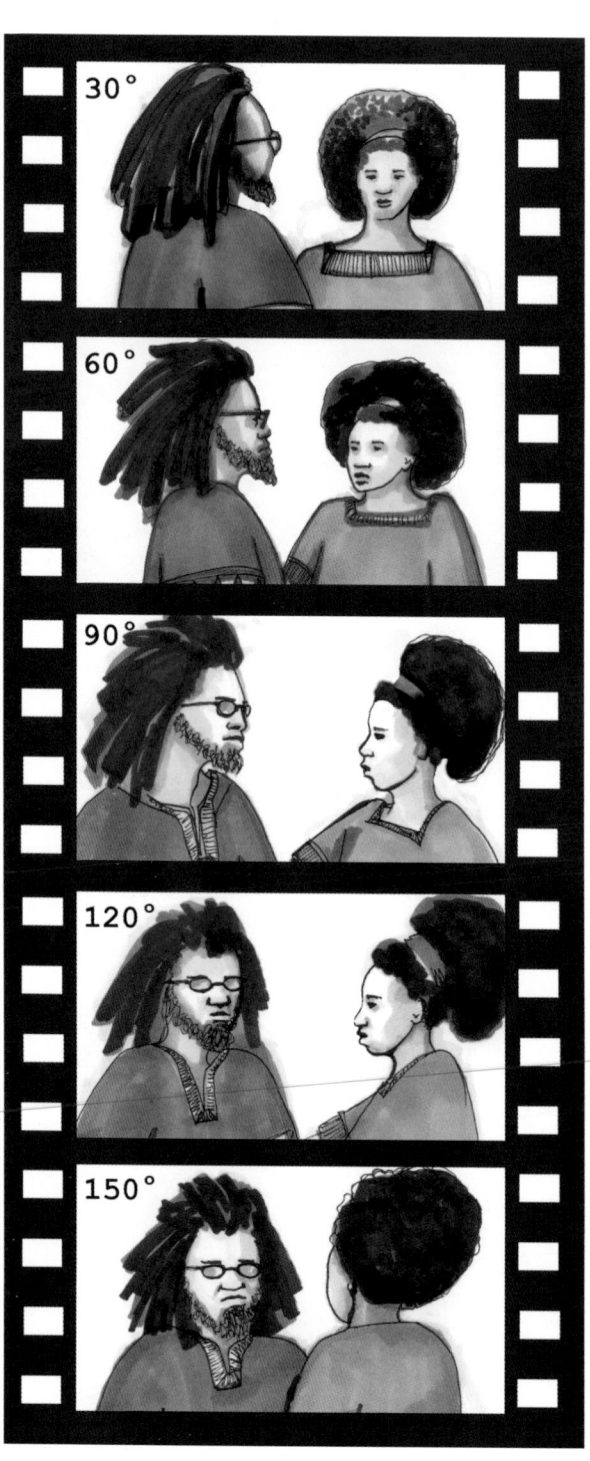

Note how 30 degrees of separation preserves the 180-degree rule.

## Neutralizing and Cutaway Shots

The 30-degree rule is all but set in stone. But what happens if there is an unintended shift caused by, say, an unfortunate movement by one of the actors? A talented illustrator or cinematographer will have at the ready a trusty cutaway to neutralize the shot.

*Cutaways* are usually something other than the current action depicted. Typical examples of cutaways include a *close* on a particular action performed by the subject—perhaps writing a note, drumming his or her fingers, or adding sugar to a cup of coffee. Other cutaways include different subjects entirely—perhaps a passing bicyclist or birds flying overhead. Just as an experienced director will always have a crew shoot copious amounts of *B roll*, an experienced camera operator will always look for cutaways.

A *neutralizing shot* differs from the cutaway in that it is an anticipated continuation of the action in order to allow for a *reverse angle* that would not violate the 180-degree rule. The audience is still able to follow the movement by being given a steady (and usually wide) shot of the scene. This allows the viewer an opportunity to "settle in" as the action unfolds.

### Terms

***B roll:*** Generally used in television news, the purpose of the B roll is akin to the purpose of the cutaway. This secondary (sometimes stock) footage disguises the elimination of unwanted content, such as stammering, uncomfortable pauses, or unintentional movement by the principles or background performers (**extras**).

***Cutaway (CA):*** This type of pick-up shot is used as a buffer between shots in order to add interest or information or to help with the editing process. These shots are taken from significantly different angles from the original shoot and are then edited into the final cut.

***Key frame:*** The key frame captures the main actions of a movement—usually the beginning, middle, and end. Animation storyboards are always depicted as key frames.

***Pick-up:*** Also ***insert*** and, in television news, ***reax,*** which stands for ***reaction shot.*** These relatively minor shots are recorded after the fact to supplement previously shot footage.

***Reshoot:*** When an entire scene has been redone, the resulting footage is called a ***reshoot.***

***Reverse shot:*** A transposition of a camera move, which provides a point of view that is 180 degrees apart from the original shot.

***Stock:*** Also ***archive, file,*** or ***library.*** Sometimes cheaper than shooting new material, stock footage consists of previously recorded and often archived shots of common events used to add interest or information or used to disguise the elimination of unwanted content. Popular examples of stock shots include pharmacists counting pills, traffic jams on busy turnpikes, commuter activity in subway stations, and presses printing currency or newspapers.

***'tweener:*** Slang for "in-betweener." The 'tweener is the tireless animator who draws the transitional frames "in between" the key frames.

. . . the *reverse angle*, which is the setup for a gag.

This Two-Shot brings the audience back into the van with the overconfident compadres and prepares the viewers for the payoff . . .

. . . which is a *close* on a fuel gauge reading empty..

The Close-Up (CU) Shot shows that our dim-witted driver is not too happy.

**LEFT:** And with this Long Shot, we can see why.

**BELOW:** Thumbnail sketches for the road-trip storyboards. Note the concern for composition, camera position, and clarity. Secondary concerns such as lighting and rendering technique are not important at this stage and therefore not developed.

LAYOUT - ROAD TRIP SEQUENCE 1:85:1

EST 4.17

EST 4.17.

CLOSE 4.21

TWO SHOT 4.22

TWO SHOT 4.18

REVERSE 4.20

REVERSE 4.20

CLOSE 4.23

CLOSE 4.23

PAN 4.19

MED CU 4.24

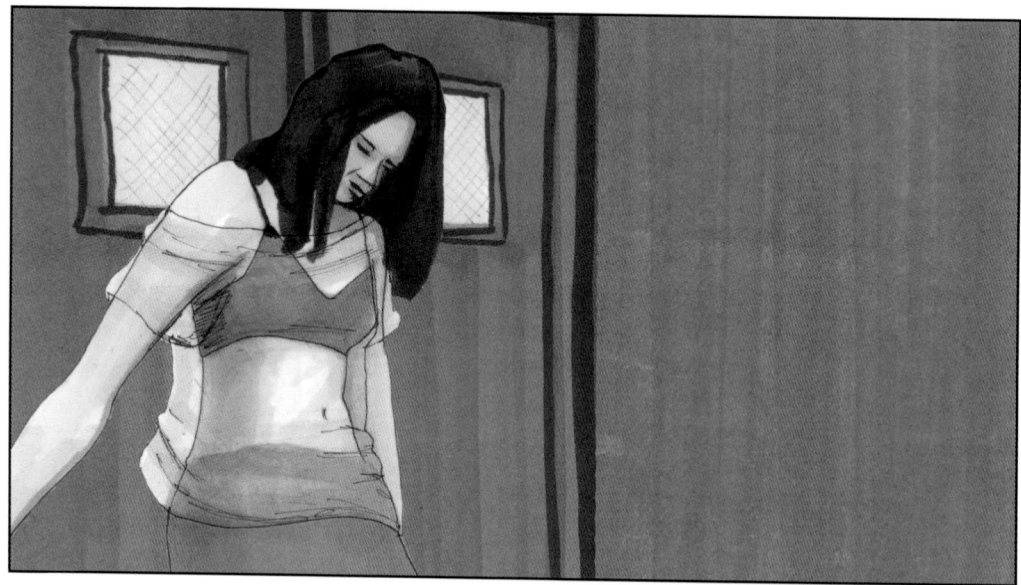

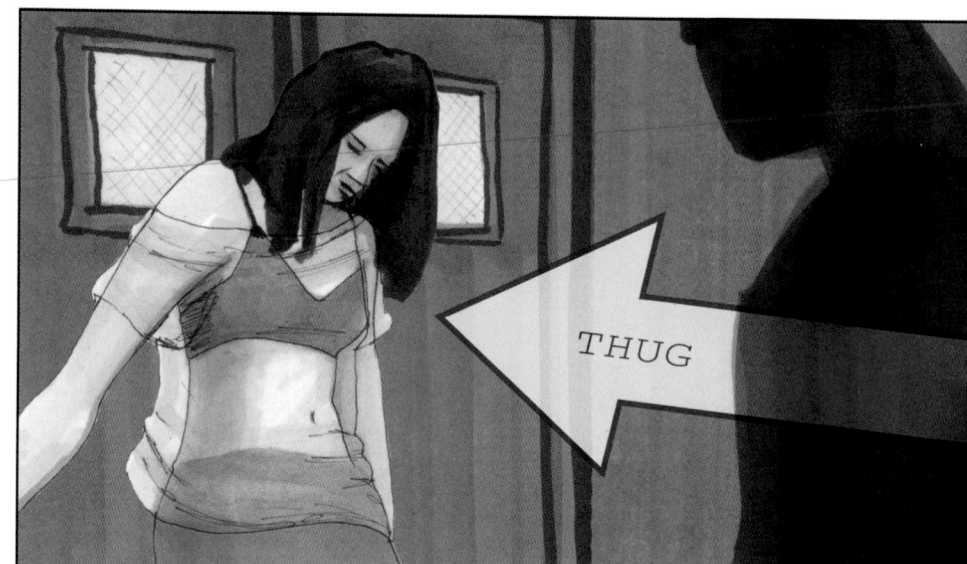

Camera 5 is a workhorse, taking up an American Shot, a Close-Up (CU) Shot, a Medium Two Shot, and an Extreme Close-Up (ECU) Shot.

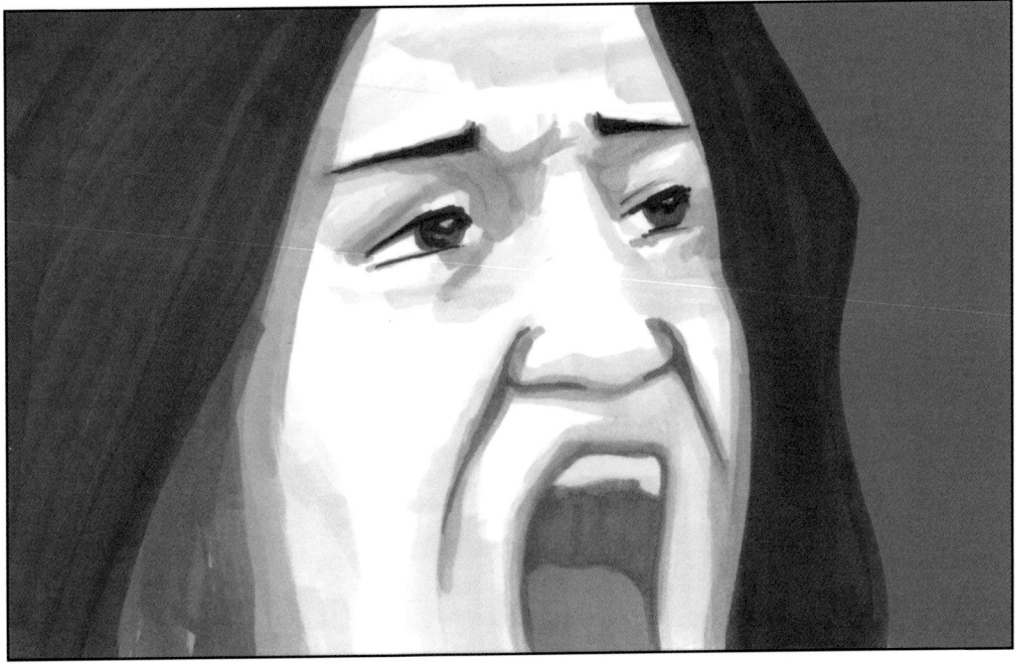

## Don't Turn Around!

In this sequence, even though the damsel darts down an impossibly long hallway, rounds corners, and bursts through swinging doors, the action maintains its general movement from *left to right*. The constant and repetitive movement of the talent entering left and exiting right has conditioned the audience to expect more of the same.

As the damsel pauses to catch her breath, the madman enters suddenly from the *right*, moving left. This sudden shift startles the viewer.

Notice how the constantly changing movement is essential to keeping the audience in a controlled state of agitation by intentionally and momentarily disrupting the established visual connection—yet none of the exploits violate the 180- or 30-degree rules. The simple-yet-effective transitions from shot to shot within the scene preserve the overall sequence that has engaged and retained the attention of the viewers, making them hang on for the next sequence or scene.

A Close-Up reveals Hyde's sinister grin; it also cues the audience to the ground below.

The artist has the camera cut back to its previous position as Hyde leaps over the railing.

Soh ends the sequence with a canted High Hat Shot as Hyde hits the ground and rolls.

## David Balan's Version

In his establishing shot, David Balan uses isolation within the composition to draw our eye to the two constables. It's also worth noting that he establishes his screen direction as right to left.

As the scream from off screen catches the constables' attention, the camera pans up with their reaction. Notice that they turn and reverse their screen direction. The camera then reinforces this new direction in the pan.

Balan also chooses to place the camera in the building behind Hyde as he bursts through the window. This maintains the new screen direction and introduces Hyde into the scene.

Employing a High Hat Shot, the artist shows Hyde's landing and emphasizes his superhuman abilities.

With another High Hat Shot, Hyde shoves a child and mother out of his way. These dynamic shots and the strong screen direction in this series of shots give a lot of visual speed to Hyde's mad dash.

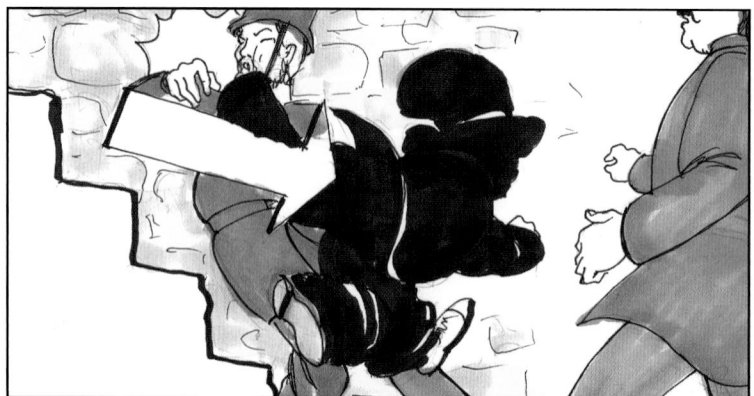

Balan stages the shot with Hyde at the rail a bit differently than Nicky Soh. Here Balan employs a straight-on shot with Hyde in the foreground. The artist makes liberal use of arrows to indicate motion in the screen as opposed to ghost images.

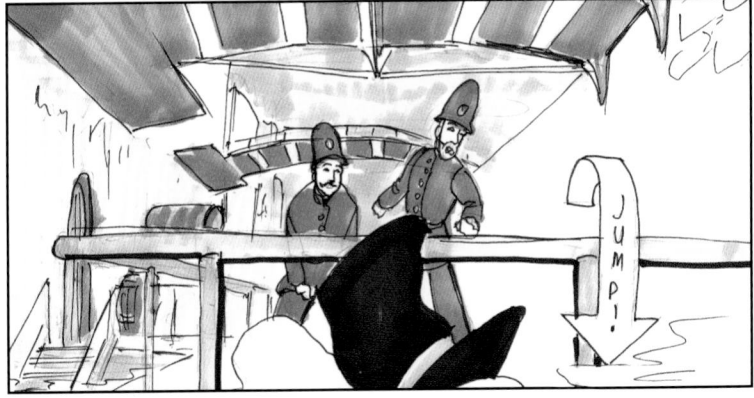

A high angle shot reveals the impossible distance from which Hyde has jumped.

Again, Balan moves the camera in a pan to follow the action of the two constables.

Closing with a Wide Shot and using numbered arrows to indicate the order of the various actions, the artist is able to let the action play out in front of a static camera.

# WHAT THE CAMERA SEES

6

# The Camera

Ken Chaplin, DGA/DGC (see pages 38–39), often describes storyboards as road maps for the crew. But what if storyboards were more like mile markers and street signs? After all, both tell you where to turn, how fast to go, when to yield, when to stop, and whether to expect a detour. Both convey the "rules of the road" using a kind of visual shorthand that makes it easy to navigate.

Storyboarding is all about the camera's position relative to the framing of the action. Does the scene call for the camera to be perched on a crane high above the crowd? Or is it to be nestled between two sandbags on the ground? Is the camera positioned several blocks away from the action? Or is it barely inches from the actor's nose?

> KEY COMPONENTS FOR DETERMINING THE APPROPRIATE SHOT
> 1. Framing height or shot length
> 2. Camera angle
> 3. Movement

## A Short List of Framing Heights

**American:** Also **Cowboy Shot;** sometimes **Hollywood Shot.** This is a Medium Full Shot of a group of characters arranged so that all are visible to the camera. Because it's generally shot from the knee up, it is sometimes called a **Knee Shot.**

**Close:** This is a direction for the camera to close in on an object or action for emphasis.

**CU:** A **Close-Up** (CU) **Shot** is a direction for the camera to capture an actor's expression, generally framing the head, neck, and maybe shoulders.

**EST:** An **establishing** (EST) **shot,** also called an **Extreme Wide Shot** (EWS) or **Extreme Long Shot** (ELS), "establishes" the setting.

**ECU:** An **Extreme Close-Up** (ECU) **Shot** is a more intense version of a CU, most often showing only the eyes, for example.

**Full:** A **Full Shot,** or **Long Shot** (LS) is a direction for the camera to be placed some distance away from the action in order to capture the full height of the actor.

**MED:** The **Medium Shot** is the most common shot used in western films, and it depicts half of the subject.

**MED CU:** The **Medium Close-Up** (MED CU) **Shot,** as the name implies, is halfway between a Medium Shot and a Close-Up Shot. It generally captures the subject from the chest up.

**OTS:** The **Over-the-Shoulder** (OTS) **Shot** calls for shooting over someone's shoulder from behind.

**WS:** The **Wide Shot** (WS) captures as much of the setting as possible and is often used as an establishing shot.

# Deep and Wide

Terms used in film and television can be quite literal. To a cinematographer, the terms *wide* and *long* imply the type of lens used for any given shot; *Extreme Long Shot* implies the use of a telephoto or zoom lens.

For the illustrator, Wide Shots (WSs), Long Shots (LSs), and Extreme Long Shots (ELSs) are used to introduce a setting and are therefore considered "establishing shots." Because of this, there is understandable confusion as to whether a difference truly exists between the different framing heights.

The storyboards to the left are broad generalizations intended to clarify the difference between the three framing heights typically used for establishing shots.

**TOP:** *Long Shot (LS):* Wider than a Full Shot, the subjects depicted take up maybe a third of the frame. By and large, Long Shots are used as transitional devices to set up a scene within an already-established location. In this example, the viewer has already been introduced to the western town.

**MIDDLE:** *Wide Shot (WS):* Wide Shots may be used to establish a setting, or they may be used as transitional devices, which creates an opportunity to move the action to a different setting.

**BOTTOM:** *Extreme Long Shot (ELS):* This is the framing height most folks think of when asked to identify an establishing shot. In an ELS, we see as much of the town as possible. Because the figures seem to blend in with the environment (therefore negating the need for principle and lead actors to be on set), Extreme Long Shots are typically picked up by the second unit director and his or her team.

## Terms

*Camera angle:* Also *camera height.* This is the position of the camera relative to the ground plane and/or eye level, which determines framing. There are six basic camera angles: *bird's-eye view,* or Extreme Down Shot (*XDS*); high angle, or *crane;* eye level, which is assumed; low angle, or *high hat; worm's-eye view,* or Extreme Up Shot (*XUS*); and *Dutch,* or *canted.*

*Framing height:* Also *shot length.* This is the amount of space occupied in the picture frame by the subject, often related to the proximity of the camera relative to the action. While there are numerous camera angles, there are really only seven framing heights: *wide,* or Extreme Long Shot (ELS); *full,* or Long Shot (LS); *American,* or *cowboy; medium* (MED); *medium-close* (MED-Close); *close; extreme close-up* (ECU). These directions help the cinematographer determine the appropriate lens (for example, anamorphic, zoom, or telephoto) for the shot.

# Shooting on Location

When filming, each location presents particular challenges, so it is important to take a moment to understand the environment. Take note of any possible hindrances to shooting, such as trees, power lines, signage, buildings, or technologies that are clearly not appropriate for the setting. While the location scout has already discussed these impediments with the director and production designer, the storyboard artist, too, may need to note these in some way—or at least be aware of their existence.

*A Plan View of City Hall on Bay Street in Savannah, Georgia:* Note the placement of trees and buildings, as well as the width of the street. These are all factors used to determine and set shots.

In this example, the story takes place during the Great Savannah Races in 1911, where rugged men of derring-do pushed their roadsters to the limit in a Grand Prix auto race that took them out along Savannah's rural roads.

The scene (from the spec script on page 20) takes place in front of Savannah's city hall, where a crowd gathers to greet the racers.

The visual breakdown follows:

```
EXT. CITY HALL—DAY
The crowd gathers along
BAY STREET as drivers and
engineers tune up their racers.
DAHLIA has just stepped out
of her Buick and is talking
with JACK. He is distracted
and eager to get back to his
roadster.
```

As a storyboard artist, here is the moment when you need to start taking notes and asking questions:

- What elements are needed for this scene?
- What is the most logical way to depict each of these elements?
- Which framing height and angles are most appropriate for setting the mood of the shot or scene?

Just as in creating a script breakdown, make a list of the things you will need to illustrate. At a minimum, this scene calls for the following:

- A specific location (Savannah's city hall)
- Extras (a large crowd gathering on the street)
- Background performers (mechanics, drivers, passersby)
- Props (various race cars)
- Two specific vehicles (the 1911 Buick Touring, Jack's roadster)
- Two principal characters (Jack and Dahlia)

By making this simple list, you can already imagine a variety of simple-but-effective shots. You may choose to use some of these shots:

- Bird's-Eye View Shot to show the crowd gathering
- Wide Shot to introduce Jack and Dahlia and the racers
- Full or American Shot to bring us closer to Jack and Dahlia
- MED Two-Shot—perhaps with an OTS—to indicate a sense of intimacy
- Close-Up (CU) to allow for a reaction

## A Short List of Camera Angles

**Aerial:** Also **Helicopter Shot.** This shot is made from a great height, perhaps from a helicopter. The differences between this shot and **Bird's-Eye View Shot** are that the Aerial Shot angle need not be looking straight down, and it allows for a range of movement.

**Bird's-Eye View:** Also **Extreme Down Shot (XDS).** As the name implies, this is an unnatural and extreme shot looking down from a considerable height.

**Canted:** Also **Dutch** or **Oblique.** This is a shot with a tilted horizon, generally used to indicate instability, unease, or a moment of transition.

**Crane:** This is similar to an Aerial Shot, but it is less extreme and closer to the action. It affords a greater range of movement.

**Eye level:** This is the most natural looking shot. Because it is so common and so obvious, its use is almost always assumed.

**High Hat:** A low camera angle shot a few inches above and parallel with the ground.

**Worm's-Eye View:** Also **Extreme Up Shot (XUS).** This is an unnatural and extreme shot looking up, generally from ground level.

# Framing Heights and Angles

Let's take a look at some of the framing heights and angles covered previously, starting with the Bird's-Eye View Shot and ending with a Close-Up Shot. To enhance understanding of camera placement, diagrams have been included with most panels.

*Bird's-Eye View or Extreme Down Shot (XDS):* Notice that this image was rendered digitally, using a vector-based program, which allowed for the rapid creation of a gathering crowd. It also allowed for accurate placement of buildings and trees, which gives a realistic understanding of street width.

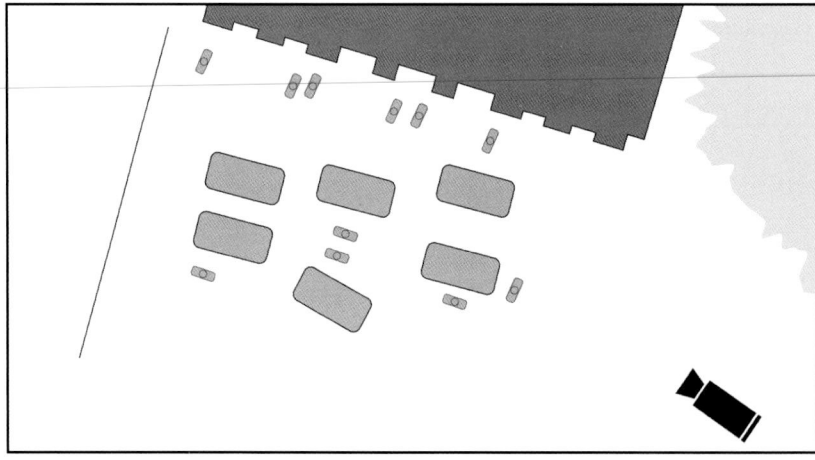

*Wide Shot, Crane:* This shot calls for a number of elements: city hall, cars, background performers, and two principle characters. It's a tough shot to get, so the decision was made to use a high angle.

NTS

*Full Shot, eye level:* Here, we finally see Jack and Dahlia. Notice in the diagram how at least one of the cars and two of the background performers have been "removed" from the set. In filmmaking, it is important to know what is not seen.

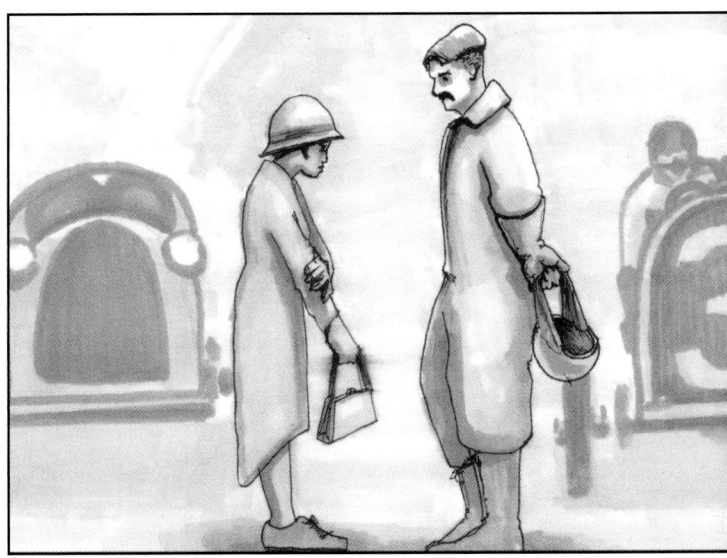

*American Shot, eye level:* There is a little more intimacy here. This shot gives enough room for the actors to move, but it still gives the DP an opportunity to capture subtleties of action and reaction.

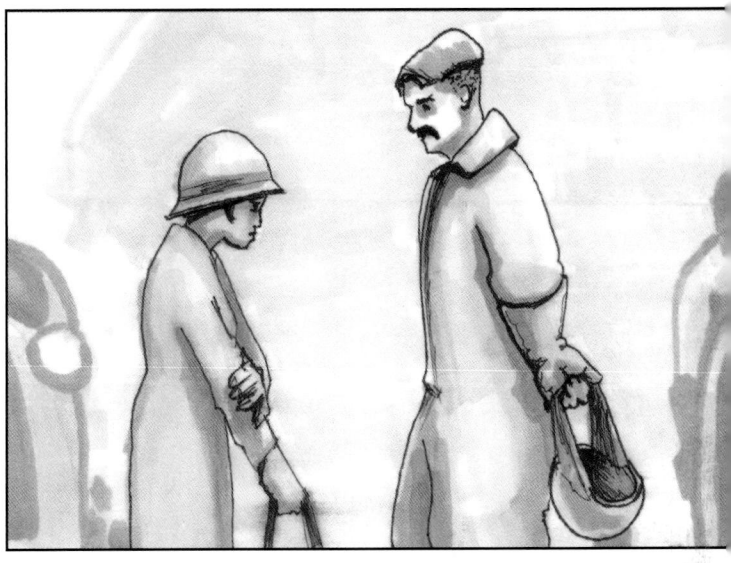

*MED Close:* One of the beautiful things about storyboarding is that it enables people to analyze a shot before it's shot. This Two-Shot loses something in translation, so we change the position and . . .

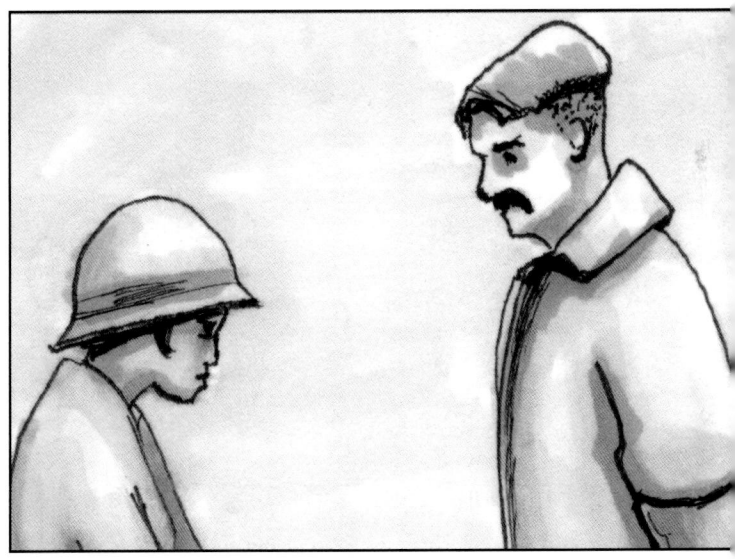

*MED Two, OTS:* . . . this over-the-shoulder shot gives us a better sense of intimacy and allows the camera to capture the reaction of the actor. Note in the diagram how another car had to be moved out of the shot in order to allow for placement of the camera.

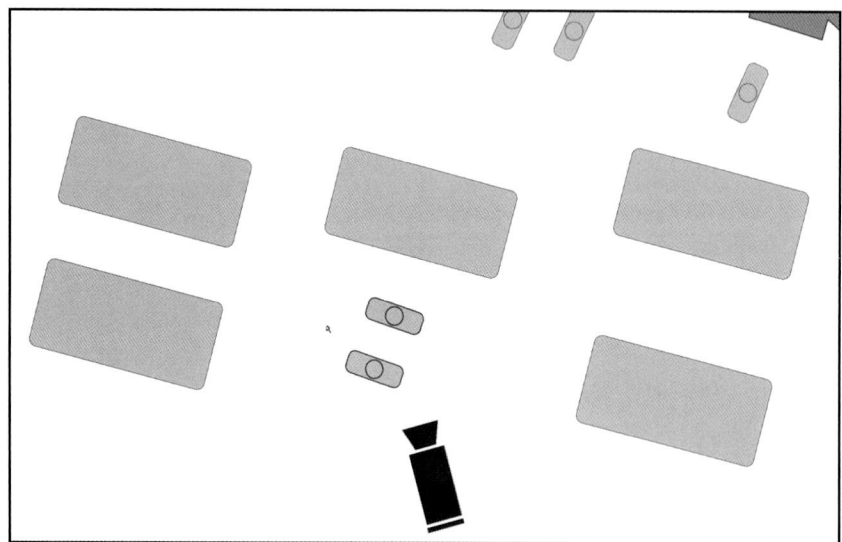

*Close:* This Close-Up Shot can be picked up by the same camera that covered the OTS Shot.

## Other Shots to Consider

Of course, other shots may be considered. These should be used sparingly:

- An Extreme Close-Up (ECU) Shot, perhaps used to indicate an interior monologue, or subtle reaction

- A low angle, Worm's-Eye View Shot to emphasize a dramatic or pivotal moment
- A High Hat Shot, to dramatize the action

*Extreme Close-Up (ECU):* Out of context, a viewer has no idea whether Jack is lost in deep thought, reacting to something said by Dahlia, or distracted by an action off screen. Whatever it is, it must be important.

*Worm's-Eye View (XUS), Canted:* The canted, oblique, or Dutch angle usually indicates a sense of imbalance, but in this case, it could very well suggest a transitional moment for the main character because crossing the finish line is always a dramatic moment, win or lose.

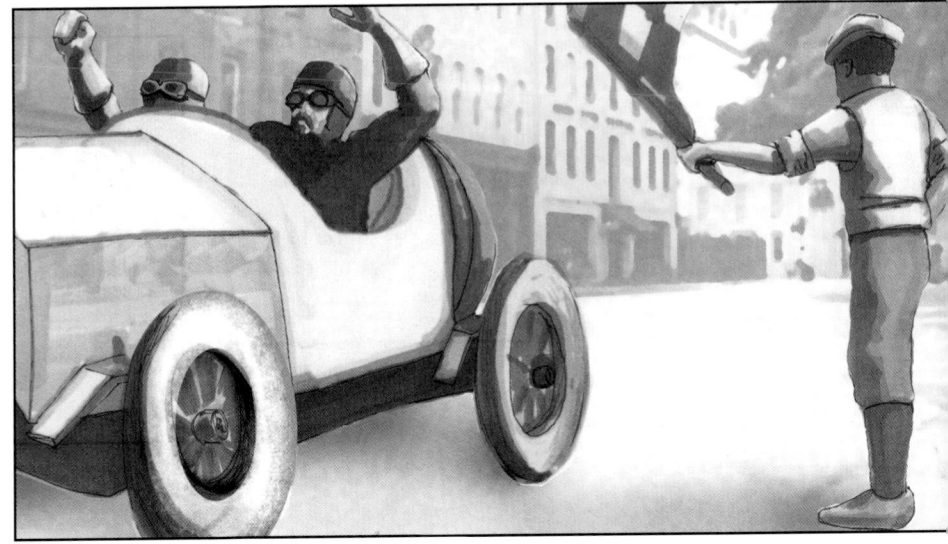

*High Hat:* Placing a camera in a low position gives the subject a grand and heroic (or sometimes, intimidating) presence. Here, the hero crosses the finish line, blowing past the camera that had been placed low to the ground in order to get images that would emphasize the power and speed of his roadster.

With no regard for his own safety, he leaps out to retrieve his derby in this Wide Shot.

We cut away for another Wide Shot of a tired construction worker getting ready to sit down on a lift to enjoy his lunch break.

We go close on a hand grasping the rope on a pulley . . .

. . . and we cut wide with an Extreme Up Shot to reveal that our Rascal has saved himself by grabbing hold of the pulley. Again note how an arrow indicates that his derby floats past the camera and off screen.

The camera goes wide but at eye level this time as our Rascal zips down the rope.

Then we cut back to our previous Wide Extreme Up Shot. Once again the arrows are used to indicate movement within the frame.

In a Full Shot we cut back to the tired construction worker. Just as he's getting ready to sit, the lift takes off and he crashes to the ground.

In this low angle shot, the arrows have been numbered to indicate the order of the events. First we see the construction worker rise up very confused. Then we see our Rascal reach the ground. We now understand that he's responsible for the lift going up.

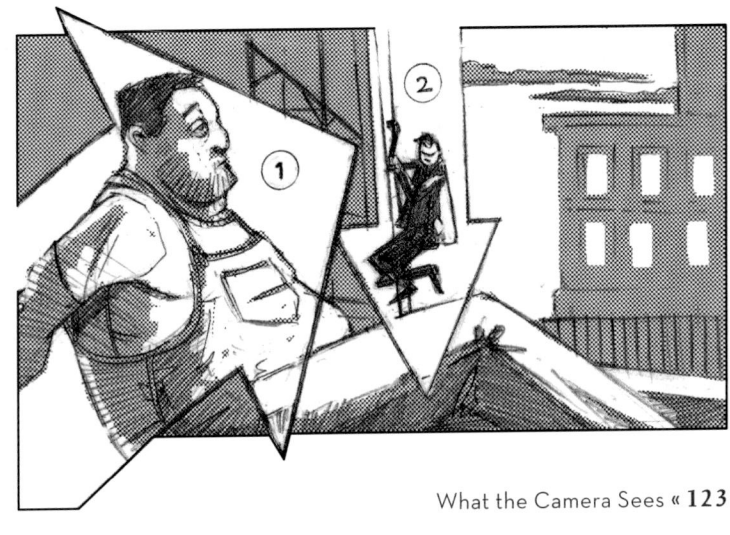

A Medium Shot reveals our Rascal looking rather sheepish.

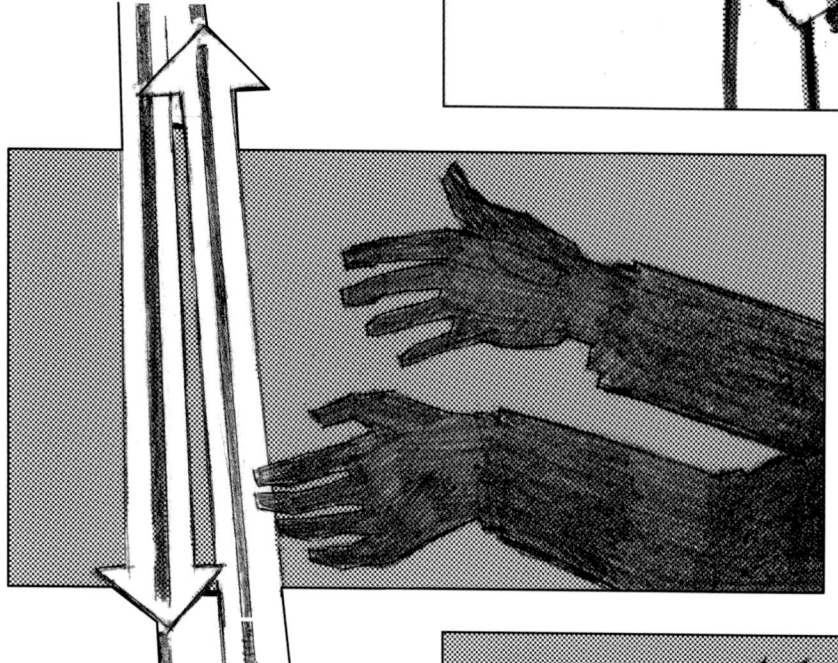

ands as he lets the rope go. Once again the arrows are used to indicate motion in the frame.

The construction worker looks on confused in this Medium Close-Up.

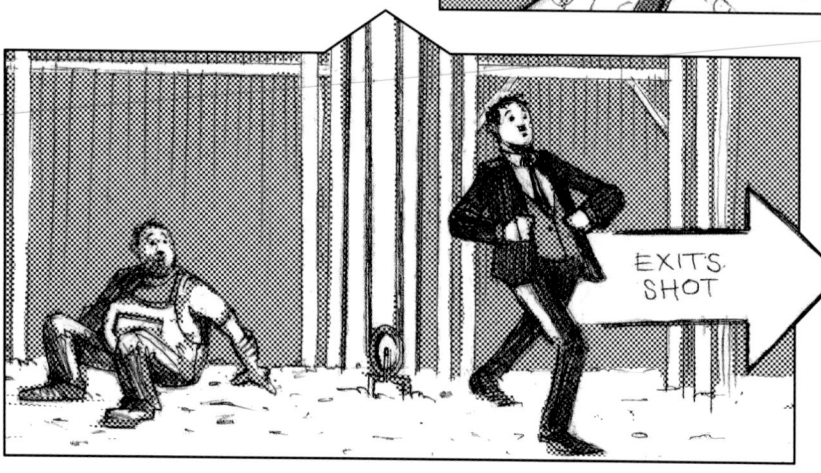

EXITS SHOT

We cut out wide to see our Rascal whistling as he walks out and exits frame. Meanwhile in the background the arrow still shows that the pulley ropes are still moving . . .

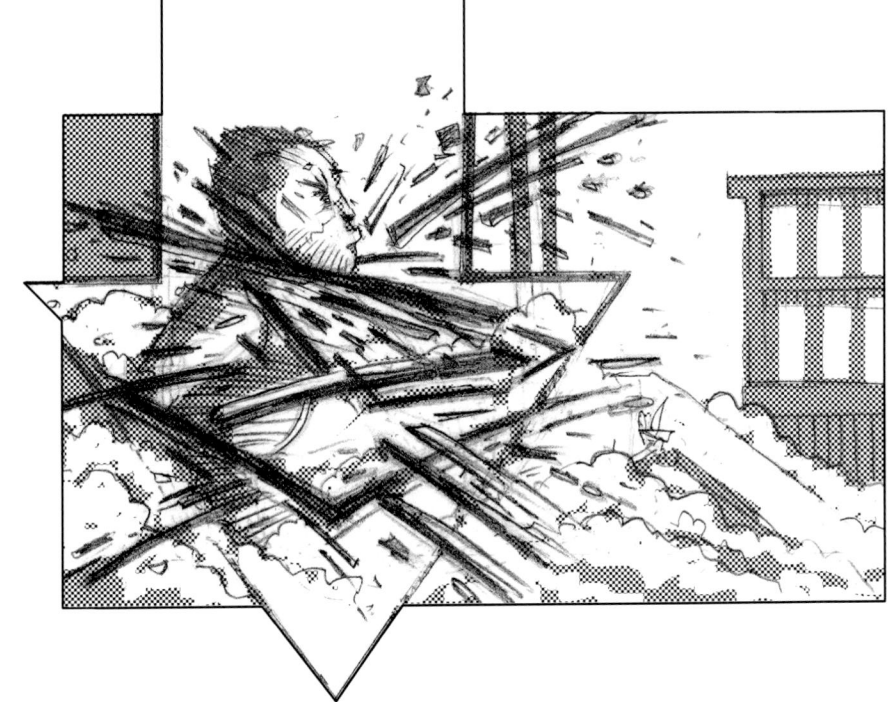

. . . and as we cut back to our previous low angle shot, we see that the lift comes crashing back down upon the head of the confused construction worker.

With a final Close-Up we enjoy a comical moment of dazed confusion . . .

. . . before we cut to a Full Shot to see him fall over backward, knocked out. An arrow emphasizes his motion.

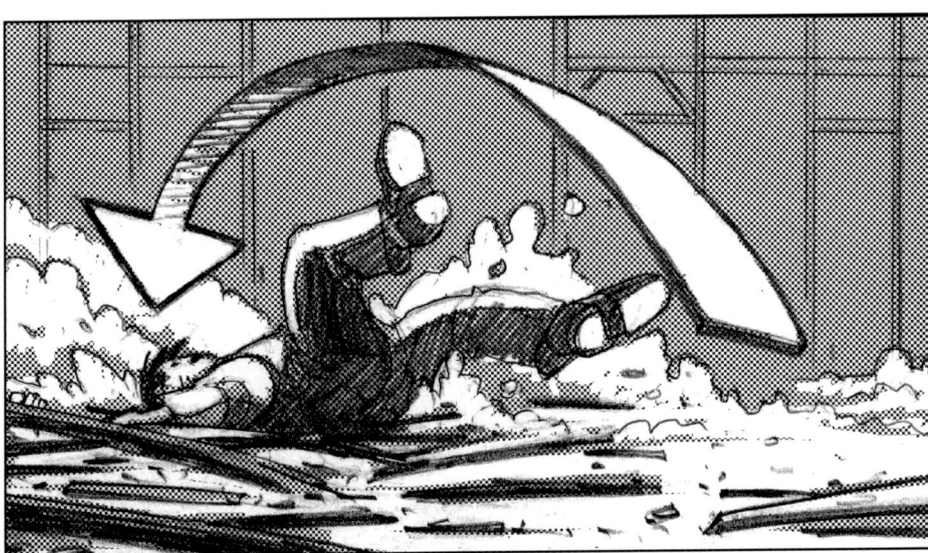

# Behind the Scenes

Sometimes, it's hard to wrap your head around the concept of what the camera sees—especially from the perspective of the storyboard artist. Fortunately, thanks to photographer Grant Fitch, we are able to take you behind the scenes of the psychological thriller and ghost story *The Firstling*—with the blessings of the producers, of course!

*The Firstling* is a contemporary ghost story about a pregnant woman who fears she will lose her baby unless she does the unthinkable to avenge a wrathful entity.

In a pivotal scene, Bianca (played by Rebecca Da Costa) is going into labor—and something is terrifyingly wrong. She drifts in and out of consciousness as Dr. Ghozland (Andie MacDowell)

and her medical team (Dr. Peter M. Britt and David Harland Rousseau) wheel her down the corridor and into the operating room. On screen, this scene might last a whopping 2 minutes, yet it involved no fewer than four cameras and took hours to shoot.

Let's take a moment to compare camera placement with camera views.

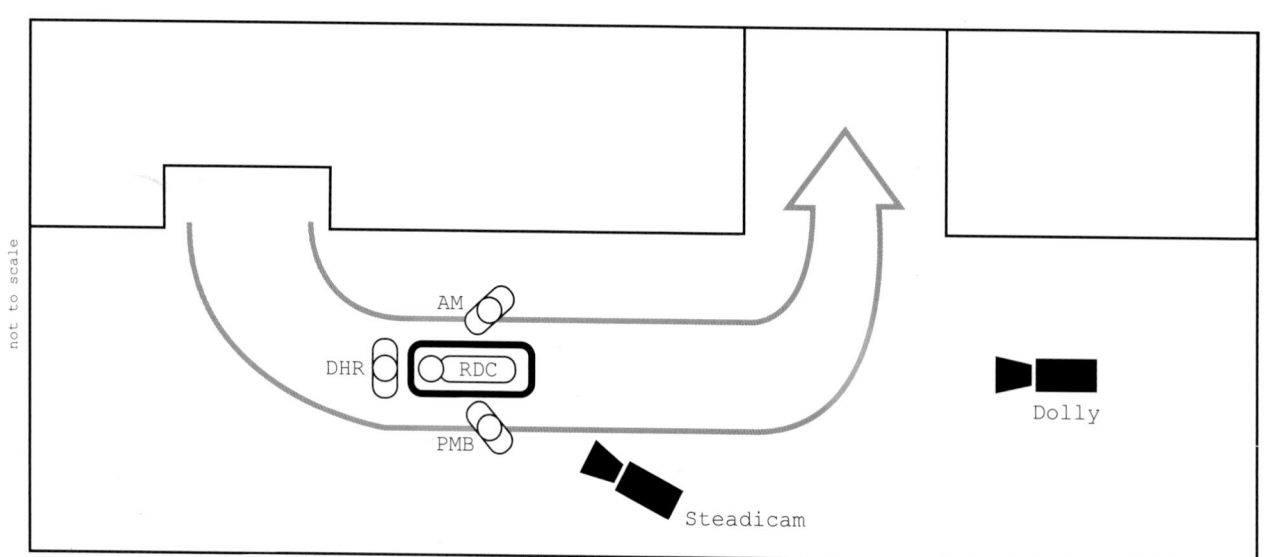

not to scale

AM  
DHR  RDC  
PMB  
Steadicam  
Dolly

AM = Andie MacDowell    RDC = Rebecca Da Costa    PMB = Dr. Peter M. Britt    DHR = David Harland Rousseau

**ABOVE:** This diagram shows the placement of two of the cameras and the path taken by the cast and crew.

**RIGHT:** Here, the cast and crew race down the hallway in one of many takes.

**LEFT:** In this Medium (MED) Shot, Dr. Ghozland and her medical team rush Bianca into the operating room.

**BOTTOM LEFT:** To enhance the action, the shot was captured using a Steadicam. Here, David Knight, the camera operator, makes final adjustments to his Steadicam mount as he heads to the set.

**TOP RIGHT:** This Close-Up (CU) on Bianca's face captures her panicked expression...

**BOTTOM RIGHT:** ... and it was recorded with a camera secured to a gurney. Here, the camera crew adjusts focus for the intense shot.

# Exercise

## ✓ Identifying Framing Heights and Camera Angles

To help you better understand framing heights and camera angles, we asked sequential artist Jon Feria to give us his take on a handful of shots. Take a moment to look at the panels. See if you can properly identify framing heights, such as medium close-up, and camera angles, such as high hat, that were discussed in this chapter.

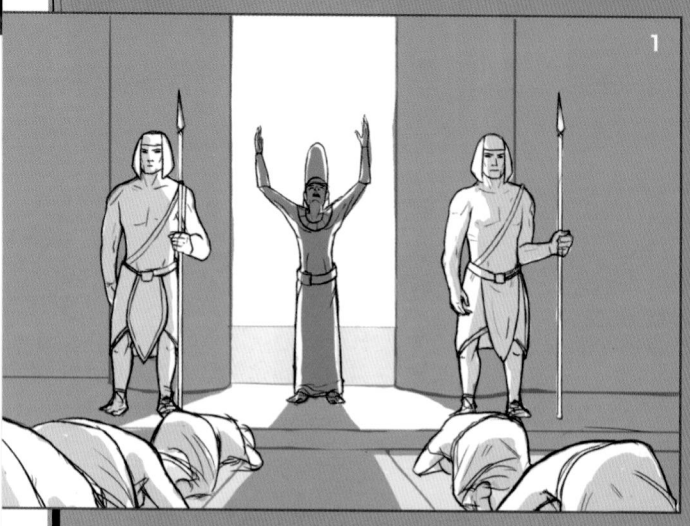

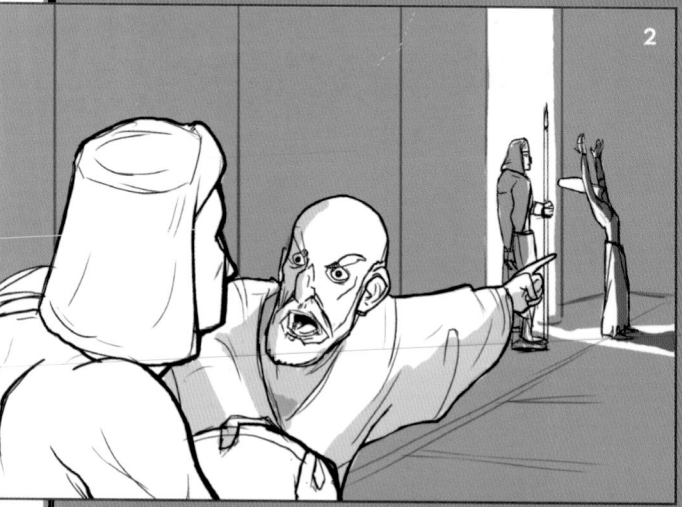

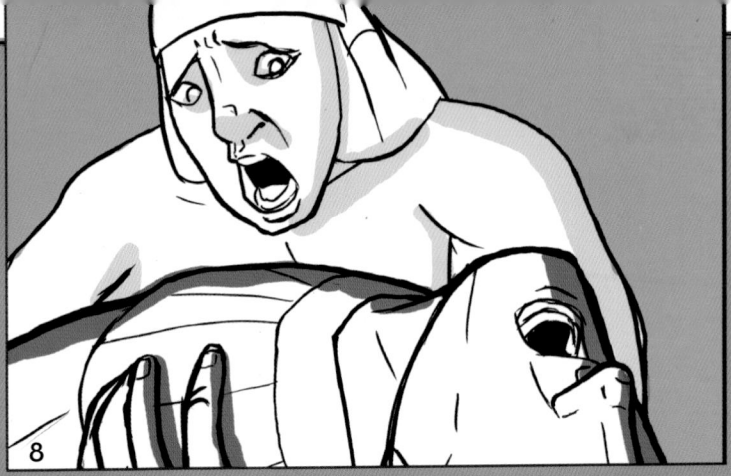

# No Reaction Without "Action!"

Few audiences can stomach sitting for two hours watching people talk over coffee. At some point, one of them had better drop a spoon or get up to refill the sugar bowl. That simple movement is considered action, but it's not worth storyboarding—unless something grand is about to happen, such as a wrecking ball crashing through the wall of the kitchen. That might merit a storyboard or two.

Still, some movies are so full of smash cuts and constant movement that, by the end, the audience feels as though it has just stepped off a roller coaster. That's not always a good feeling. The balance lies in the middle. Every movement should have meaning or purpose to advance the plot and enhance storytelling. It ultimately falls on the director to determine whether the camera remains stationary or literally follows the action. Much of this depends on how much ground is covered by the action taking place in the scene. After all, the audience would get just as weary of cut after cut when a tracking shot would suffice.

In the previous chapter, you saw the characters of Jack and Dahlia as they were standing in front of city hall, waiting for the race to begin. Every shot depicted was a simple cut; basic editing worked just fine with the straightforward storyline for this particular scene.

Now, imagine that Dahlia is about to deliver the news that she is with child. This life-changing news could not come at a worse time for either of our protagonists. She is conflicted and sick with worry. He needs to be focused on winning his last race. To emphasize the conflict, the director decides to capture Jack's reaction with a Close-Up, but uses the slow forward movement of a *push* or *zoom* to emphasize the gravitas.

## Terms

**Crane:** This is similar to tilt, but it affords greater range of movement.

**Cut:** An immediate transition from shot to shot, in animation a cut is denoted with a point-down triangle, or the word **cut** in between the storyboards.

**Dolly:** Also **track** or **truck.** Generally, this is a camera on wheels, of sorts. Sometimes, a Steadicam may be used to achieve similar shots, such as **camera in, pull back to reveal, truck with,** or **push in.**

**Pan:** This is a steady horizontal movement across a scene.

**Steadicam:** A piece of equipment made by the Tiffin company, the Steadicam is used for steadying a handheld camera, which is attached to a shock-absorbing arm supported by a harness worn by the camera operator.

**Tilt:** This is a steady vertical movement across a scene.

**Tracking Shot:** Also **Follow Shot.** This camera movement call is an indication for the camera to follow the action. It is so named because tracks are laid on uneven terrain to make the shot possible.

**Zolly:** This is a zoom combined with a dolly shot. Hitchcock successfully used these to create a compressed shot that enhanced the viewer's sense of unease.

**Zoom:** This is a stationary camera that uses a zoom lens to enlarge or diminish the image within the frame.

# Movements

Directors rely on six basic movements, three kinetic, three static: push/pull versus zoom out/zoom in; tilt versus crane; pan versus track/truck/dolly. With the photographic stills and diagrams of *Factor's Walk* in Savannah, Georgia (as seen on pages 136–141), you can see how the various movements work.

## I Want My Dolly!

Movie terminology is easy to comprehend once you understand its simplicity. For example, *dolly*, *truck*, and *track* are very literal in their meanings, as are the actions *push in* or *pull back*. To achieve a follow shot—where the camera follows the actor (are you getting this yet?)—the crew had to push or pull the dolly on a track.

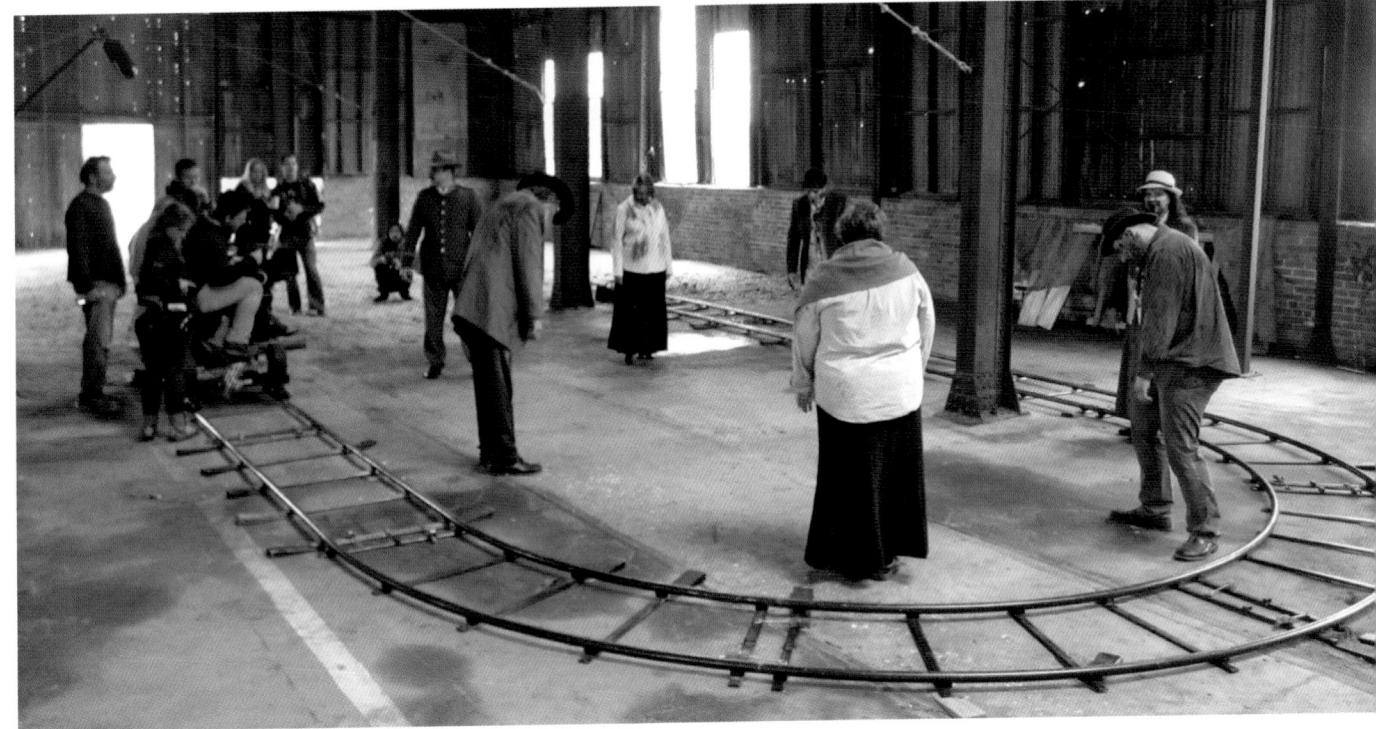

## Tip

Choosing the right camera movement largely depends on the action taking place, location or setting, and placement of the camera itself.

*Shooting on location for Abraham Lincoln vs. Zombies:* Here, cast and crew rehearse for a complex dolly shot. Note the track, laid specifically for this one shot, and the dolly on the track.

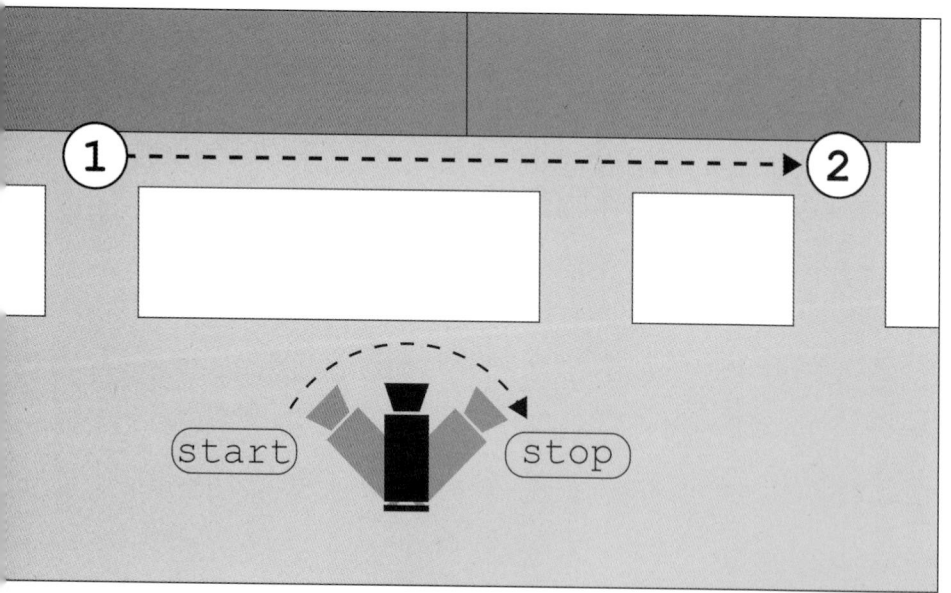

Arguably the simplest of the camera movements, a *pan* mimics the turning of the head, as if the viewer is standing still, watching the world go by. The camera is fixed, yet it rotates on a single pivot.

In the two images above, note the dramatic shift in perspective from start pan to pan stop. Contrast this movement with a lateral tracking shot.

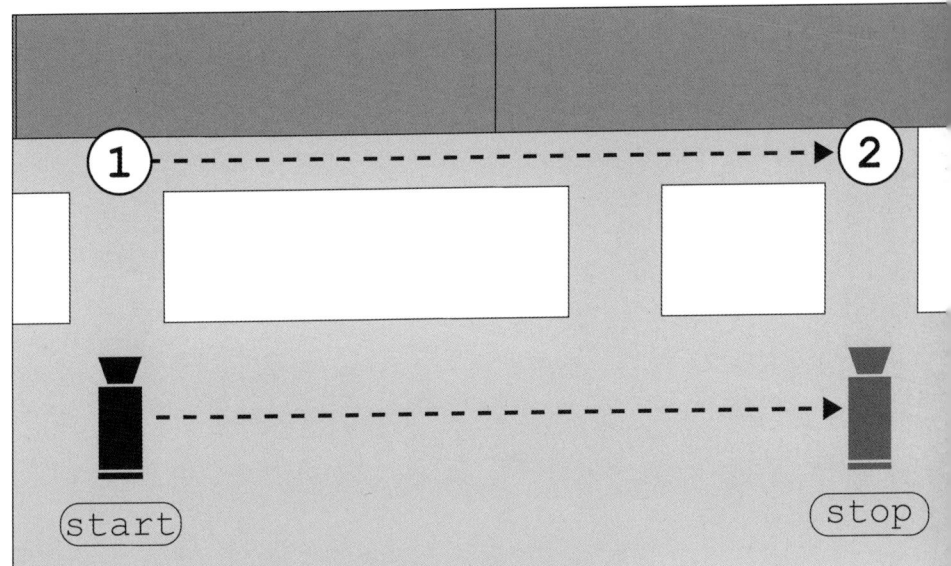

Notice in the diagram how the camera must move a considerable distance, as if the viewer is walking along with the action (albeit sideways). This shot is usually accomplished with a dolly or truck placed on tracks, hence the naming convention.

Here you can see the results of start track and track stop.

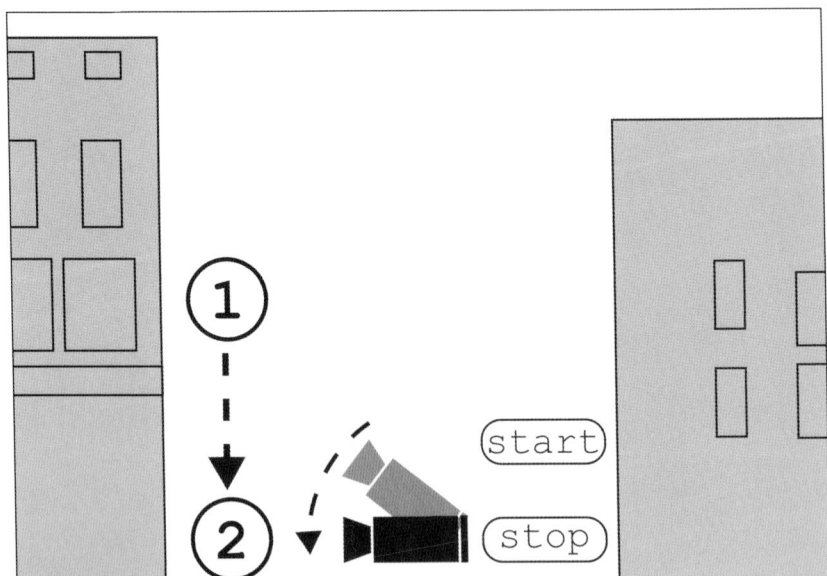

A tilt is the vertical cousin of the pan. Again, the camera is in a fixed position, but it is allowed to tilt up and down in order to mimic an easy nodding motion.

Note the extreme shift in perspective.

The kinetic cousin of the tilt is the crane shot. A camera mounted onto a crane follows the action, providing a smooth and constant shift in perspective, though the crane also allows for lateral movement.

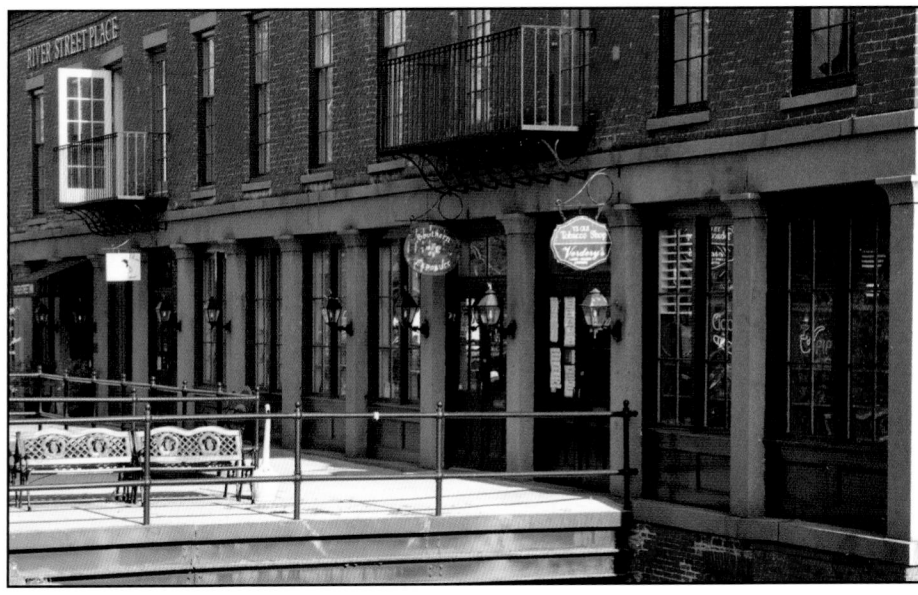

Note how the viewer is drawn closer to the action as the crane pushes closer to the footbridge.

# Photomatics and Digimatics

*Photomatics* are still photographs presented sequentially, often as photographic animatics with voice-over and sound effects. In this traditional sense, advertising agencies dominate the field—but the photomatic is also a powerful research tool.

When many people think of the preproduction process, their minds wander toward concept art and production design, often forgetting that location scouting is important to the filmmaking process. This is where photomatics and *digimatics* (digital photography) play a key role in determining camera placement and movement. The photomatic can take the place of the traditional storyboard and provide the director's team with unparalleled versatility.

There are many reasons for films to be shot on location, with budget being a key consideration—especially for period pieces. For example, Fort Pulaski National Monument, near Savannah, Georgia, has been featured in high-end historical dramas, such as *The Conspirator,* and in low-budget horror flicks, such as *Abraham Lincoln vs. Zombies.* Both movies were set in the 1860s, and the well-preserved fort provided backdrop and setting.

In the scenario depicted here, our wartime heroes return to the fort after suffering heavy casualties. The director wishes to show the column of weary soldiers marching through the demilune, then across the drawbridge and into the fort. The cinematographer suggests a pan, while the director prefers a tilt. To help with the decision before the day of the shot, an assistant director (AD) may assemble images captured by the location manager in the manner shown here.

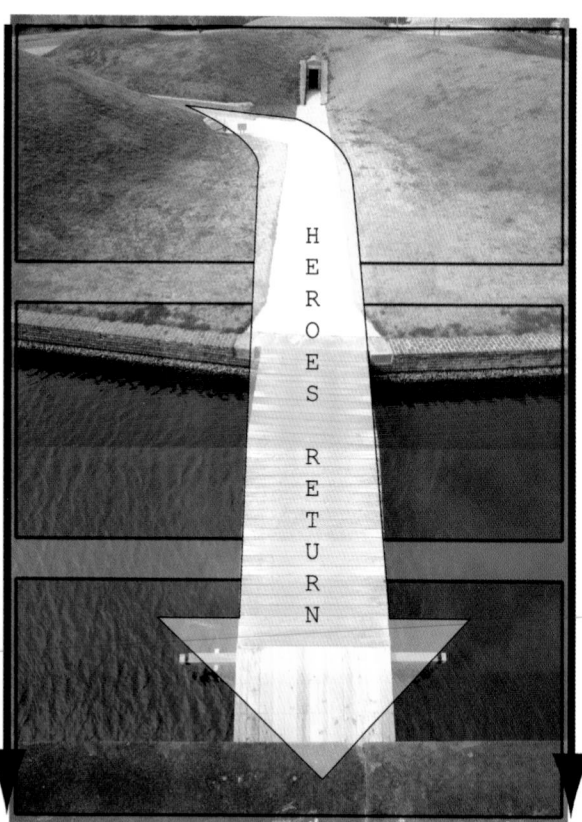

Here, the AD has taken a single image and diagrammed the frames in the desired aspect ratio (2.39:1). He includes arrows noting camera movement as well as a directional arrow noting the movement of the returning heroes.

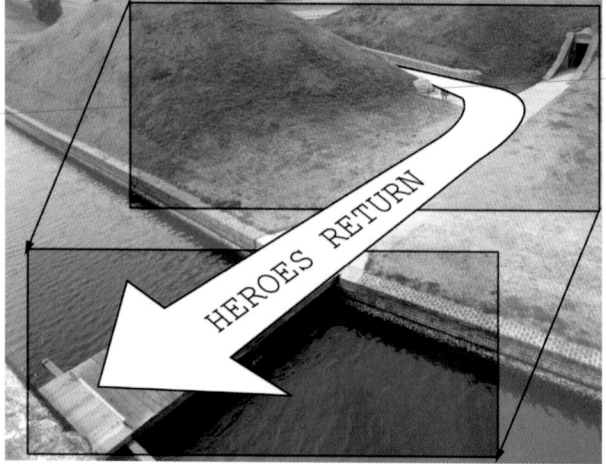

Here, the AD has composited two images to emulate the necessary shift in perspective that occurs during a dramatic tilt. Like the previous image, this one also includes camera movement arrows and a directional arrow.

## Camera Moves as Drawings

There are several things to consider when creating drawings as a means of directing the movement of the camera.

Aspect ratio tops the list because it influences framing height, which determines how much of the scene the audience sees, and camera angle, which determines where the audience is relative to the action. Once the aspects of framing and angle are considered and the movement of the action is determined, the illustrator should take a moment to identify the elements depicted in the shot in the same manner as creating storyboards for static shots—but the storyboard artist must consider how and when to use directional and notational arrows as described above. Let's revisit the six camera moves, this time represented as storyboards. Pay close attention to the aspects and elements used for each shot.

## Pan and Track

Both pan and track start and stop at the same locations along *Factor's Walk*—but the visual experience is quite different, as is the way each is drawn. Since both shots cover a lot of ground, additional fields are added to indicate framing starts and stops.

### Drawing versus Diagrams

Movement requires additional elements for clarity:

- Directional arrows indicating the movement or action taking place within a scene as framed by the camera lens
- Notational arrows indicating specific instructions for the camera operator
- If either a directional or notational arrow needs clarification, the storyboard artist can indicate the motion or action with a simple notation. Some illustrators add these instructions digitally to the scanned drawing.

**TOP:** Notice the fish-eye effect, illustrated to emphasize the shift in perspective in the pan shot. Note, too, how the directional arrow has been warped to simulate a curvilinear perspective. This emulates the panning effect.

**BOTTOM:** Like its static counterpart, this tracking shot, proportionally drawn in three fields, indicates action with a directional arrow drawn inside the fields and, to avoid confusion, a notational arrow drawn just below the illustration itself, which includes stop and start instructions as well as the shot call.

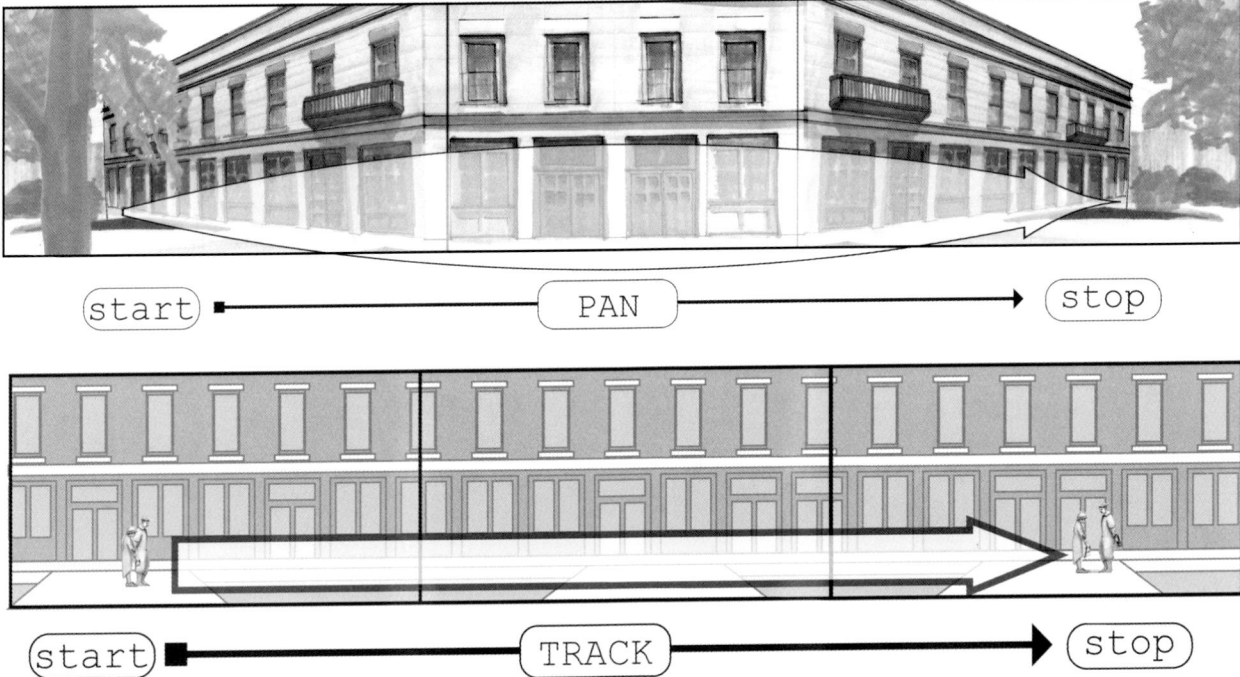

## Tilt and Crane

Tilt and crane are often drawn from a middle-of-the-road perspective. The notational arrows, which indicate camera movement, are handled differently. Note how the drawings do not exist solely in the frames. This provides the camera crew with more information on framing, angle, and movement.

**Crane:** This illustration shows that the camera is closing in on the subject as it rises in the air. Even though the dimensions of the field appear to diminish from start crane to crane stop, the ratio remains constant.

*Tilt:* Though the extremes of perspective are not depicted here, the camera movement is clearly defined by the notational arrow combined with the framing of the fields.

## Going the Distance

Sometimes, the distance is too much to cover in a single illustration. Perhaps the shift in perspective is too extreme, or it must be illustrated to convey the importance of the framing. When this occurs, it is perfectly acceptable to draw separate start and stop frames, provided that each is clearly labeled, as shown here.

**TILT START**

**TILT STOP**

## Push/Pull and Zoom

Push/pull and zoom are drawn similarly, with a smaller frame inset. Notice in both drawings how the directional arrows and the notational arrows exist within the same illustration. Start and stop notations are not necessary and might actually confuse the viewer, but the camera crew would benefit from a marginal notation indicating the kind of movement required (zoom versus push/pull).

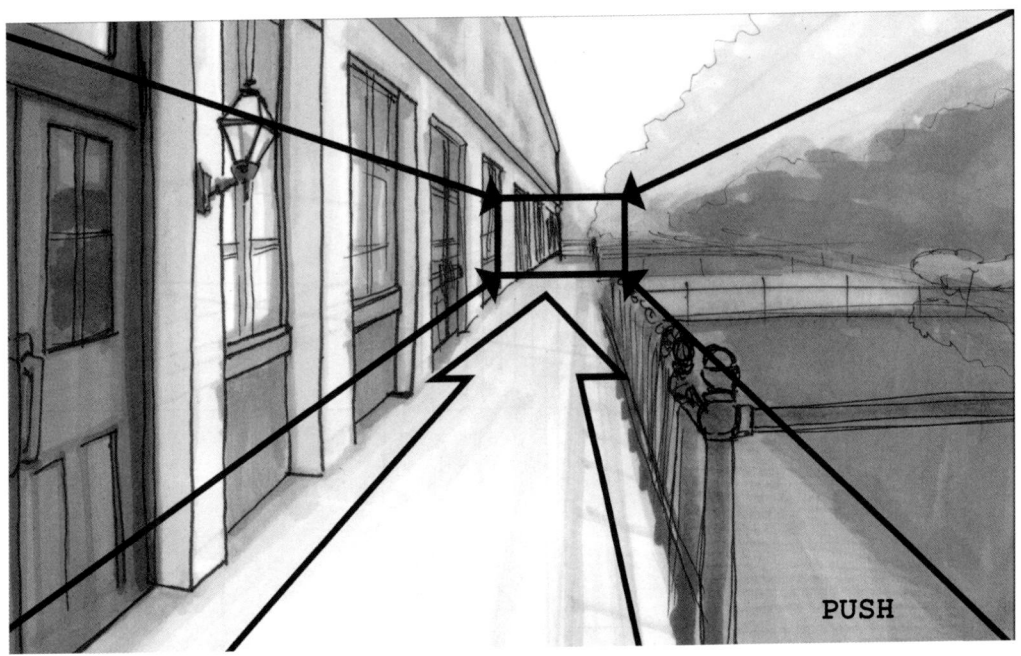

**PUSH**

*Push:* Here, the camera operator sees that he or she is to follow the action as it moves down the walkway. If the shooting script indicated a pull, the frame inset would remain, but both the directional and notational arrows would be reversed, as if pointing to the viewer.

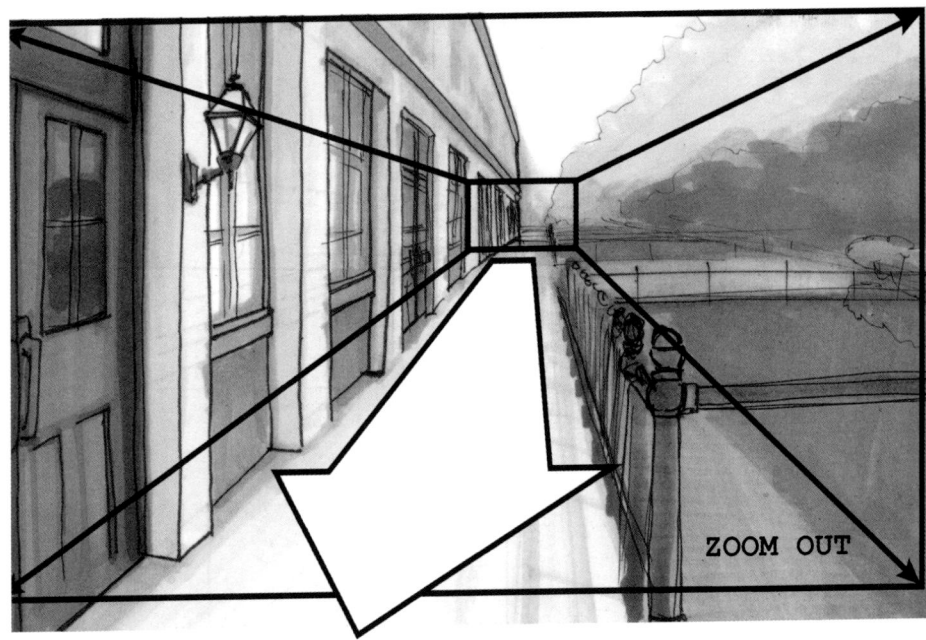

**ZOOM OUT**

*Zoom out:* Here, the camera operator knows to remain stationary as the action comes to him or her, but he or she is to follow the action shot using a zoom. If the shooting script indicated zoom in, the frame inset would remain, but both the directional and notational arrows would be reversed, as if pointing away from the viewer.

# Order Out of Chaos

As you review the panels of this action sequence, see if you can identify the key components (framing, angle, and movement) used to determine the appropriate shot, and pay particular attention to the use of directional and notational arrows.

In this Wide Shot, the Rascal strides down the street . . .

. . . and searches for his derby, as shown in this Close-Up.

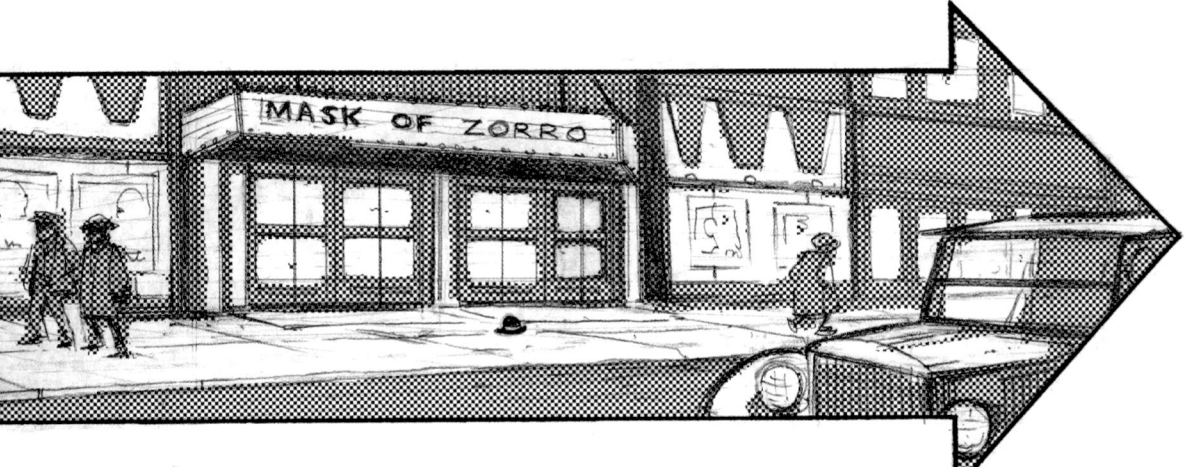

This pan also serves as a POV for the Rascal . . .

. . . and we see the object of his desire in this snap-zoom.

This Close-Up reveals the excitement felt by the Rascal.

The Rascal darts into oncoming traffic. Notice both the notational *and* directional arrows in this tracking shot.

This Close-Up of the panicked driver serves as a cutaway, which allows us to continue the action . . .

. . . of a head-on collision between two cars. Again, note the directional and notational arrows.

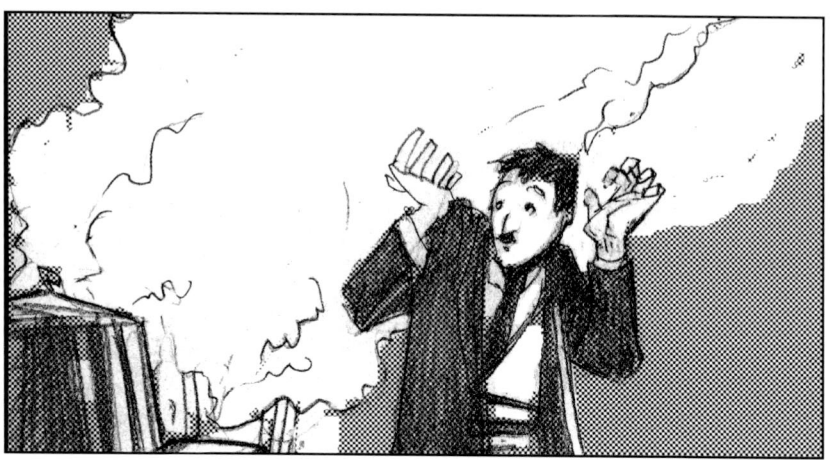

In this Medium Shot, our hapless hero has no idea that he is the cause of such mayhem.

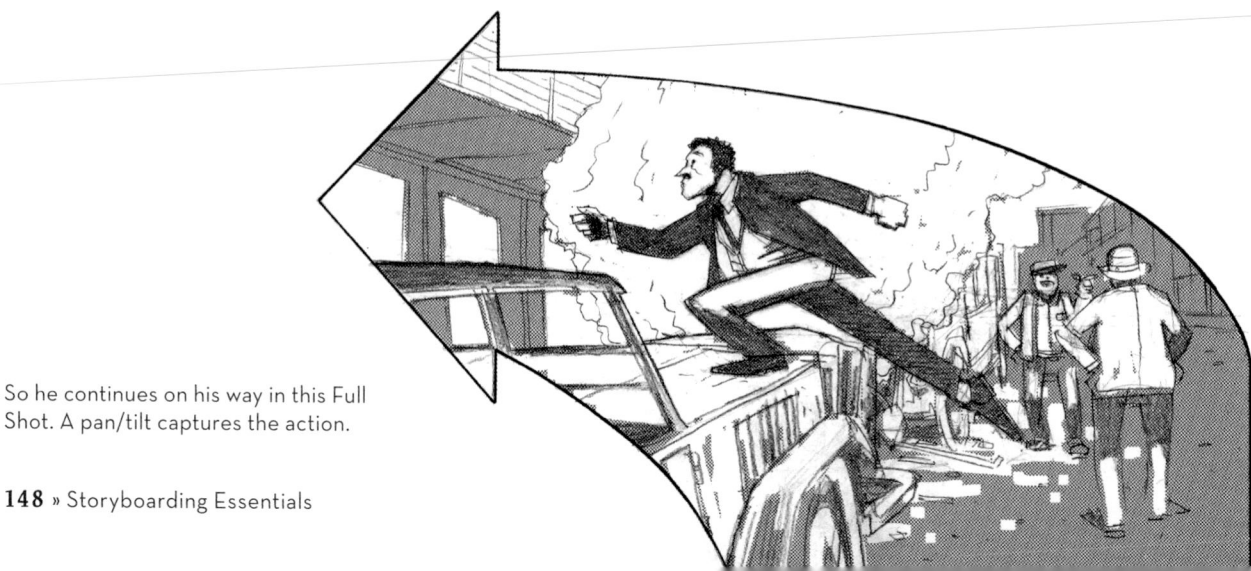

So he continues on his way in this Full Shot. A pan/tilt captures the action.

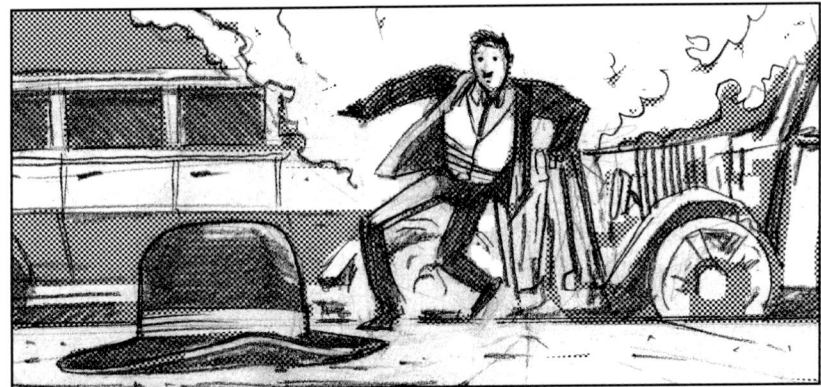

This High Hat Full Shot places the object of the Rascal's desire front and center.

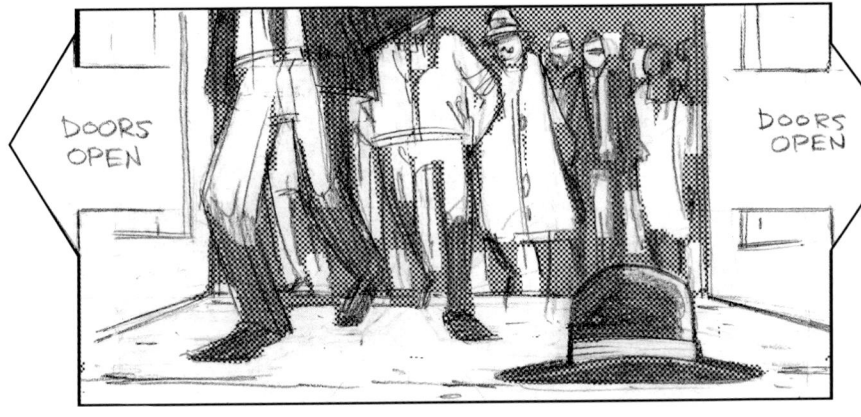

In this reverse angle, we see the doors to the theater open wide. Things aren't looking good for our hero.

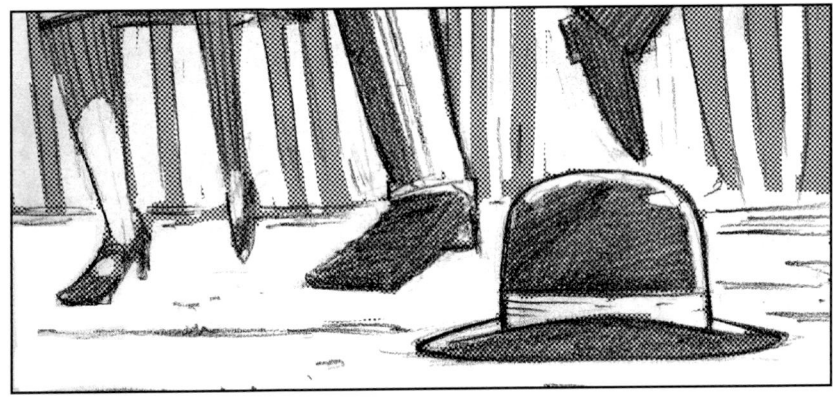

The hustle and bustle of moviegoers is captured in this High Hat.

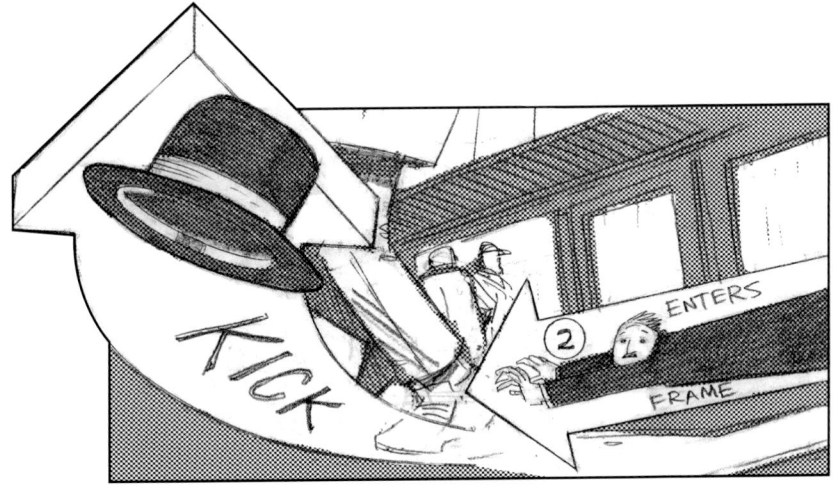

The action is picked up in this low angle. Note the arrows indicating the movement of the hat as it exits the frame as well as the movement of the Rascal as he enters the frame.

This low angle Medium Close Shot captures the confused expression of our rascal. Do his eyes deceive him?

In this zoom-in, we again see the hat, tempting him, teasing him.

Battered but not beaten, the Rascal crawls toward his favorite hat.

Could this be the hand of a Good Samaritan in this High Hat?

The chunky child dusts off the derby.

...for the Close-Up on the bubble-blowing boy...

This slow tilt sets us up...

EXITS SHOT

...who seems quite proud of his latest acquisition as he struts off in this Wide Shot.

Our Rascal just can't take it anymore, as shown in this Medium Close Shot.

# Exercise

## ✓ Movement Calls

Photocopy the pages for this exercise. Look at these storyboards created by up-and-coming illustrator Ryan James. Identify which movement is best suited for each panel. Then, using a marker, diagram the following static and kinetic movements: pan, tilt, zoom in (or out), track, crane, and push (or pull).

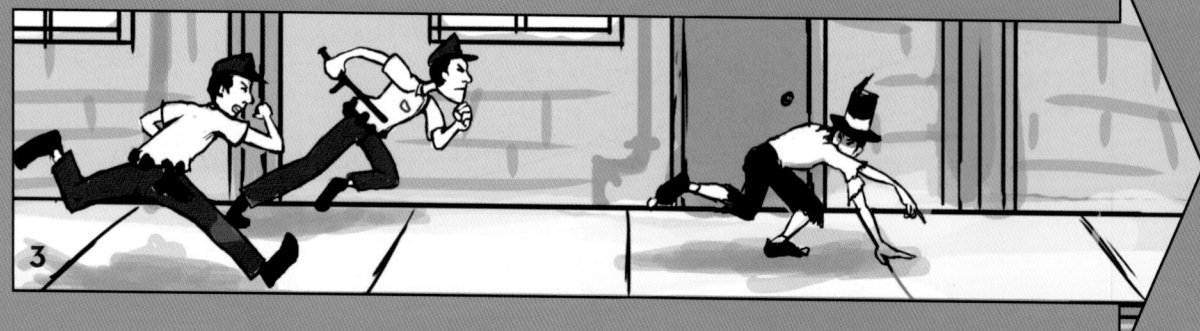

5

6

7

# A Difference of Opinion
## Hyde from Jekyll—Transmogrification

In this installment of "A Difference of Opinion," up-and-coming sequential artists Daphne Hutchenson and Graham Overby give their take on an excerpt from *Hyde from Jekyll.*

### Daphne Hutchenson's Version

Daphne Hutchenson frames the establishing shot as a Full Shot, introducing the space of the room and the two characters.

Hutchenson then chooses to frame Dr. Jekyll only in a Medium Close-Up.

The choice to have the camera tilt down with the falling beaker helps to reinforce the drama of the moment.

Tilt Down

The artist then pulls the camera back for an Over-the-Shoulder Shot; note that she has maintained her screen direction.

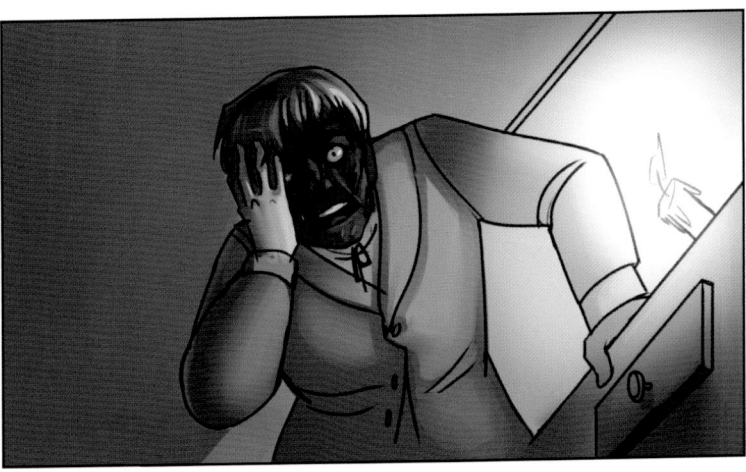

The artist also chooses to focus only on Dr. Jekyll as his transformation begins in this Extreme Up Shot.

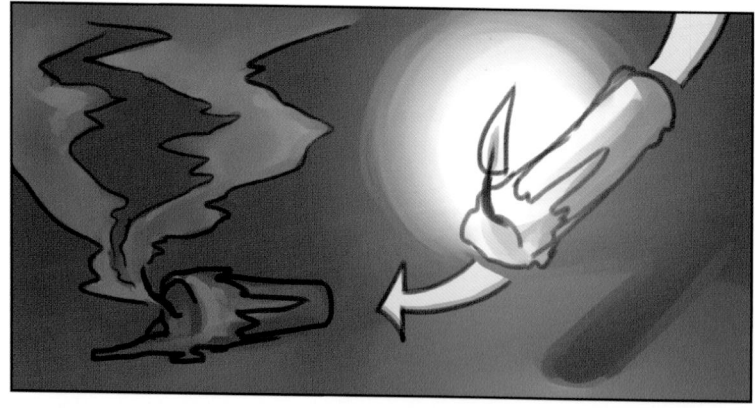

Hutchenson then employs a Close Shot on the candle falling and being extinguished . . .

. . . and reveals the terror on the face of Dr. Jekyll's companion with a Medium Close-Up.

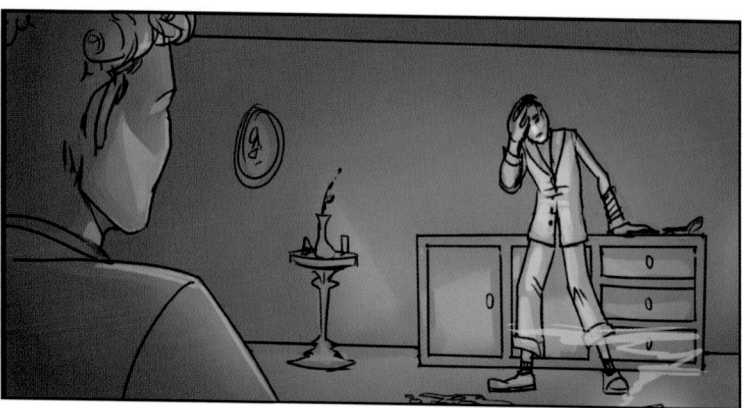

The artist sets up another Over-the-Shoulder Shot, ever mindful of screen direction.

## Graham Overby's Version

Graham Overby sets up his first shot as a Two-Shot, with a medium framing height. He still introduces both the space and the two characters.

Overby then employs a Close-Up, choosing to focus on Dr. Jekyll's companion and his reaction first.

The Medium Close-Up on Dr. Jekyll ingesting his formula is similar to Hutchenson's choice, but it employs strong lighting to suggest a more sinister mood.

With the canted Extreme Up Shot and with the art implying a wide-angle lens, the artist seeks to make the audience uneasy.

While Hutchenson focused on
Dr. Jekyll's transformation into
Mr. Hyde alone, Overby shows us
the transformation and the reaction
from the companion simultaneously
over two shots.

Overby also makes the choice to indicate
that Dr. Jekyll has fallen to the floor
during his transformation into Mr. Hyde;
he spends the next two shots building the
suspense as Mr. Hyde is revealed.

The artist chooses to focus on both characters again, emphasizing the relationship between them to end the sequence.

While Overby uses a Medium Close-Up for the reaction shot as well, he indicates a spinning zoom in to reach the framing height.

# Interview: Whitney Cogar, Storyboard Artist

**Whitney Cogar is a freelance illustrator currently** residing in Savannah, Georgia. Her first job storyboarding Robert Redford's film *The Conspirator* jump-started her career in the film industry. Other credits include *X-Men: First Class*, shorts for Elevation Church, and several short films.

Benjamin Reid Phillips caught up with Cogar as she was working on storyboards for the American Film Company.

**BRP:** Tell us about your experience working as an on-set storyboard artist. Did the experience enlighten you to the process of filmmaking?

**WC:** I was taken on for *The Conspirator* very late in the game—I think it was ten days out from shooting. It was the first film I'd ever worked on, so I learned a lot about the process of filmmaking very quickly. I would often have to wait on set to speak to the director [Robert Redford] during breaks so that we could work out a future scene.

**BRP:** Tell us about which members of the production you, as a storyboard artist, are dealing with on a daily basis.

**WC:** Mostly the director and his or her assistant, with the help of the DP and production designer. If the film is in very early stages, I might be working with producers and others directly with the studio to come up with a look book or pitch.

**BRP:** How important is it to have a functional knowledge of cinematography or even film history?

**WC:** It's very important. How do you know what to show in your boards if you don't even know what aspect ratio to use? What will be picked up in the shot if a wide-angle lens is used? It becomes even more important in films that have a lot of visual effects (VFX)—these films require very precise and accurate boards for the visual effects department to use, so you really need to know what the camera will and will not capture and what the limitations are.

**BRP:** What would you say to emerging directors and cinematographers who prefer to shoot "on the fly"?

**WC:** Storyboards can be used to work out a lot of unforeseen problems and can save a lot of time and money in the long run. Maybe snap decisions can make for guttural and exciting storytelling, but if a story can pull you in—even in storyboard form— then you'll not be taking any chances when filming. Storyboards can also help keep your crew on the same page! When I was on set, a lot of PAs and people in the AD department would come up and thank me for the boards on display.

**BRP:** Since a storyboard's main goal is communication, what's more important, speed or drawing prowess?

**WC:** Drawing prowess can mean a lot of things. If drawing prowess means you can photorealistically render a chrome bumper on a car without reference, that's great, but it's not going to do you any good. If drawing prowess is the ability to portray things clearly and accurately, then you're all set. It doesn't

In the following sample storyboards, Cogar explores the old sailor's myth about the danger of mermaids. We start with a wide establishing shot.

Then the camera cuts to a Full Shot of the ship's bow. We see the two sailors aboard and the dramatic carving of a mermaid that decorates the bow.

We follow that with the camera cutting to an Up Shot fully framing the mermaid and her sudden movement.

Staying with the slight Up Shot, the camera comes closer for a dramatically foreshortened Medium Close-Up.

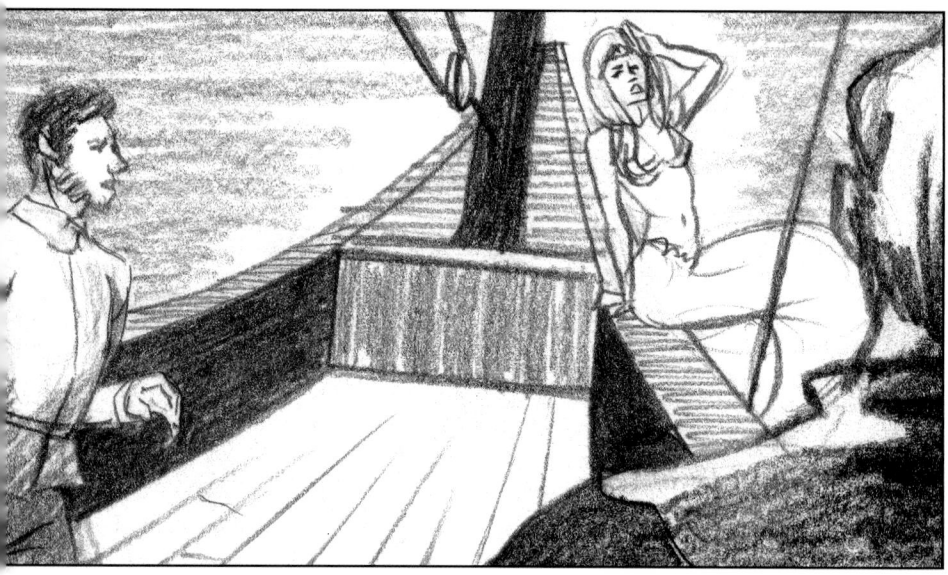

With an Over-the-Shoulder Shot, the camera reveals the mermaid coming up onto the deck to the surprise of its occupants...

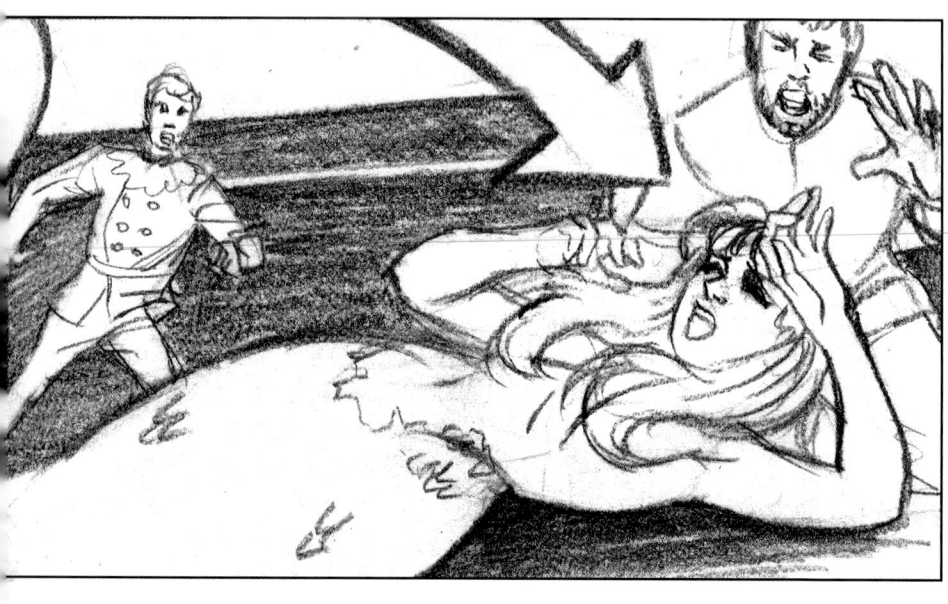

...followed immediately by a canted High Hat Shot as she falls to the deck and one of the sailors rushes to her rescue.

necessarily have to be pretty, but viewers have to be able to tell what they're looking at without a second thought. That is what's most important, since fast, sloppy, unreadable boards are useless to everyone. But good luck being able to get gigs without the speed.

**BRP:** Do storyboards need to be well rendered?

**WC:** Usually I'd say no—but it depends on the application. If the lighting in a scene is important, then the storyboards should be well rendered. If you're making the storyboards to impress someone who is about to fund your project, then they should be as pretty and polished as you have time or money to make them.

Having said that, the most important thing is clarity, followed by drama, and then more clarity. They should be just as clear the first time they are run off as the twelfth time.

**BRP:** What makes for a great storyboard artist?

**WC:** A great storyboard artist should be able to tell a story just as much as the director can. He or she should know how to draw people, objects, and environments for what they are and not get too caught up in minor things. And he or she should be able to deal with insane hours. A little bit of mind doesn't hurt either—you may be working with visual people who can't easily communicate what they need verbally.

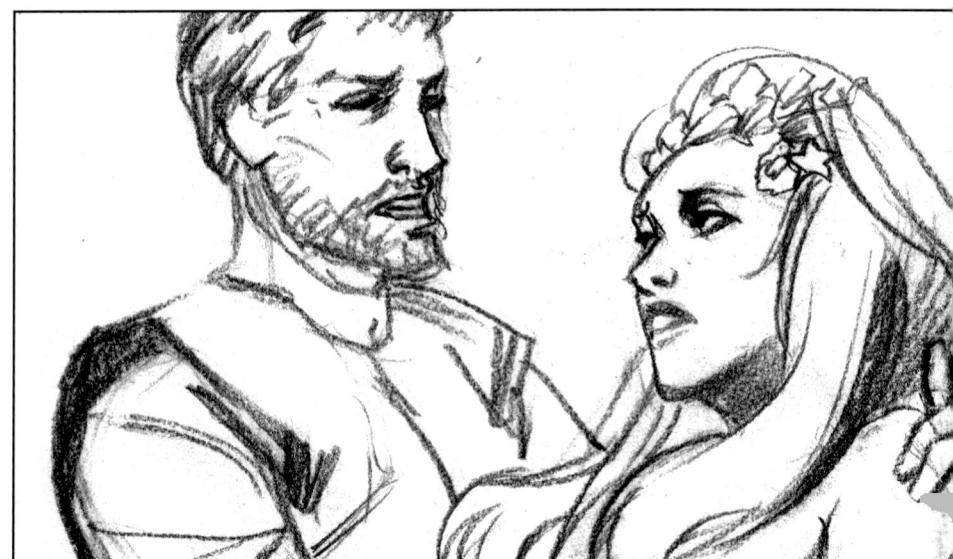

Then with a medium close up two shot we see as he pulls her up closer to him.

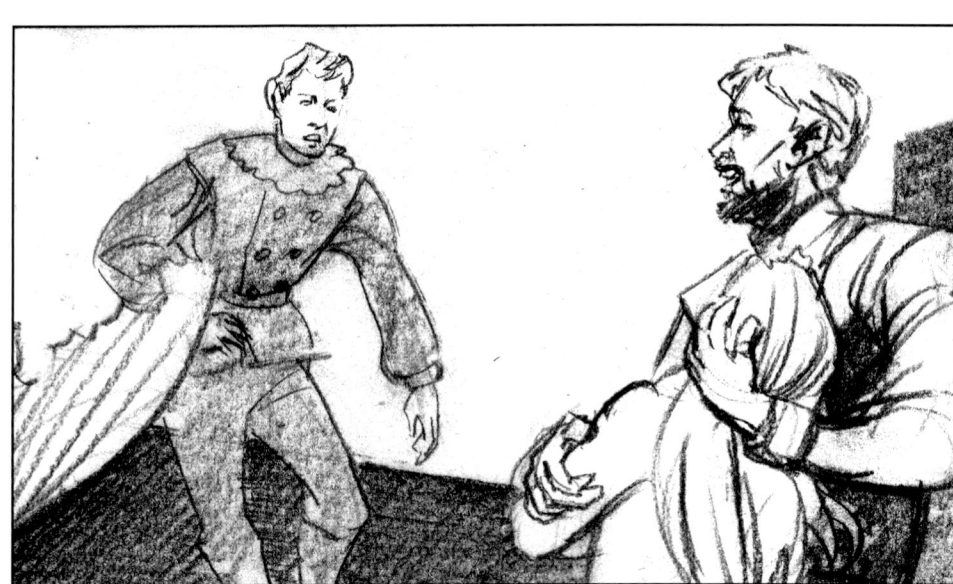

Following with a slight up shot pulling back to show that his comrade is coming closer as he cradles the mermaid.

# STORYBOARDING CHECKLIST

| ✓ | STORYBOARDING CHECKLIST | NOTES |
|---|---|---|
| | **Category Identified**<br>○ Editorial or Shooting Board<br>○ Advertising or Comp<br>○ Animation<br>○ Pre-Viz/VFX | |
| | **Aspect Ratio Required**<br>○ 1.33:1<br>○ 1.78:1<br>○ 1.85:1<br>○ 2.39:1<br>○ Other? | |
| | **Essential Elements Identified**<br>○ Setting (INT./EXT.)<br>○ Time of Day (DAY/NIGHT)<br>○ Cast<br>○ Background Performers<br>○ Transportation<br>○ Props<br>○ Set Dressing (S/D)<br>○ Special Effects (VFX or FX)<br>○ Animal Wrangler (A/W)<br>○ Makeup/Hair/Wardrobe (MU/H/W)<br>○ Other | |
| | **Thumbnail Sketches**<br>○ Variety of Shots<br>○ Considered as a Sequence<br>○ Dynamic Compositions<br>○ Perspective<br>   ○ Clear focal point<br>   ○ Overlapping<br>○ Framing Height and Camera Angle<br>○ Movement and Screen Direction<br>○ Sequencing, Timing, Pacing | |
| | **Shot Blocking**<br>○ Framing Height (FULL, MED, CU, etc.)<br>○ Camera Angle (High Hat, XUS, XDS, etc.)<br>○ Movement<br>   ○ Kinetic (PUSH/PULL, TRACK/DOLLY, CRANE)<br>   ○ Static (ZOOM, PAN, TILT) | |
| | **Continuity and Visual Logic**<br>○ 180° Rule<br>○ 30° of Separation<br>○ Screen Direction Logical and Consistent<br>○ Neutralizing Shots? | |
| | **Numbering**<br>○ Panel<br>○ Scene<br>○ Sequence<br>○ Shot<br>○ Insert shots? | |
| | **Submission Requirements Met?** | |

# WORKSHEET FOR SCRIPT BREAKDOWN

Name of PRODUCTION:                Aspect Ratio:

| SLUGLINE | SCRIPT NOTATION | ELEMENTS | FRAMING/ANGLE | MOVEMENT | PANEL NUMBER |
|---|---|---|---|---|---|
| | | | | | |

# TEMPLATES FOR ASPECT RATIOS 1.78:1

# TEMPLATES FOR ASPECT RATIOS 1.85:1

# TEMPLATES FOR ASPECT RATIOS 2.39:1

# VIEWFINDER TEMPLATE

1.33:1

1.78:1

# VIEWFINDER TEMPLATE

2.39:1

1.85:1

# Index

# ACKNOWLEDGMENTS

We wish to thank the following people for their significant and inspiring contributions to this book: Kenny Chaplin, Keith Ingham, Whitney Cogar, Tina O'Hailey, and Stratton Leopold for their words of wisdom; Grant Fitch, Andy Young, David Balan, Casey Crisenberry, Jon Feria, Daphne Hutchenson, Ryan James, Sarah Kelly, Katrina Kissell, Courtney Mayo, Isaac McCaslin, Graham Overby, and Sam Reveley.

We also thank Joshua Reynolds, Wai Ming "Nicky" Soh, and Lavina Westfall for gracing our pages with top-notch photography and illustrations; Kerri O'Hern for her sharp eye and tenacity; Angela Rojas and Jackie Meyer for their pursuit of perfection; and Savannah College of Art and Design president Paula Wallace and Design Press for giving us this incredible opportunity.